AMERICAN IMAGES:

New Work by Twenty Contemporary Photographers

Robert Adams

Lewis Baltz

Harry Callahan

William Clift

Linda Connor

Bevan Davies

Roy De Carava

William Eggleston

Elliott Erwitt

Larry Fink

Frank Gohlke

John Gossage

Jonathan Green

Jan Groover

Mary Ellen Mark

Joel Meyerowitz

Richard Misrach

Nicholas Nixon

Tod Papageorge

Stephen Shore

AMERICAN IMAGES:

New Work by Twenty Contemporary Photographers

Edited by Renato Danese

McGraw-Hill Book Company

New York St. Louis San Francisco Düsseldorf Mexico Toronto

123456789 A C H O 7832109

Book design by Carl Zahn

Library of Congress Cataloging in Publication Data

Main entry under title:
American images.
 1. Photography, Artistic. I. Danese, Renato.
TR654.A53 779'.9'973926 79-19927
ISBN 0-07-015295-0

Acknowledgments

I would like to acknowledge the contributions of many people to *American Images*:

Jane Livingston, associate director, The Corcoran Gallery of Art; Carroll T. Hartwell, curator of photography, The Minneapolis Institute of Arts; and Carole Kismaric, managing editor, *Aperture, Incorporated*, for their assistance in selecting the photographers.

Kathy Gauss, program specialist, National Endowment for the Arts, for her invaluable help and advice throughout this project.

Annette DiMeo Curlozzi, curator, Laguna Gloria Art Museum, for interviewing the photographers and preparing their statements, and for assisting me at every stage in the development of this book.

I am grateful to Carl Zahn of the Museum of Fine Arts, Boston, for designing this book, for joining me in overseeing its production, and for providing worthy counsel on so many aspects of this undertaking. I would like to thank, as well, Judy Spear, editor, the Museum of Fine Arts, Boston, for compiling the photographers' biographies.

For their commitment to the craft of printing and their keen understanding of the special requirements of reproducing photographs, I am indebted to Francis Canzano, Jr. and Robert A. Savigni of the Acme Printing Company.

I am grateful to the Bell System for its generous and enthusiastic support of this project, particularly Edward M. Block, vice-president of public relations, AT&T, whose personal advocacy and perception of the role of business in the arts made *American Images* possible.

I wish to thank Herman Klurfeld, consultant to AT&T, for his efforts during the early stages of this undertaking.

Throughout the entire course of this project I relied heavily on the advice and guidance of Max B. Schwartz, public relations director, AT&T. His contributions to every facet of this endeavor are deeply appreciated.

Above all, I wish to extend my gratitude to the photographers for the opportunity to learn about their work in depth and for their patience, good will, and commitment to this project.

R.D.

Preface

In early 1977, I was invited by representatives of the Bell System to assist them in designing and implementing a project in photography. After several months of discussion about the exact form such a project might take, we settled upon a program consisting of three major components — commissions to twenty contemporary American photographers to produce new work; an exhibition of those photographs, which will be presented in museums throughout the country; and the publication of this book, which reproduces 160 of the 300 photographs created under the program.

One of the most exciting aspects of the undertaking was the commissioning of new photographs not predetermined or restricted in theme or content. The photographers themselves selected their subject matter, adhering only to the provision that all photographs were to be taken in the United States. In return for a commission and expenses, each photographer submitted three identical portfolios of fifteen photographs each.

At the close of this project two complete sets of photographs, each consisting of 300 prints, will be donated by the Bell System to two American museums that have demonstrated a commitment to contemporary photography through their exhibition or acquisition programs. Thus, the body of photographs created for *American Images* will remain intact, preserved and available to the public in the future.

The most crucial form of support in the arts, and the support most difficult to obtain, is that which provides direct assistance to individual artists. Through its sponsorship of *American Images*, the Bell System has made it possible for photographers to undertake new work. This is a particularly rare and enlightened form of corporate patronage in the arts. The Bell System's further support of this book and the accompanying exhibition insures widespread public access to the works of art produced for this project.

RENATO DANESE

Washington, D.C.
July 1979

Contents

Robert Adams

These pictures are part of a series of landscapes begun in 1975, taken from the Missouri River westward to the Pacific. I started at the river because it was there that exploration of the Far West began, and, also important to me, it was in towns along the Missouri that my grandparents settled. What I wanted, if possible, was to rediscover some of the landforms that had impressed our forebears. I had been photographing suburbs, those almost wholly man-altered places, for so long that I had begun to wonder if they alone were the American geography. Were words like "majesty," so common in nineteenth-century vocabulary, now without application except for views of clouds? I set out, then, making one precautionary requirement of myself in order to try not to lie — I determined always to include some evidence of man.

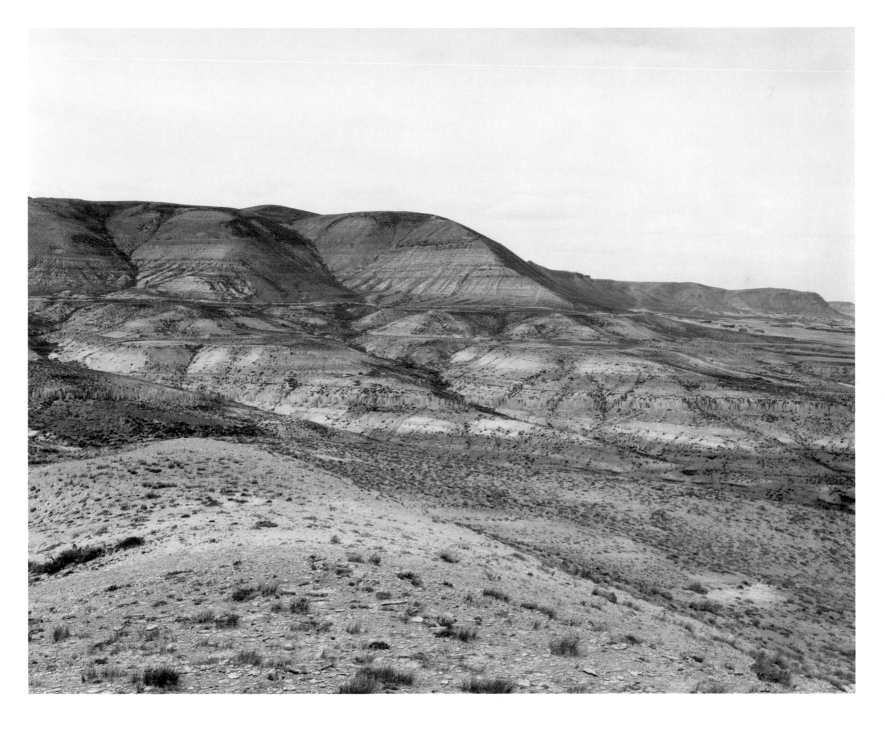

11 Robert Adams *Green River, Wyoming, 1977*

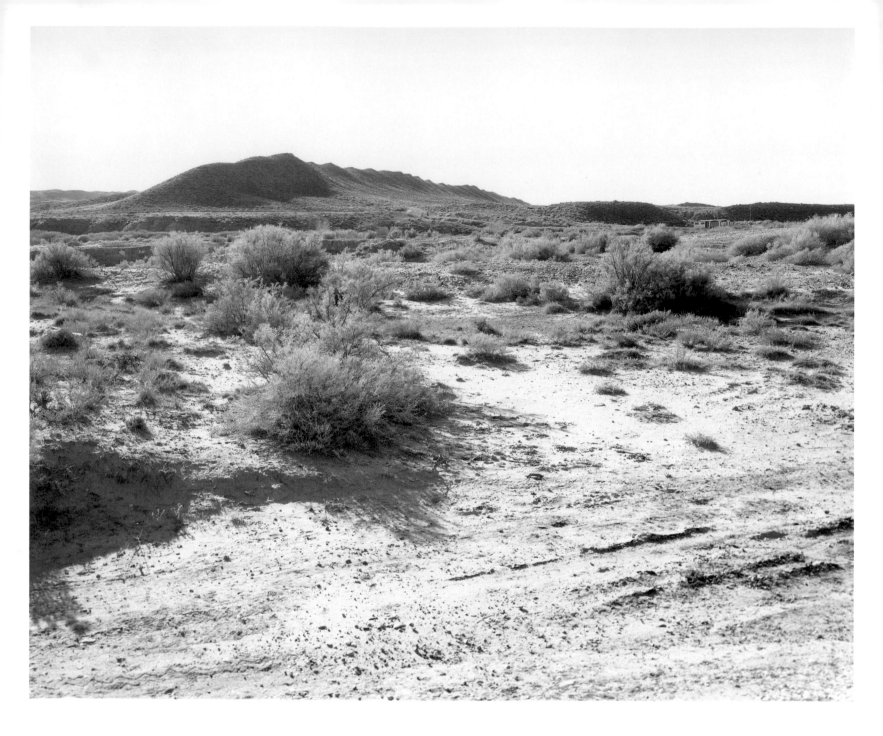

12 Robert Adams *Fort Steele, Wyoming, 1977*

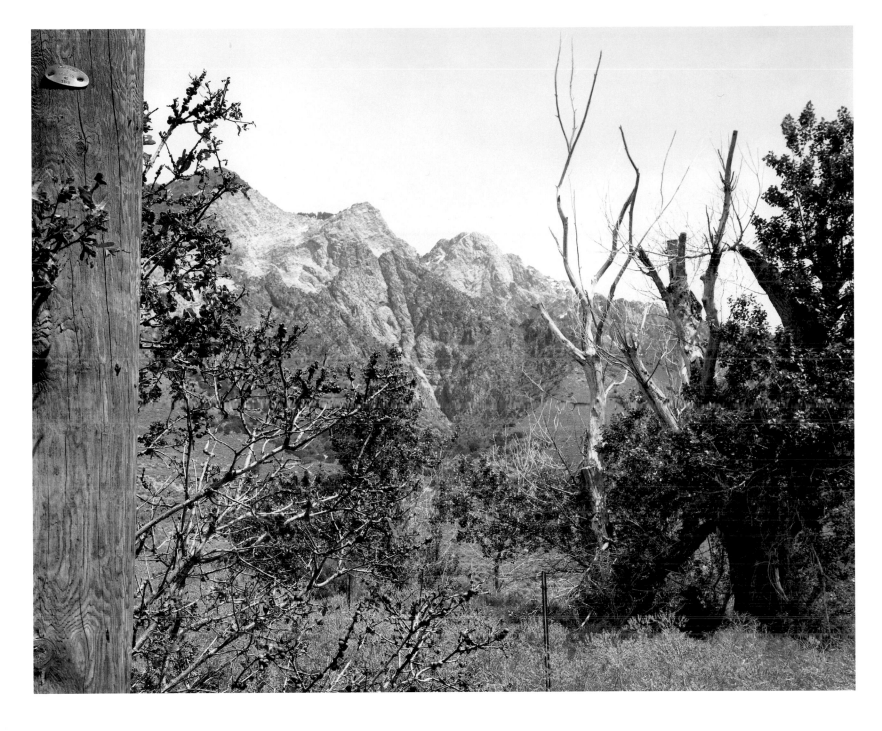

13 Robert Adams *Near Willard, Utah, 1978*

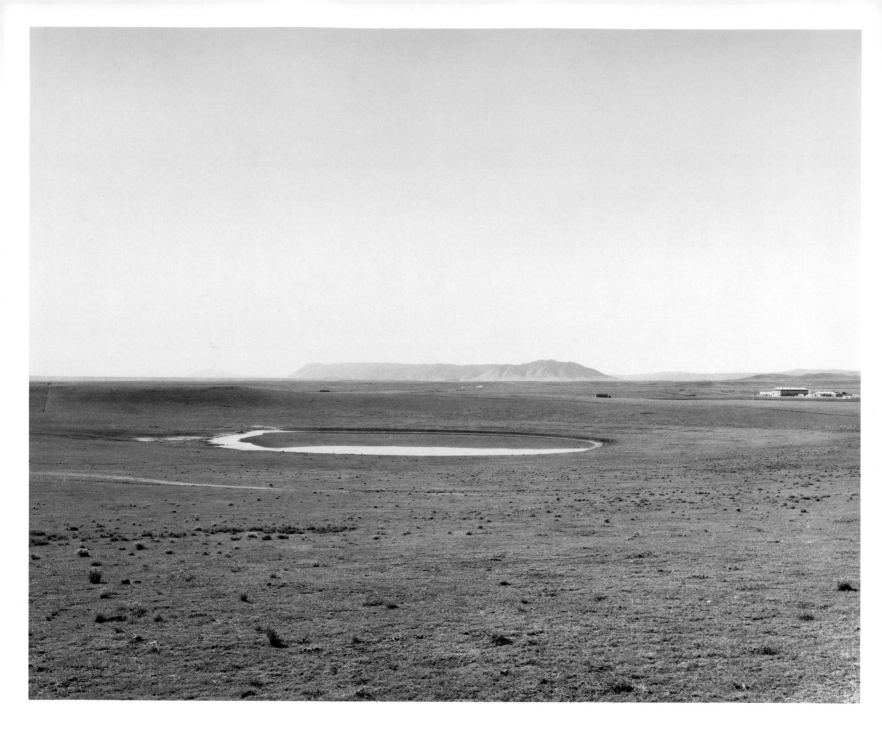

14 Robert Adams *Alkali Lake, Albany County, Wyoming, 1977*

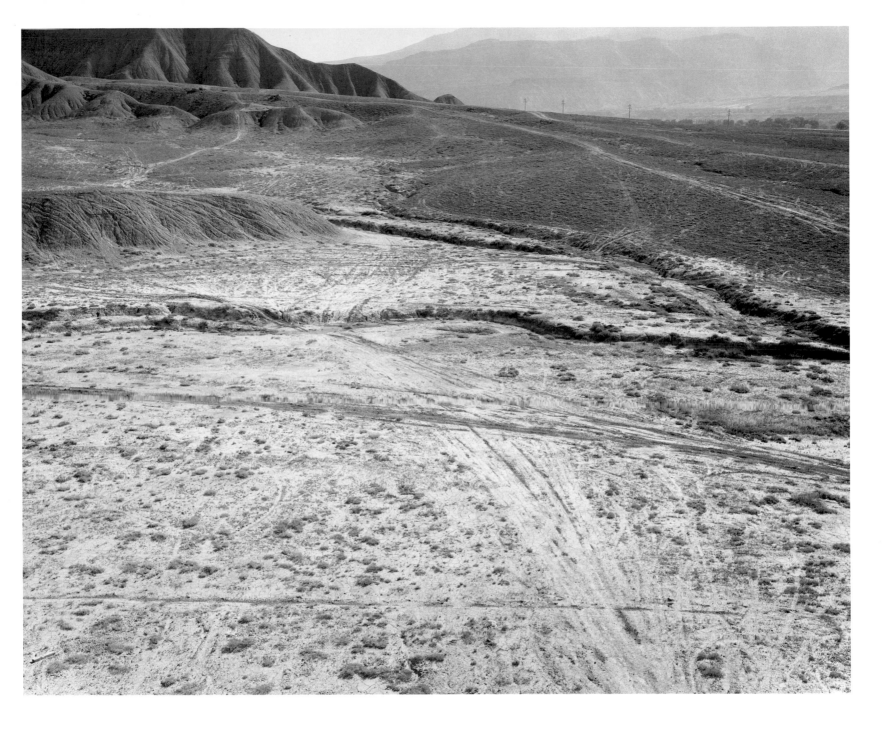

15 Robert Adams *Below Mt. Garfield, Mesa County, Colorado, 1977*

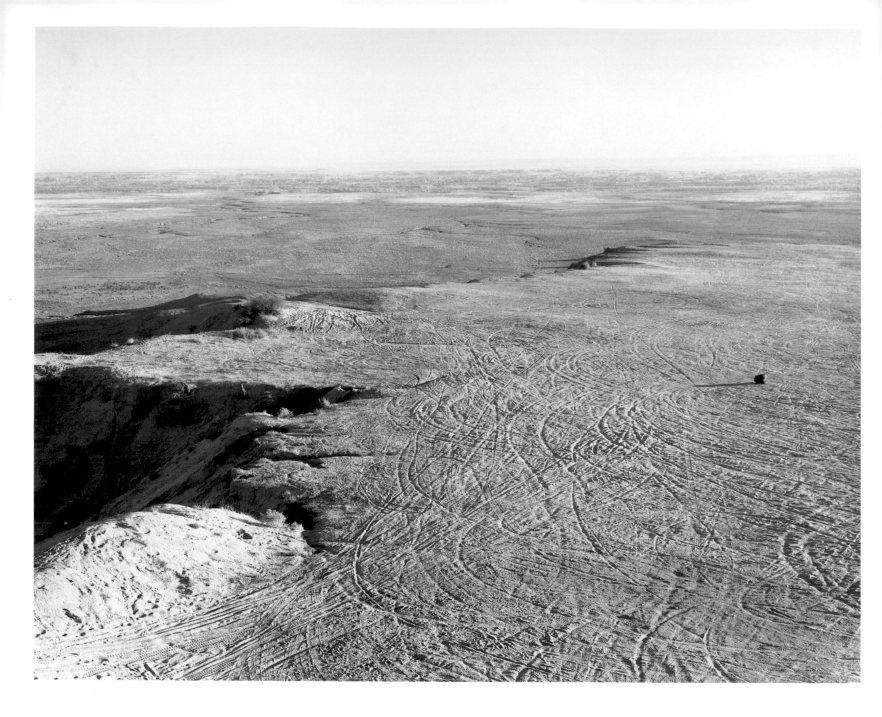

16 Robert Adams *East of Eden, Colorado, 1977*

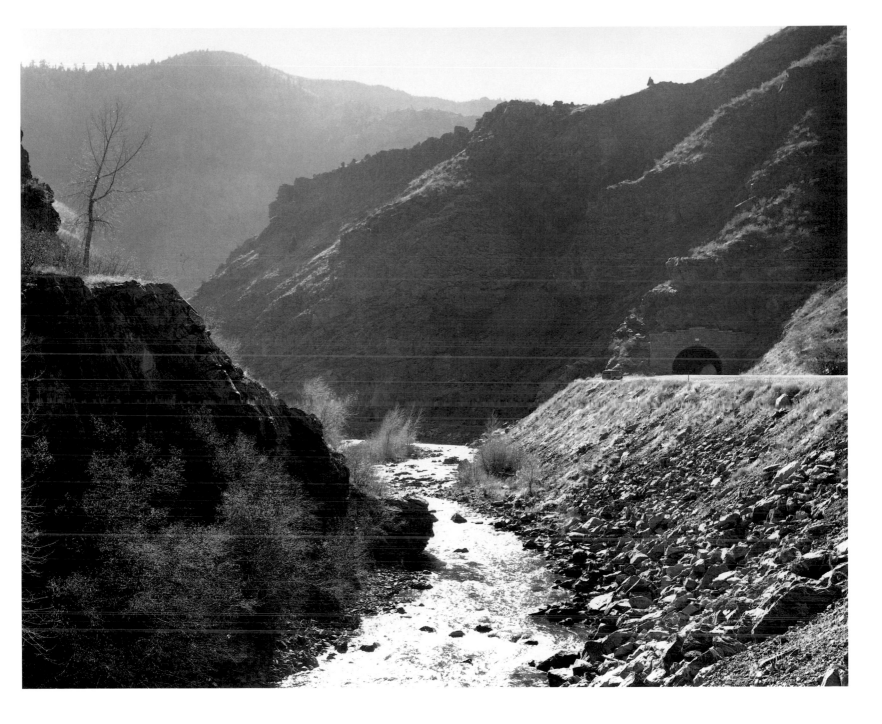

17 Robert Adams *Clear Creek Canyon, Jefferson County, Colorado, 1977*

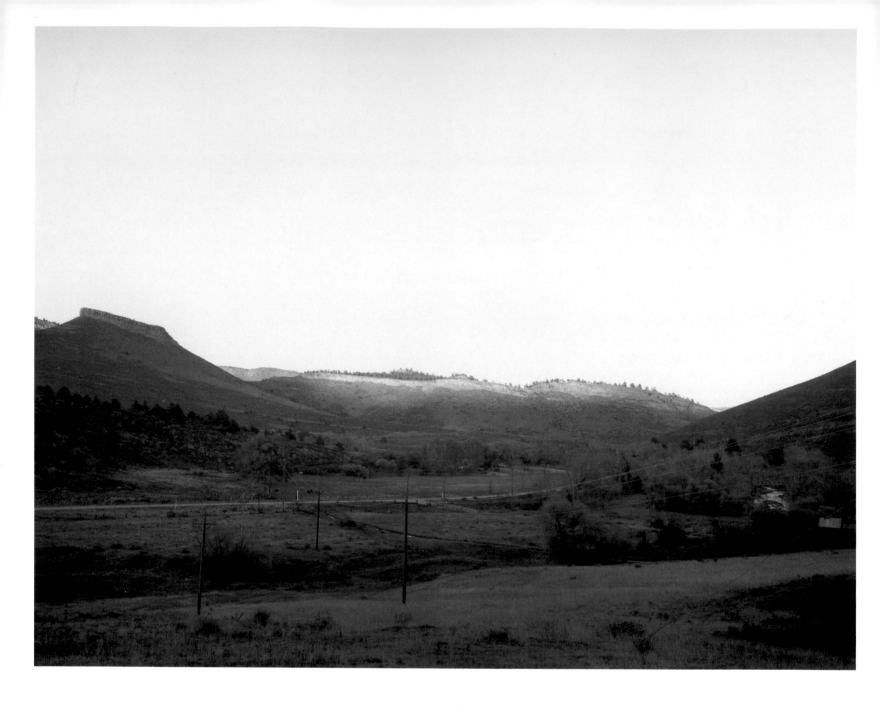

18 Robert Adams *Near Lyons, Colorado, 1977*

Born in 1937 in Orange, New Jersey; now living in Longmont, Colorado.

Background
University of Redlands, California, A.B., 1959
University of Southern California, Ph.D., 1965
Lecturer and Assistant Professor of English, Colorado College, Colorado
 Springs, 1962–1970
National Endowment for the Arts Photographer's Fellowships, 1972 and 1978
Guggenheim Fellowship, 1973

Selected Individual Exhibitions
1971 Colorado Springs Fine Arts Center
1976 St. John's College, Santa Fe, New Mexico
 Rice University Media Center, Houston
 Salt Lake City Public Library (Utah)
 Castelli Graphics Gallery, New York
1977 Sheldon Memorial Art Gallery, University of Nebraska, Lincoln
1978 Robert Self Gallery, London
 Denver Art Museum; Museum of Modern Art, New York ("Prairie")
1979 Castelli Graphics Gallery, New York

Selected Group Exhibitions
1971 "Photographs by Robert Adams and Emmet Gowin," Museum of
 Modern Art, New York
1973 "Landscape/Cityscape," Metropolitan Museum of Art, New York
1975 "14 American Photographers," Baltimore Museum (traveling
 exhibition)
 "New Topographics," George Eastman House, Rochester, New York
 (traveling exhibition)

1976 "Six American Photographers," Thomas Gibson Fine Arts, Ltd.,
 London
 "Recent American Still Photography," Fruitmarket Gallery of the
 Scottish Arts Council, Edinburgh
 "Twelve Contemporary Photographers," Halsted 831 Gallery,
 Birmingham, Michigan
1977 "The Great West: Real Ideal," University of Colorado, Boulder;
 Smithsonian Institution, Washington, D.C.
 "Contemporary American Photographic Works," Museum of Fine
 Arts, Houston (traveling exhibition)
1978 "Additional Information: Photographs by 10 Contemporary
 Photographers," University of Maryland, College Park
 "American Landscape Photography: 1860–1978," Neue Sammlung,
 Munich
 "Mirrors and Windows," Museum of Modern Art, New York
 "Façades," Hayden Gallery, MIT, Cambridge

Collections
International Museum of Photography at George Eastman House, Rochester
Metropolitan Museum of Art, New York
Museum of Fine Arts, Houston
Museum of Modern Art, New York
Princeton University Art Museum
Sheldon Memorial Art Gallery, University of Nebraska, Lincoln

Lewis Baltz

The photographer prefers not to make a statement about his work.

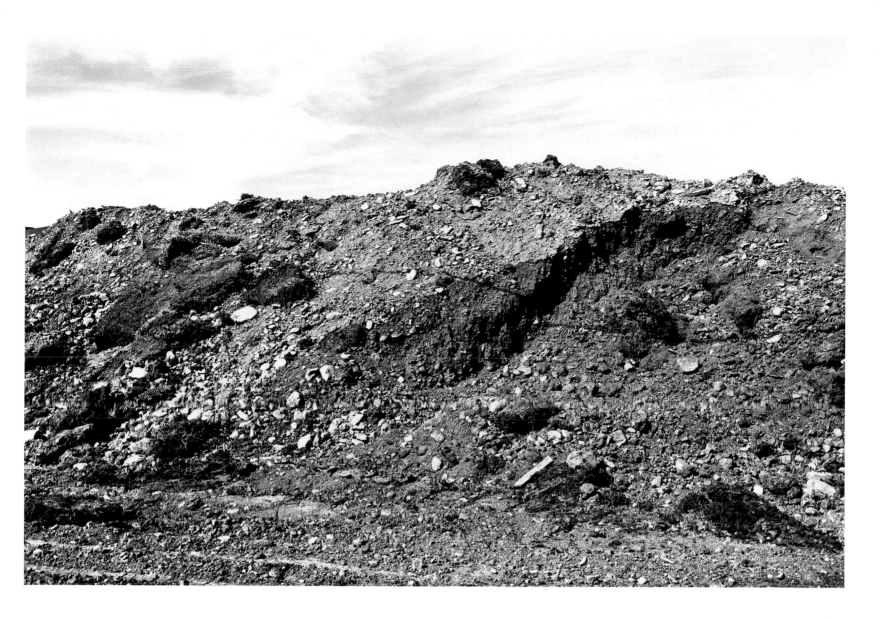

21 Lewis Baltz *Park Meadows, Subdivision #5, looking West, 1978*

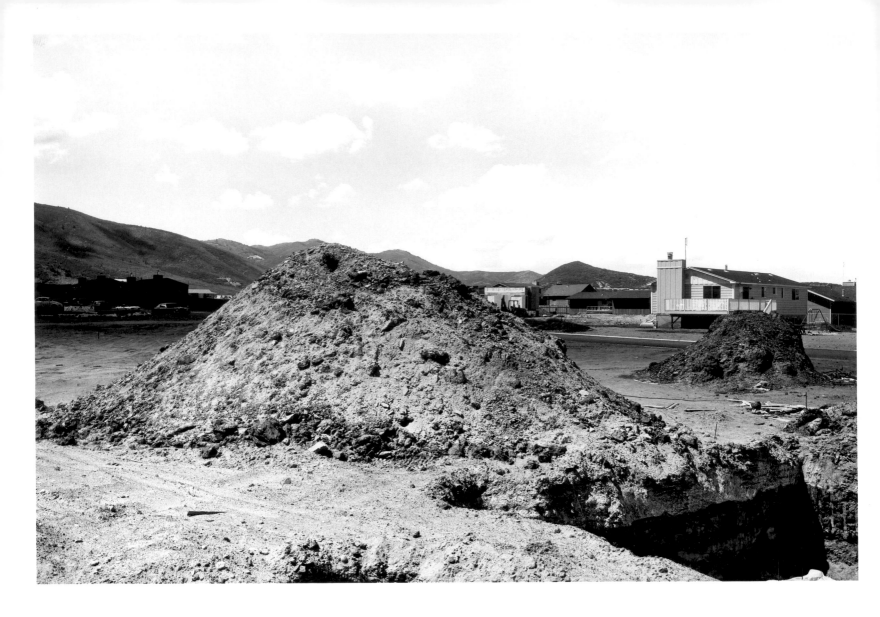

22 Lewis Baltz *Lot #123, Prospector Park, Subdivision Phase 3, looking Northwest, 1978*

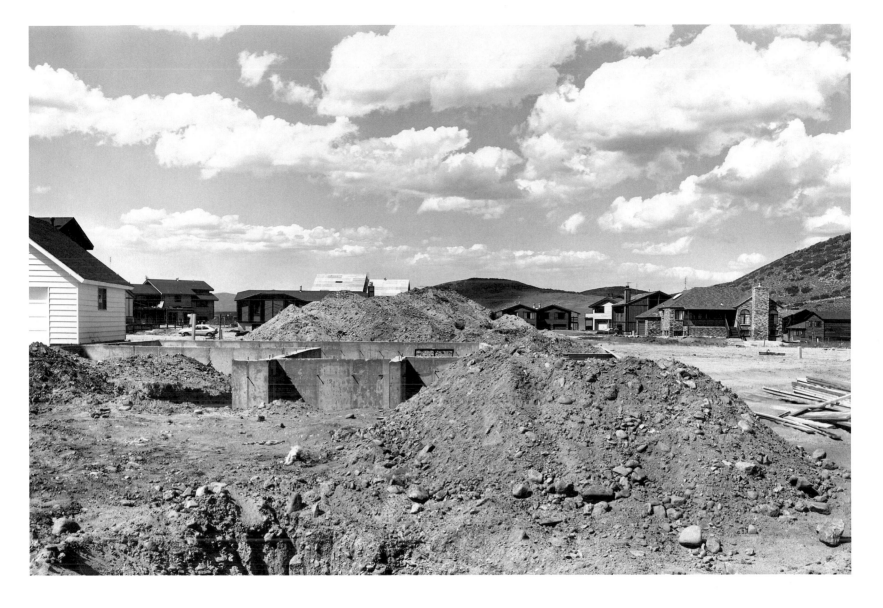

23 Lewis Baltz *Lot #105, Prospector Village, looking North, 1978*

24 Lewis Baltz *Lot #65, Park Meadows, Subdivision #2, looking East, 1978*

25 Lewis Baltz *Lot #81, Prospector Village, looking Southeast, 1978*

26 Lewis Baltz *Between Sidewinder Road and State Highway 248, looking North, 1978*

27 Lewis Baltz *Snowflower Condominiums during construction, looking West, 1978*

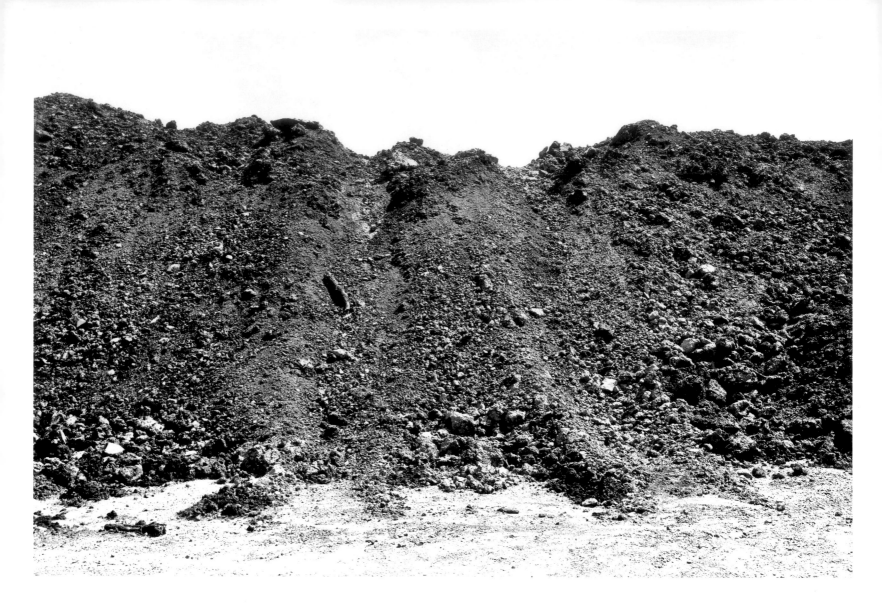

28 Lewis Baltz *Snowflower Condominiums during construction, looking East, 1978*

Born in 1945 in Newport Beach, California; now living in Sausalito, California.

Background
San Francisco Art Institute, B.F.A., 1969
Claremont Graduate School, M.F.A., 1971
National Endowment for the Arts Photographer's Fellowships, 1973 and 1976
Guggenheim Fellowship, 1976

Selected Individual Exhibitions
1970 Pomona College, Claremont, California
1971 Castelli Graphics Gallery, New York
1972 George Eastman House, Rochester
1973 Castelli Graphics Gallery, New York
1974 Corcoran Gallery, Washington, D.C.
 Jefferson Place Gallery, Washington, D.C.
1975 Castelli Graphics Gallery, New York
 Philadelphia College of Art
 Jack Glenn Gallery, Corona del Mar, California
 University of New Mexico, Albuquerque
1976 Galerie December, Düsseldorf
 Corcoran Gallery, Washington, D.C.
 Lunn Gallery, Washington, D.C.
 La Jolla Museum (California)
 Baltimore Museum
 Museum of Fine Arts, Houston
 Vision Gallery, Boston
1977 Grapestake Gallery, San Francisco
 Sheldon Memorial Art Gallery, University of Nebraska, Lincoln
 Photographers' Gallery, Saskatoon (Canada)
1978 Yarlow-Salzman Gallery, Toronto
 Castelli Graphics Gallery, New York
 Grapestake Gallery, San Francisco
 Susan Spiritus Gallery, Newport Beach, California
 University of Nevada, Reno

Selected Group Exhibitions
1973 "Photography: Recent Acquisitions," Museum of Modern Art, New York
 Yale University, New Haven
1975 "9th Biennale," Paris
 "14 American Photographers," Baltimore Museum (traveling exhibition)
 "New Topographics," George Eastman House, Rochester (traveling exhibition)
1976 "Contemporary American Photography," Scottish Arts Council, Edinburgh

1977 "La Photographie Créatrice au XXe Siècle, Musée Nationale d'Art Moderne, Centre Pompidou, Paris
 Biennial exhibition, Whitney Museum, New York
 "Art and Architecture," Galerie Magers, Bonn (Germany)
 "Concerning Photography," Photographers' Gallery, London
 "Eye of the West," Hayden Gallery, MIT, Cambridge
 "American Photographers," Forum Stadtpark, Graz (Austria)
1978 "Court House," Museum of Modern Art, New York
 "Certain Landscapes," Castelli Graphics Gallery, New York
 "Changing Prospects," Corcoran Gallery, Washington, D.C.
 "Mirrors and Windows," Museum of Modern Art, New York (traveling exhibition)
 "23 Photographers — 23 Directions," Walker Art Gallery, Liverpool (England)
 "Architectures," Bibliothèque Nationale (Galerie de Photographie), Paris
1979 "Industrial Sights," Whitney Museum (Downtown), New York

Collections
Art Institute of Chicago
Baltimore Museum of Art
Bibliothèque Nationale, Paris
California State University, San Diego
Corcoran Gallery of Art, Washington, D.C.
Dallas Art Museum
International Museum of Photography at George Eastman House, Rochester
La Jolla Museum of Contemporary Art (California)
Library of Congress, Washington, D.C.
Museo Civico e Gallerie d'Arte Antica e d'Arte Moderna, Udine
Museum of Fine Arts, Boston
Museum of Fine Arts, Houston
Museum of Fine Arts, St. Petersburg, Florida
Museum of Modern Art, New York
National Collection of Fine Art, Washington, D.C.
National Endowment for the Arts, Washington, D.C.
Oakland Museum (California)
Philadelphia Museum of Art
Phillips Academy, Andover, Massachusetts
Princeton University Art Museum
San Francisco Museum of Modern Art
Joseph E. Seagram Collection, New York
Sheldon Memorial Art Gallery, University of Nebraska, Lincoln
Stanford University Art Museum, Palo Alto
University of California Art Museum, Berkeley
University of New Mexico, Albuquerque

Harry Callahan

I've been nuts about the city for a long time. Since 1940 I've been photographing streets and buildings, trying always to do it — to see it — in a different way. The idea of using a building in the foreground against another in the background — juxtaposing two different styles and eras — is something I began in the forties. But those early city pictures, taken with an 8 x 10 or a 4 x 5 view camera, were more static. I was very careful about lining up all the windows, etc. This was the first time I took pictures of architecture with a telephoto lens, and I liked the way the buildings looked distorted and crammed together in one space. I'd never looked *through* buildings like that before.

Ever since I started, I've seemed to photograph the same subjects. But I've constantly shifted from one thing to another because you always have to find a way to see it fresh, to feel intensely about it again. If you do only one thing all the time, your work becomes decorative and you just get dull.

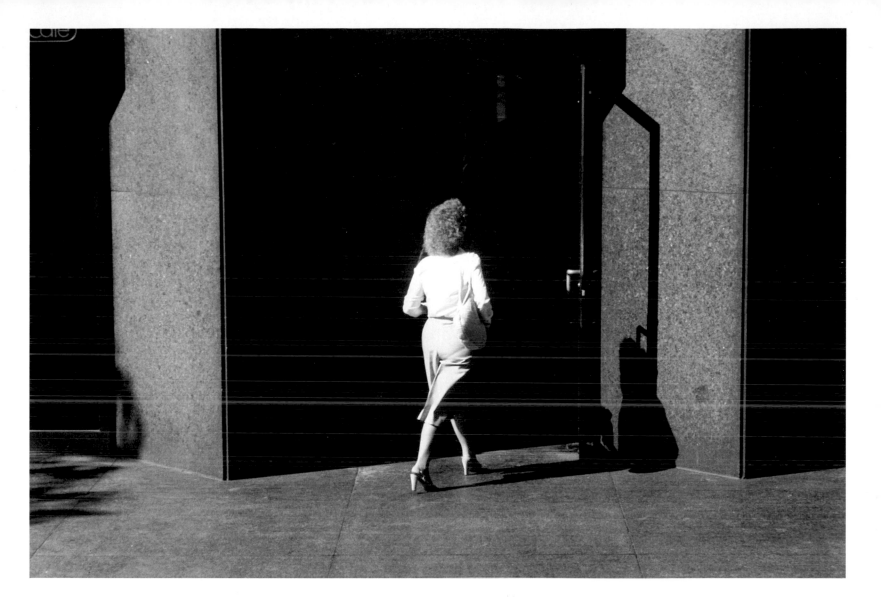

31 Harry Callahan *Untitled, 1978*

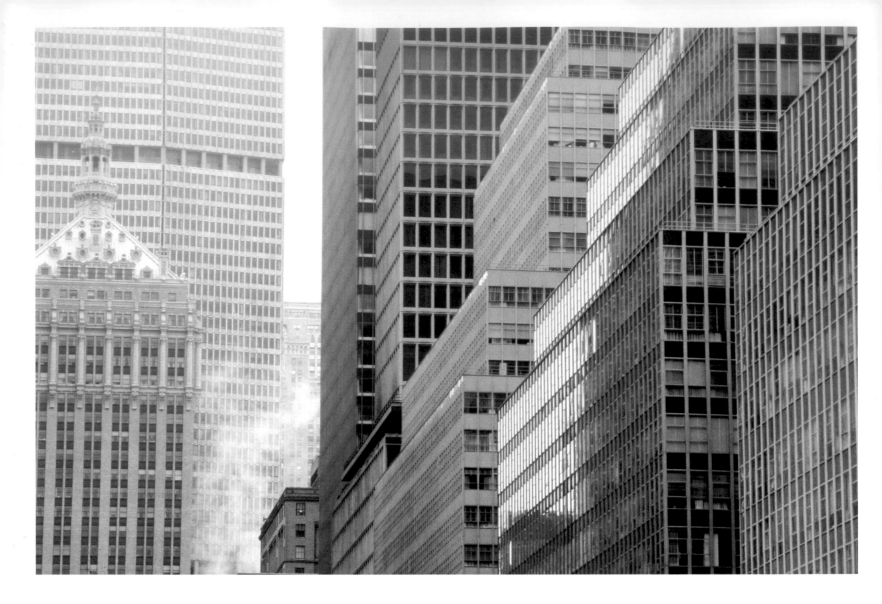

32 Harry Callahan *Untitled, 1978*

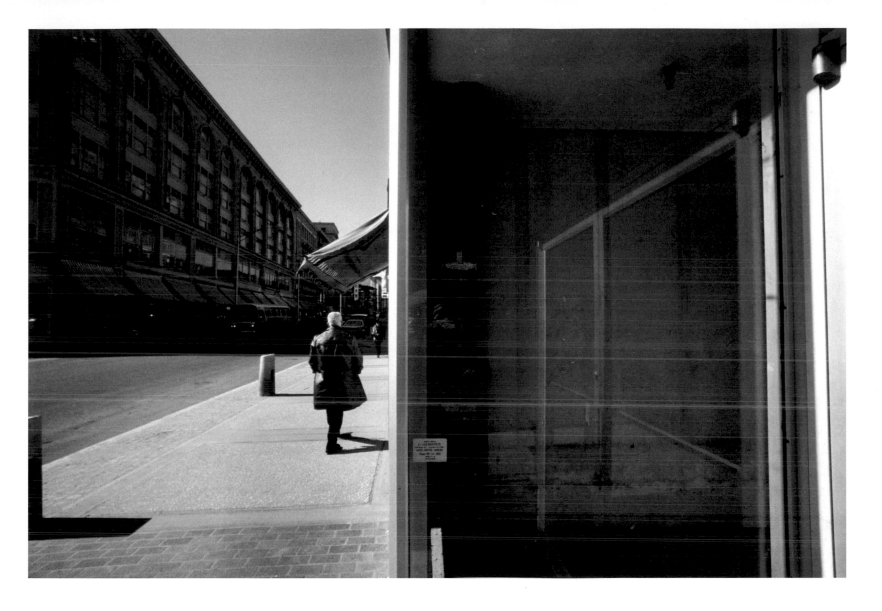

33 Harry Callahan *Untitled, 1978*

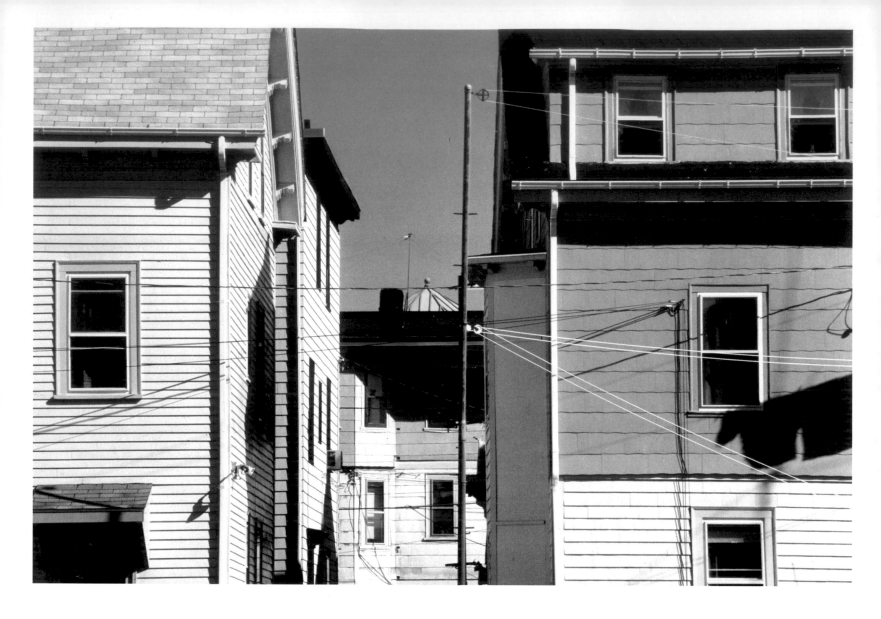

34 Harry Callahan *Untitled, 1978*

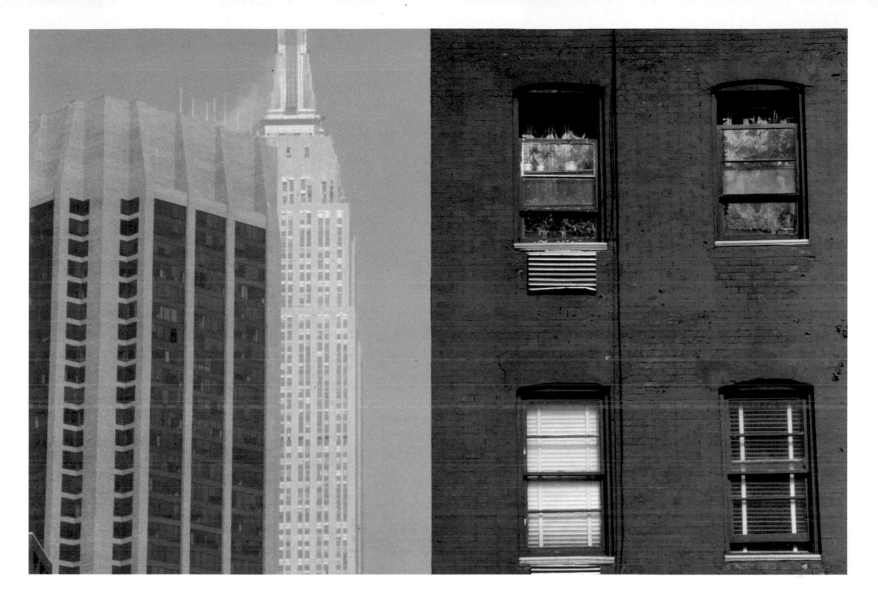

35 Harry Callahan *Untitled, 1978*

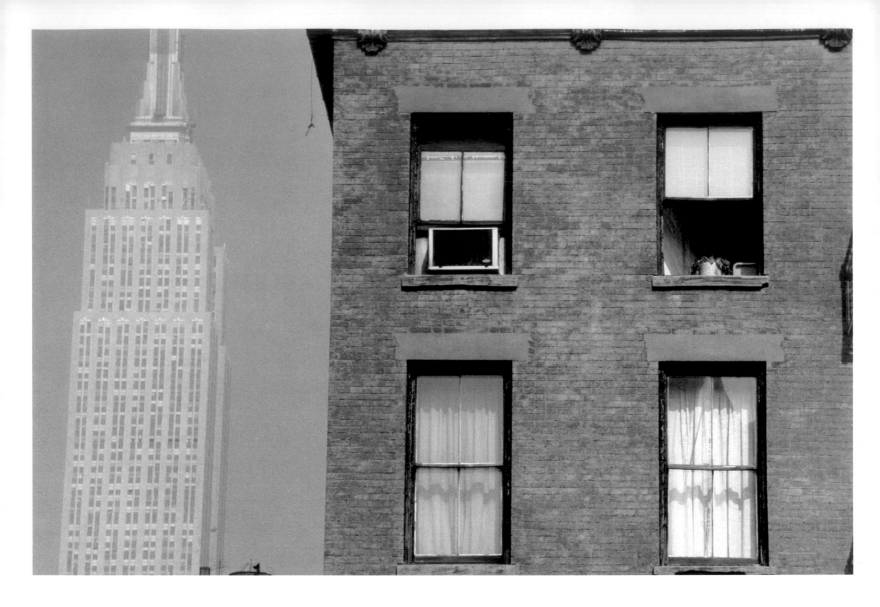

36 Harry Callahan *Untitled, 1978*

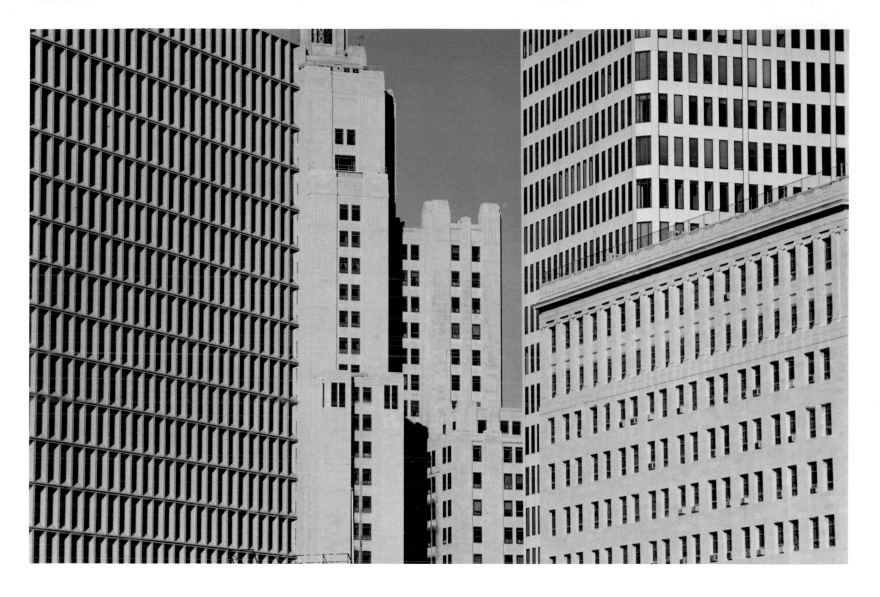

37 Harry Callahan *Untitled, 1978*

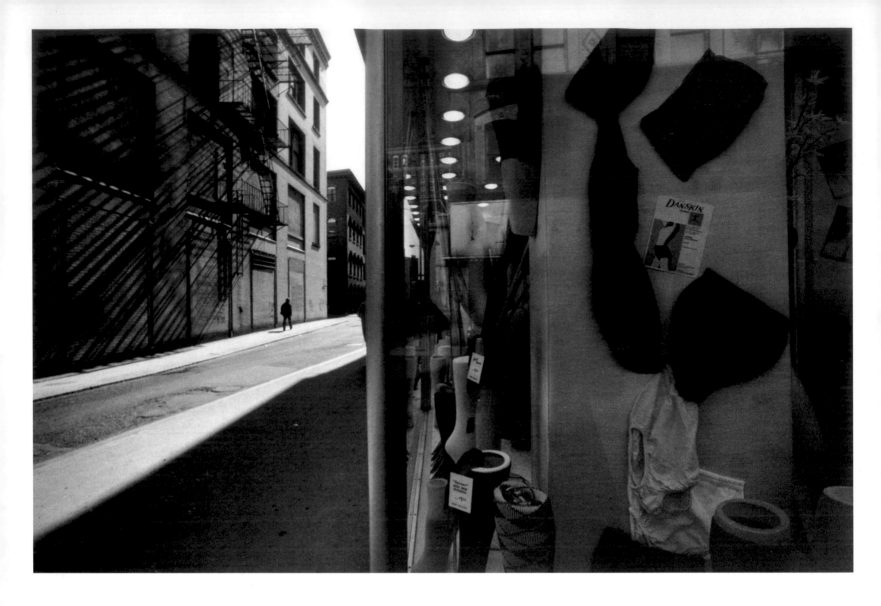

38 Harry Callahan *Untitled, 1978*

Born in 1912 in Detroit, Michigan; now living in Providence, Rhode Island.

Background
Michigan State College (studied engineering briefly), 1930
Instructor at Institute of Design (formerly the New Bauhaus; after 1950 part of the Illinois Institute of Technology), 1946; head of Department of Photography, 1949
Instructor at Black Mountain College (North Carolina), summer 1951
Head of Department of Photography at Rhode Island School of Design, Providence, 1961; Professor in 1964; retired in 1967
Graham Foundation Award for Advanced Studies in the Fine Arts, 1956
Guggenheim Fellowship, 1972
National Endowment for the Arts Photographer's Fellowship, 1975

Selected Individual Exhibitions
1946 750 Studio Gallery, Chicago
1951 Art Institute of Chicago
 Black Mountain College, North Carolina
 Museum of Modern Art, New York (traveling exhibition)
1956 Kansas City Art Institute
1958 George Eastman House, Rochester
1962 University of Warsaw, Poland
1966 Kiosk Galleries, Reed College, Portland, Oregon
1968 Hayden Gallery, MIT, Cambridge
 Museum of Modern Art, New York (traveling exhibition)
1969 George Eastman House, Rochester (traveling exhibition)
1970 Friends of Photography, Carmel, California
 Witkin Gallery, New York
 Carl Siembab Gallery, Boston
1971 George Eastman House, Rochester
1972 Light Gallery, New York
1974 Light Gallery, New York
1975 Hayden Gallery, MIT, Cambridge
 Cronin Gallery, Houston
1976 Minneapolis Institute of Arts
 Picture Gallery, Zurich (Switzerland)
 Galerie Lichttropfen, Aachen (Germany)
 Light Gallery, New York
 Museum of Modern Art, New York
1977 Galerie Zabriskie, Paris
 David Mirvish Gallery, Toronto
 Musée Réattu, Arles (France)
 Grapestake Gallery, San Francisco
1978 Galerie Fiolet, Amsterdam
 Light Gallery, New York
 Venice Biennale (with Richard Diebenkorn)

Selected Group Exhibitions
1948 "In and Out of Focus," Museum of Modern Art, New York
1949 "Four Photographers," Museum of Modern Art, New York
1950 "Photography at Mid-Century," Los Angeles County Museum of Art
1951 "Abstraction in Photography," Museum of Modern Art, New York
1952 "Diogenes with a Camera 1," Museum of Modern Art, New York
1953 "Contemporary Photography," National Museum of Modern Art, Tokyo
1954 "Subjektive Fotografia 2," State School of Arts, Saarbrucken (Germany)
1955 "The Family of Man," Museum of Modern Art, New York

1956 "Five Photographers," Photographer's Gallery, New York
 "American Artists Paint the City," 28th Biennale, Venice
1957 "Harry Callahan — Aaron Siskind: Photographes Americains," Centre Culturel Americain, Paris
 "Abstract Photography," American Federation of Arts, New York (traveling exhibition)
1959 "Photography in the Fine Arts," Metropolitan Museum of Art, New York
1960 "The Sense of Abstraction," Museum of Modern Art, New York
1961 "Six Photographers," University of Illinois, Urbana
1962 "Photographs by Harry Callahan and Robert Frank," Museum of Modern Art, New York
 "Ideas and Images," Worcester Art Museum (Massachusetts)
1963 "The Photographer and the American Landscape," Museum of Modern Art, New York
 "Ten Photographers," Schuman Gallery, Rochester
1964 "The Photographer's Eye," Museum of Modern Art, New York
1968 "Photography in the Twentieth Century," National Gallery of Canada, Ottawa
1972 "Eleven American Photographers," Hofstra University, Hempstead, New York
1976 "Six American Photographers," Thomas Gibson Fine Arts, Ltd., London
 "Photographs by Aaron Siskind and Harry Callahan," Washington Gallery of Photography
1977 "The Photographer and the City," Museum of Contemporary Art, Chicago
 "Forty American Photographers," Crocker Art Gallery, Sacramento
1978 "Photography," Moderna Museet, Stockholm

Collections
William Hayes Ackland Art Center, University of North Carolina, Chapel Hill
Art Institute of Chicago
Baltimore Museum of Art
Bibliothèque Nationale, Paris
Center for Creative Photography, University of Arizona, Tucson
Delaware Art Museum, Newark
Fogg Art Museum, Harvard University, Cambridge
Hayden Gallery, MIT, Cambridge
International Museum of Photography at George Eastman House, Rochester
Metropolitan Museum of Art, New York
Minneapolis Institute of Arts
Museum of Fine Arts, Boston
Museum of Fine Arts, Houston
Museum of Fine Arts, St. Petersburg
Museum of Modern Art, New York
National Gallery of Canada, Ottawa
New Orleans Museum of Art
Princeton University Art Museum
Rhode Island School of Design, Museum of Art, Providence
Joseph E. Seagram Collection, New York
Smith College Museum of Art, Northampton, Massachusetts
University of New Mexico Art Museum, Albuquerque
Vassar College Art Gallery, Poughkeepsie, New York
Victoria and Albert Museum, London
Virginia Museum of Fine Arts, Richmond
Frederick S. Wight Art Gallery, University of California, Los Angeles
Yale University Art Gallery, New Haven

William Clift

There's an area called La Bajada Mesa not far from where I
live, and I've always been curious about it, always felt drawn
to it and wondered what was beyond the small hills I could
see from the highway. When I explored it for the first time in
the spring of 1978, I was amazed to discover a dramatic land-
scape, so awesome and complexly detailed when viewed
from atop Cerro Seguro, that it resembled aerial views of
New Mexico I'd seen and remembered over the years.
Finally I'd found an actual location to photograph and make
those impressions real. La Bajada contained everything I was
interested in photographing — relationships between rising
and falling land masses, delineated by the intricate play of
sunlight and shadow, and traces of human presence — and I
returned to photograph the area several times over an eight-
week period.

When the photographing was done, I struggled with the
prints, laboring to reproduce what I had felt through tonal
values, color, and the proper size of the images. I finally real-
ized that the prints needed to be large — wider than my body —
like the breadth of the landscape I had responded to so
strongly. I didn't want them to look just like photographic
objects or products of a skillful technique — I wanted my feel-
ings about the landscape to be communicated immediately.

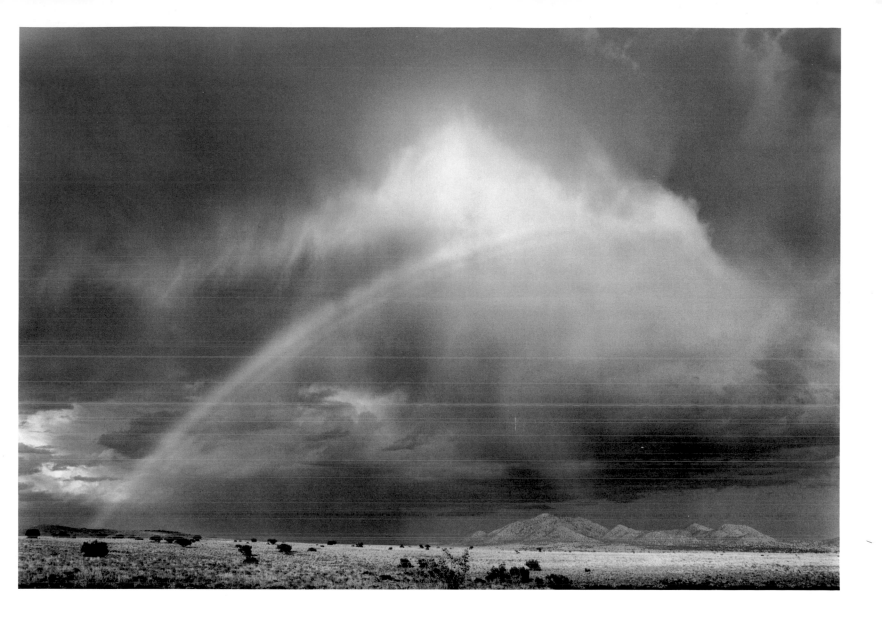

41 William Clift *Rainbow, Waldo, New Mexico, 1978*

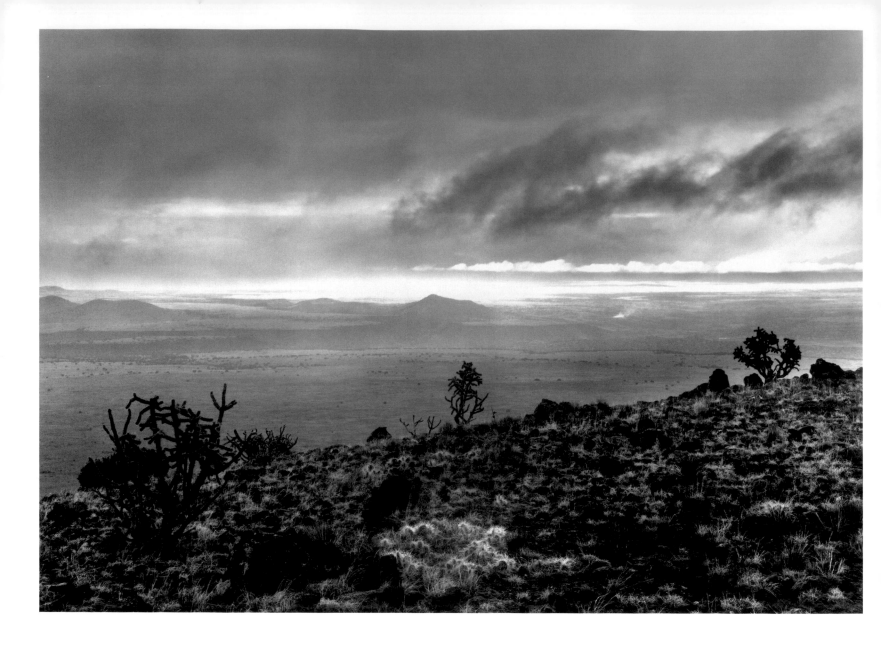

42 William Clift *View toward Cerro Seguro, 1978*

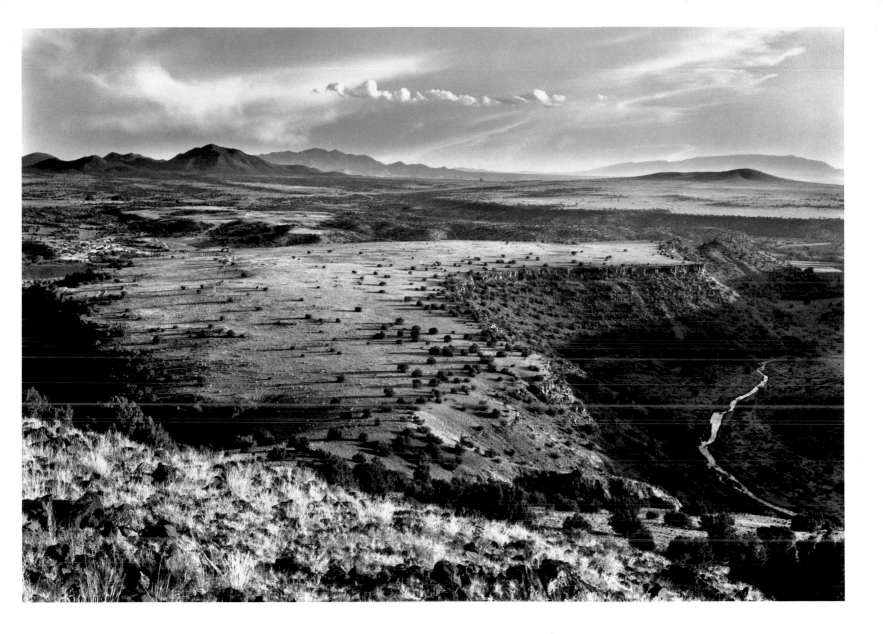

43 William Clift *La Mesita from Cerro Seguro, 1978*

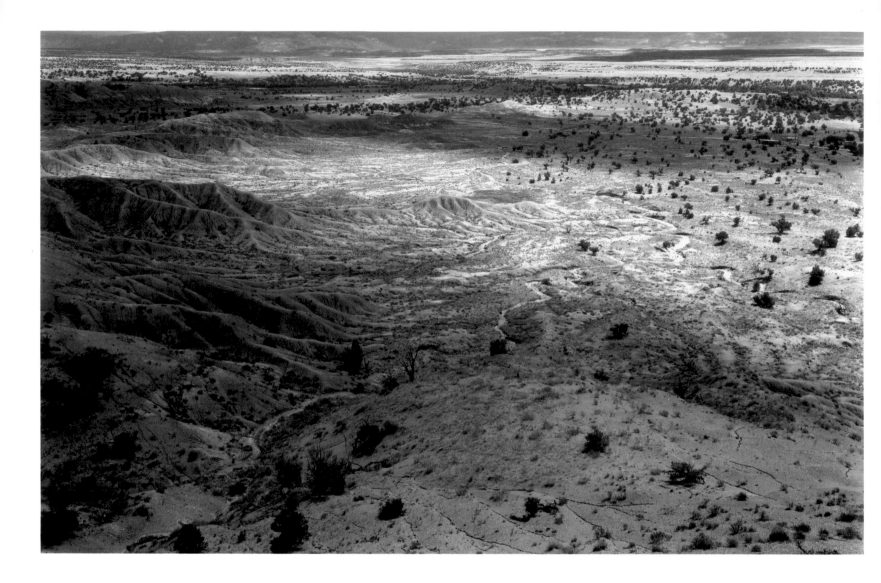

44 William Clift *Ghost Ranch, 1978*

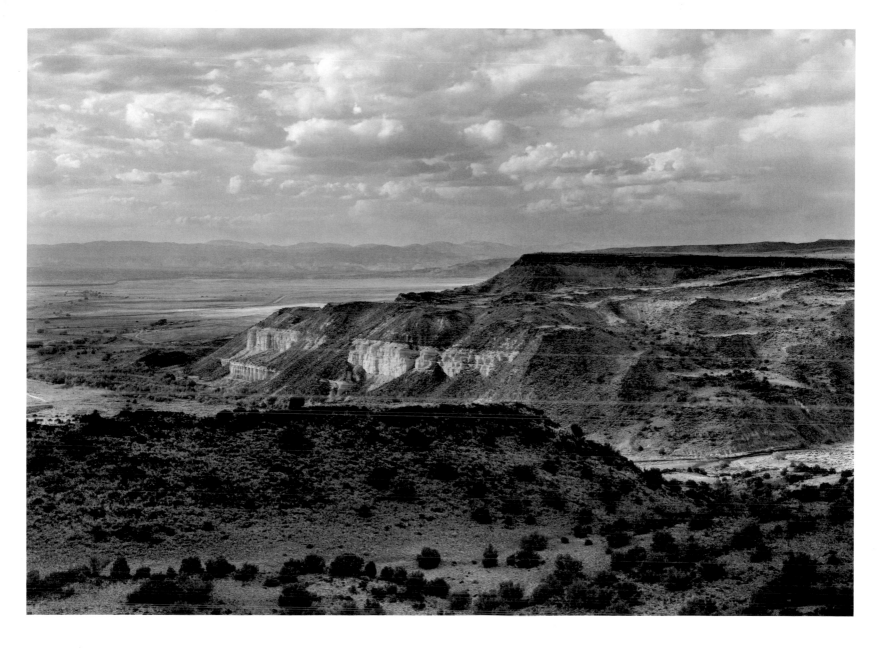

45 William Clift *End, Santa Fe River Gorge, 1978*

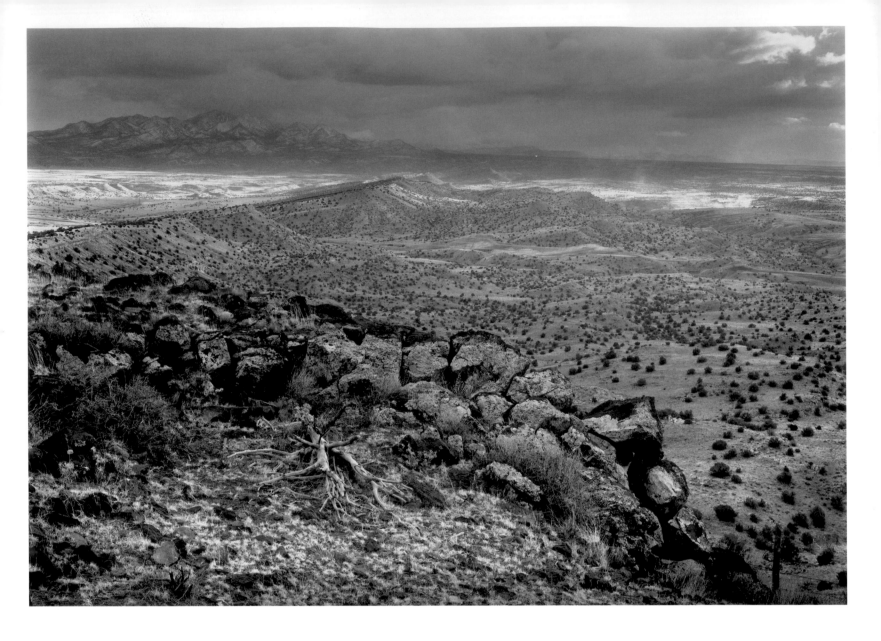

46 William Clift *From La Bajada Mesa toward the Ortiz Mountains, 1978*

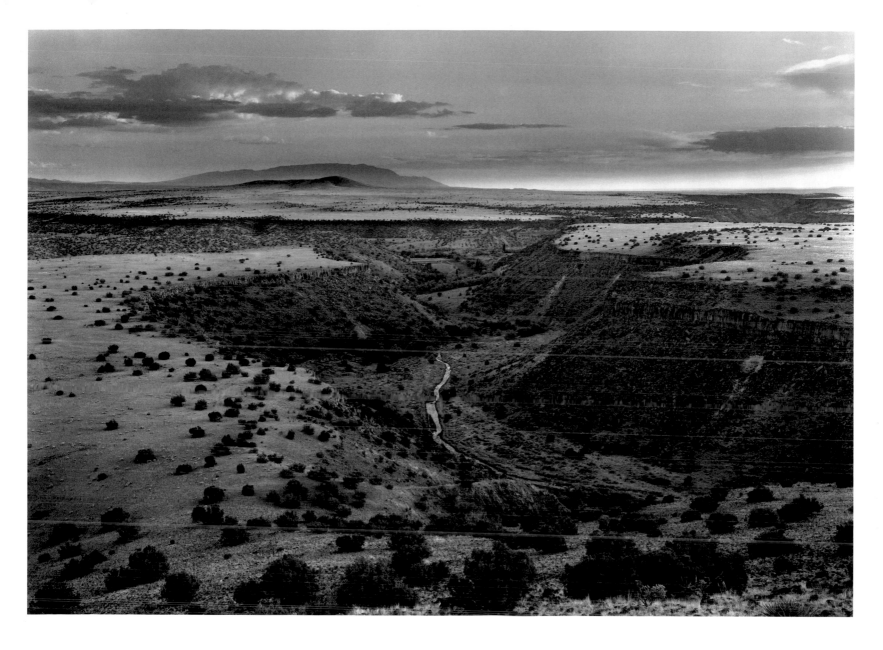

47 William Clift *Santa Fe River Gorge from Cerro Seguro, 1978*

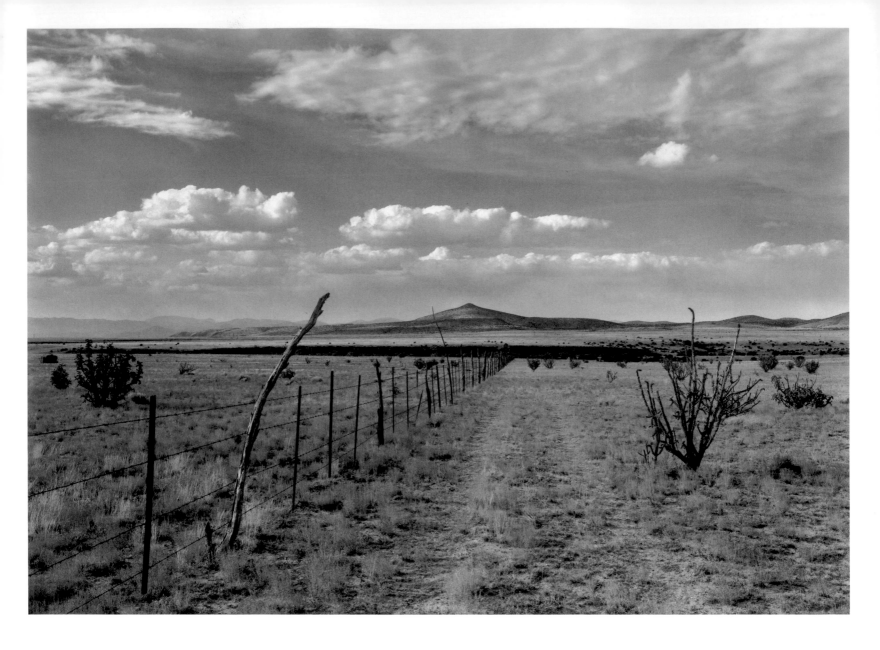

48　William Clift　*Fence, Tetilla Peak, 1978*

Born in 1944 in Boston, Massachusetts; now living in Santa Fe, New Mexico.

Background
Studied with Paul Caponigro
Charter member, Association of Heliographers, New York, 1962
Commercial photographer in partnership with Stephen Gersh under the name
 of Helios (specializing in architectural photography), 1963 – 1971
Massachusetts Council on the Arts commission: extensive photographic
 document of Old City Hall, Boston, 1970 – 1971
National Endowment for the Arts Photographer's Fellowship, 1972
Guggenheim Fellowship, 1974
Seagram's Bicentennial project commission: "Court House," 1975 – 1976

Selected Individual Exhibitions
1969 Carl Siembab Gallery, Boston
 University of Oregon Museum of Art (Eugene)
1970 New Boston City Hall Gallery, Boston (traveling exhibition)
1972 Carl Siembab Gallery, Boston
1973 St. John's College Art Gallery, Santa Fe
1974 Boston Public Library Wiggin Gallery
1977 Photographic Gallery and Workshop, Melbourne (Australia)
1978 Australian Center for Photography, Sydney
1979 Susan Spiritus Gallery, Newport Beach

Selected Group Exhibitions
1963 Association of Heliographers show, Lever House, New York
1964 Gallery Archive of Heliography, New York (with Scott Hyde)
1966 Carl Siembab Gallery, Boston
 "Exhibition One," Hayden Gallery, MIT, Cambridge
1973 "Six New Mexico Photographers," Museum of Fine Arts, Santa Fe
1975 Museum of Fine Arts, Santa Fe (with Arthur Lazar)
1976 "Twelve Artists Working in New Mexico," Art Museum, University of
 New Mexico, Albuquerque

1977 "Court House," Museum of Modern Art, New York
 Elaine Horwitch Gallery, Santa Fe
 "The Great West," University of Colorado, Boulder
1978 "The American West," Galerie Zabriskie, Paris
 "Mirrors and Windows," Museum of Modern Art, New York
 (traveling exhibition)
 "Landscape," Vision Gallery, Boston

Collections
Addison Gallery of American Art, Andover, Massachusetts
Art Institute of Chicago
Bibliothèque Nationale, Paris
Boston Athenaeum
Boston Public Library
Center for Creative Photography, University of Arizona, Tucson
Danforth Museum, Framingham, Massachusetts
Denver Art Museum
Exchange National Bank of Chicago
Fogg Art Museum, Harvard University, Cambridge
Library of Congress, Washington, D.C.
Museum of Fine Arts, Boston
Museum of Fine Arts, Santa Fe
Museum of Modern Art, New York
National Gallery at Adelaide (Australia)
National Gallery at Canberra, Australia
National Gallery at New South Wales, Australia
Polaroid Collection, Cambridge, Massachusetts
Roswell Museum and Art Center (New Mexico)
St. Louis Art Museum
Joseph F. Seagram Collection, New York
University of Colorado Art Museum, Boulder
Worcester Art Museum (Massachusetts)

Linda Connor

My work has never been about temporal situations. I had
always gravitated toward images that reveal the "essence" of
something, the apparition of a form or idea, rather than any
particular fact. Recently, I've switched from using a soft-
focus lens to a sharp-focus lens, and I find that the challenge
of using a system that so clearly reveals the specific and fac-
tual reality of things is to respond somehow to the balance
between that which is recognized and understood and that
which remains unknown and mysterious. I want the subject
matter of these pictures to signify my receptiveness to the
intricate patterns of the natural world, and to reflect my own
interior perceptions and growth.

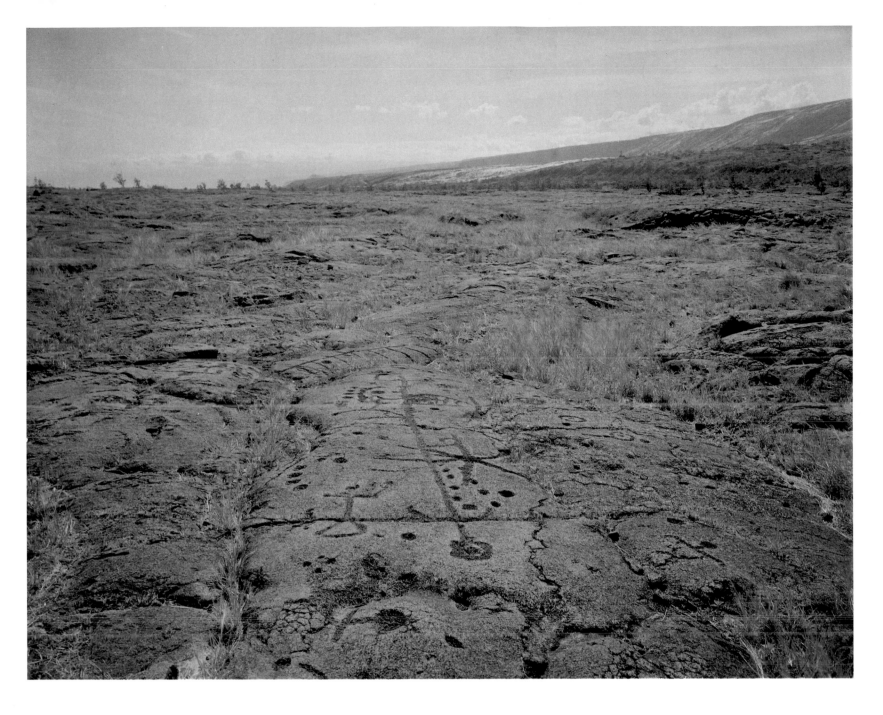

51 Linda Connor *Petroglyphs, Hawaii, 1978*

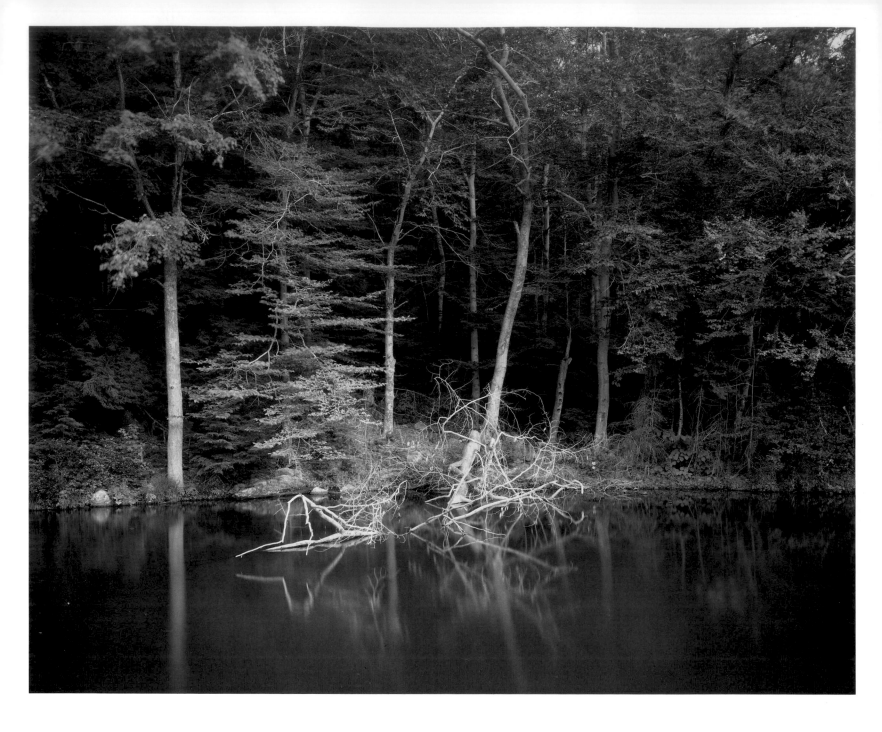

52 Linda Connor *Pond, Connecticut, 1978*

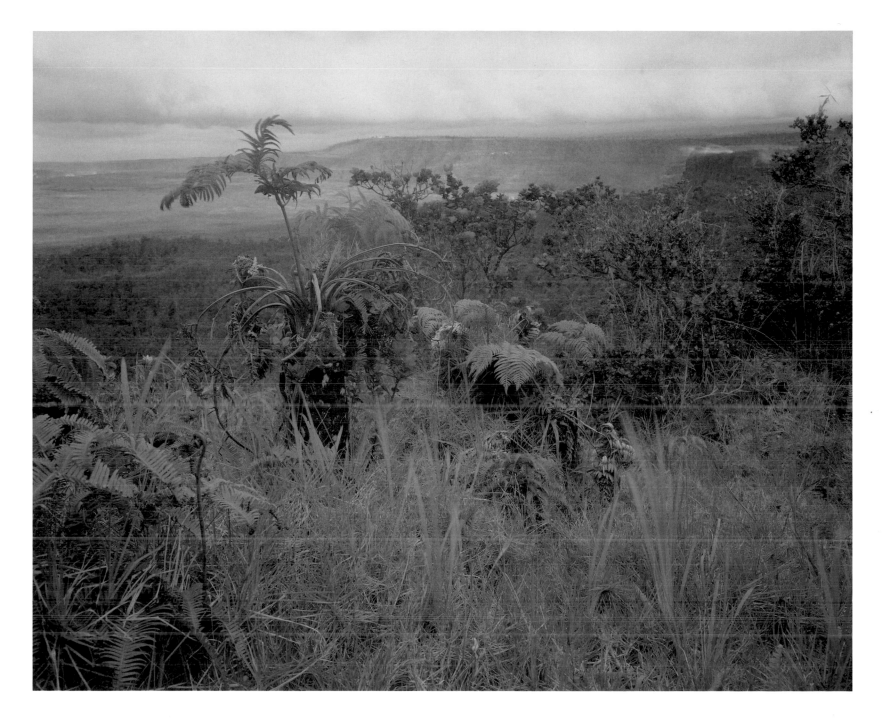

53 Linda Connor *Volcano Rim, Hawaii, 1978*

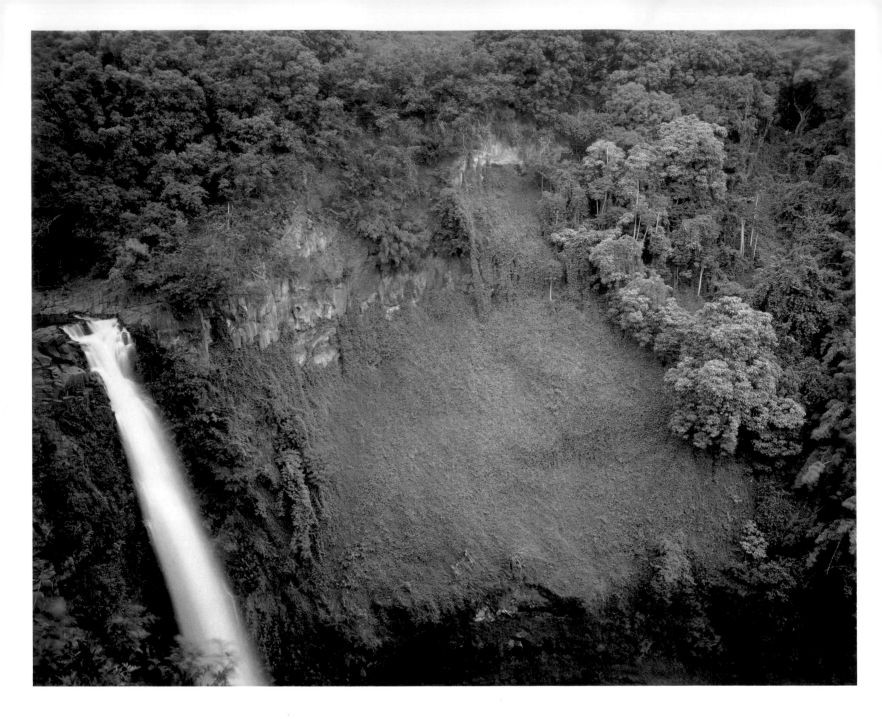

54 Linda Connor *Waterfall, Maui, Hawaii, 1978*

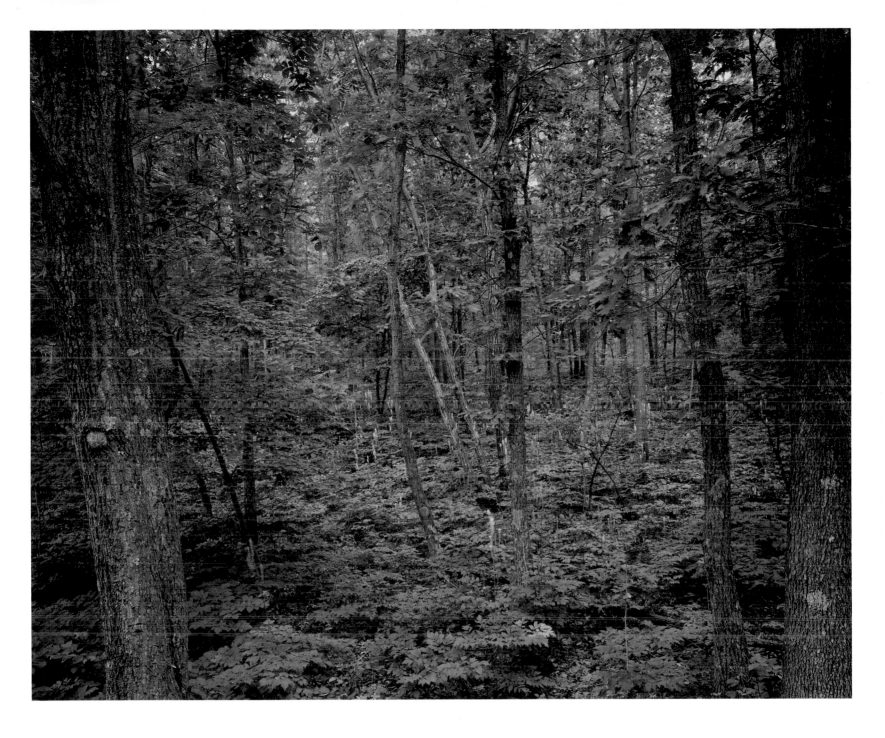

55 Linda Connor *Forest, Blue Ridge Mountains, Virginia, 1978*

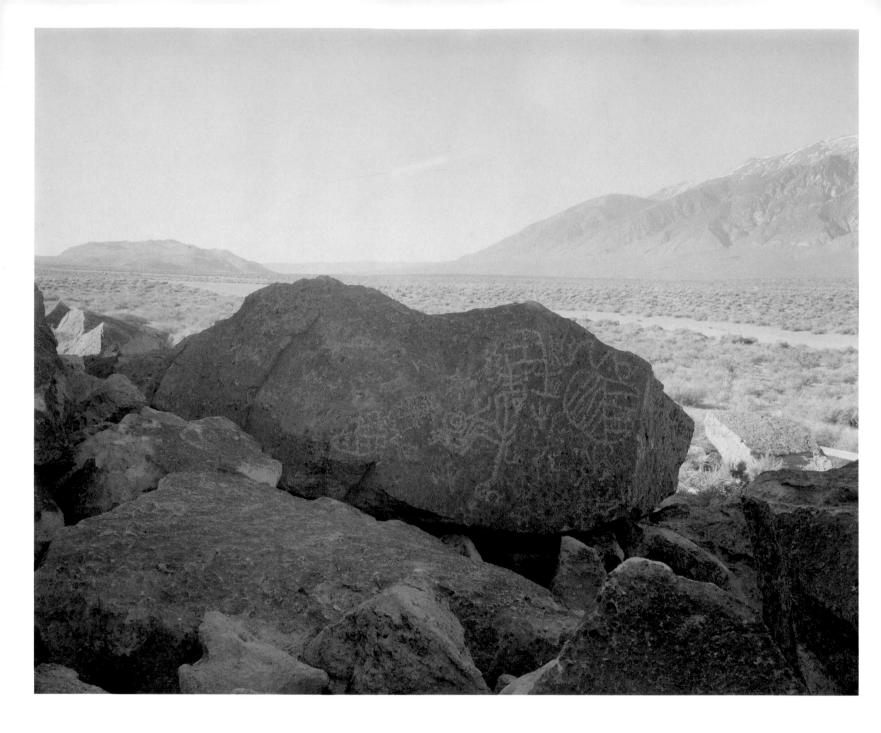

56 Linda Connor *Petroglyphs, Bishop, California, 1978*

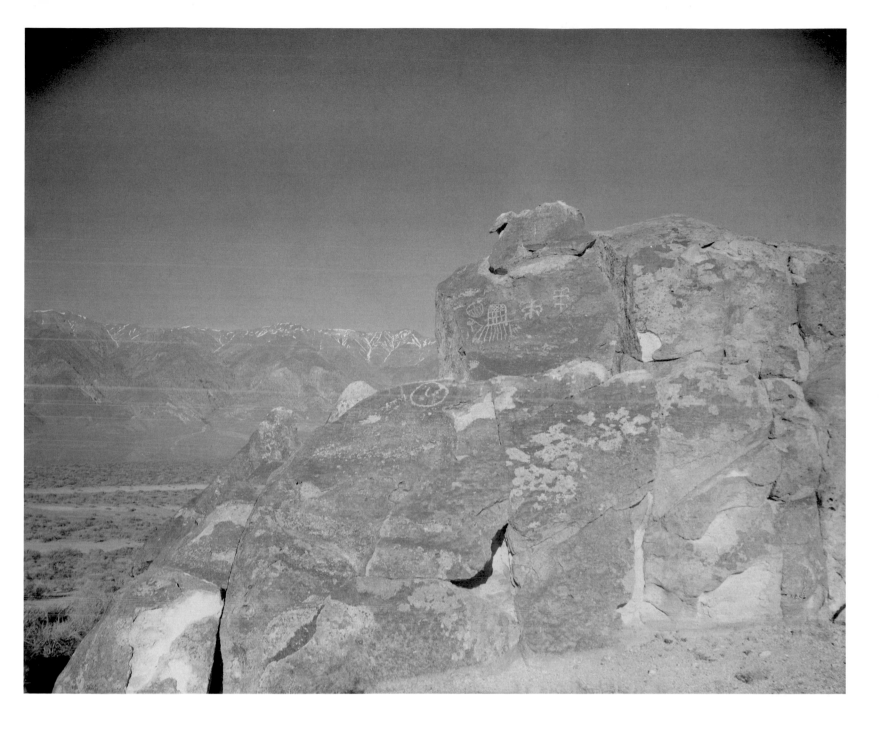

57 Linda Connor *Petroglyphs, Bishop, California, 1978*

58 Linda Connor *Spiral Petroglyph, Canyon de Chelly, Arizona, 1978*

Born in 1944 in New York City; now living in San Francisco.

Background
Rhode Island School of Design, Providence, B.F.A., 1967
Institute of Design, Illinois Institute of Technology, Chicago, M.S., 1969
Studied with Harry Callahan, Aaron Siskind, and Arthur Siegel
U.I.C.A. Faculty Grant, 1973
National Endowment for the Arts Photographer's Fellowship, 1976
National Endowment for the Arts Survey Grant, 1978
Guggenheim Fellowship, 1979
Teacher at San Francisco Art Institute, 1969 – present

Selected Individual Exhibitions
1969 Dayton Art Institute (Ohio)
1970 San Francisco Art Institute
1971 Focus Gallery, San Francisco
 Corcoran Photographic Workshop, Washington, D.C.
 Chicago Art Institute
1973 Dayton Art Institute (Ohio)
 Light Gallery, New York
1974 Tyler School of Art, Philadelphia
 Portland School of Art (Oregon)
 University of Colorado, Boulder
 Center Gallery, University of California, San Francisco
 Slightly Sloping Gallery, Visual Studies Workshop, Rochester
1976 Spectrum Gallery, Tucson
 Susan Spiritus Gallery, Newport Beach
 Center Gallery, Sun Valley
 Center for Photographic Studies, Louisville
1977 De Young Memorial Museum, San Francisco
1978 Light Gallery, New York

Selected Group Exhibitions
1968 "Vision and Expression," George Eastman House, Rochester
1970 "12 x 12," Rhode Island School of Design, Providence
 "California Photographers," University of California, Davis (traveling
 exhibition)
 "Be-ing without Clothes," Hayden Gallery, MIT, Cambridge
1971 "La Provençale," Musée d'Arles (France)
 "Figure in Landscape," George Eastman House, Rochester
1972 "The Multiple Image," Hayden Gallery, MIT, Cambridge
 "Photographer as Magician," University of California, Davis
1973 "Three American Photographers," Musée Réattu, Arles (France)
 "Light and Lens," Hudson River Museum, Yonkers, New York
 "Light and Substance," University of New Mexico, Albuquerque
 University of Rhode Island, Kingston (with Michael Bishop)
 "Photographs from the Polaroid Collection," Museum of Fine Arts,
 Boston – Clarence Kennedy Gallery, Polaroid Corporation, Cam-
 bridge, Massachusetts

1974 "Private Realities," Museum of Fine Arts, Boston
 Fogg Art Museum, Harvard University, Cambridge
1975 "Dimensional Light," California State University, Fullerton
 "Connor, Redmond, Raymo, and Toth," Mankato State College
 (Minnesota) (traveling exhibition)
 Ohio Silver Gallery Competition, Los Angeles
 "14 American Photographers," Baltimore Museum (traveling
 exhibition)
1976 Invitational exhibition, J.B. Speed Art Museum, Louisville
 "8 x 10," Dallas Museum of Fine Arts
1977 "Survey of Contemporary Photography," Cranbrook Academy,
 Bloomfield Hills, Michigan
 "The Less than Sharp Show," Chicago Photographic Gallery,
 Columbia College
 "Center," University of Arizona, Tucson
 "The Great West," University of Colorado, Boulder
 "Eye of the West," Hayden Gallery, MIT, Cambridge
1978 "Additional Information," University of Maryland, College Park
 "8 x 10 x 10," Vision Gallery, Boston
 "Some Twenty-Odd Visions," Blue Sky Gallery, Portland, Oregon
 "Mirrors and Windows," Museum of Modern Art, New York
 "Kirklands International Photo Exhibition," Walker Art Gallery,
 Liverpool (England)
 "One-of-a-Kind Color. Color of One Kind," Polaroid Gallery,
 Cambridge (traveling exhibition)
 "40 American Photographers," Crocker Art Gallery, Sacramento
 University of Colorado, Boulder (with Henry Wessel and Jack Fulton)
 Massachusetts College of Art, Boston (with Nick Nixon)
 University of Rochester

Collections
Art Institute of Chicago
Crocker Art Gallery, Sacramento
Dallas Museum of Fine Arts
Fogg Art Museum, Harvard University, Cambridge
International Museum of Photography at George Eastman House, Rochester
Musée Réattu, Arles (France)
Museum of Fine Arts, Boston
Museum of Modern Art, New York
National Gallery of Canada, Ottawa
New Orleans Museum of Art
Polaroid Collection, Cambridge
Rhode Island School of Design, Museum of Art, Providence
J.B. Speed Art Museum, Louisville
University of New Mexico, Albuquerque
Virginia Museum of Fine Arts, Richmond
Visual Studies Workshop, Rochester
Yale University Art Gallery, New Haven
Victoria and Albert Museum, London

Bevan Davies

The practice of using a large camera to photograph architecture has historical precedents in photography of the late nineteenth century. It was with that reference in mind that I made these photographs of neoclassical buildings in Baltimore and Washington, D.C. I wanted to examine a style we seem to take for granted because of its unquestioned beauty, and I wanted to comment on what happens to the meaning of that style when it is two and three generations removed from its antecedents. By photographing in that manner — letting the camera almost see for itself — it was as though I was discovering the past for a second time.

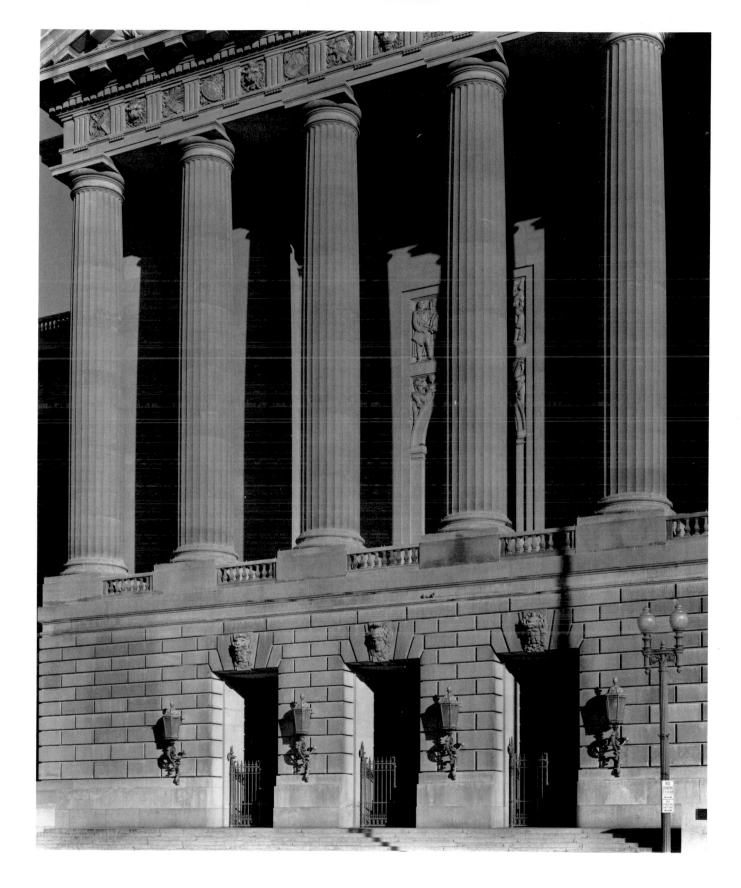

61 Bevan Davies *Washington, D.C., 1978*

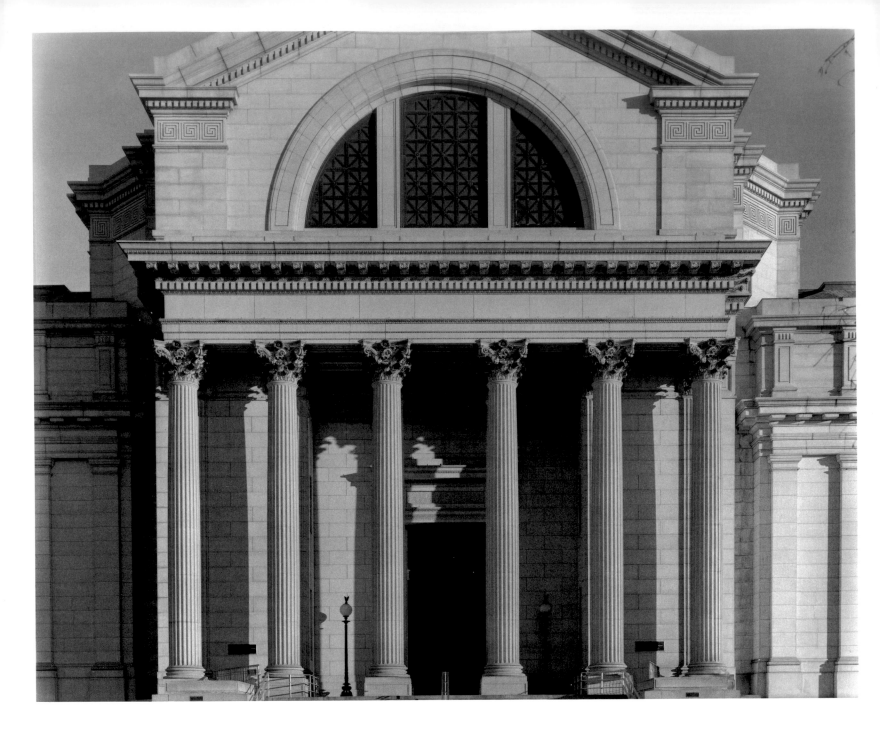

62 Bevan Davies *Washington, D.C., 1978*

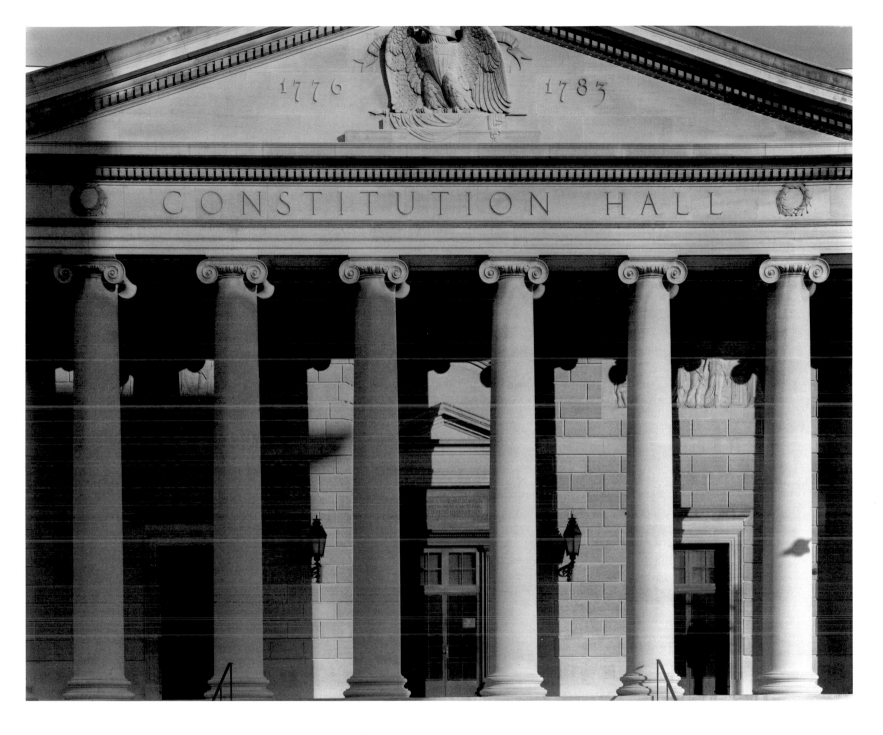

63 Bevan Davies *Washington, D.C., 1978*

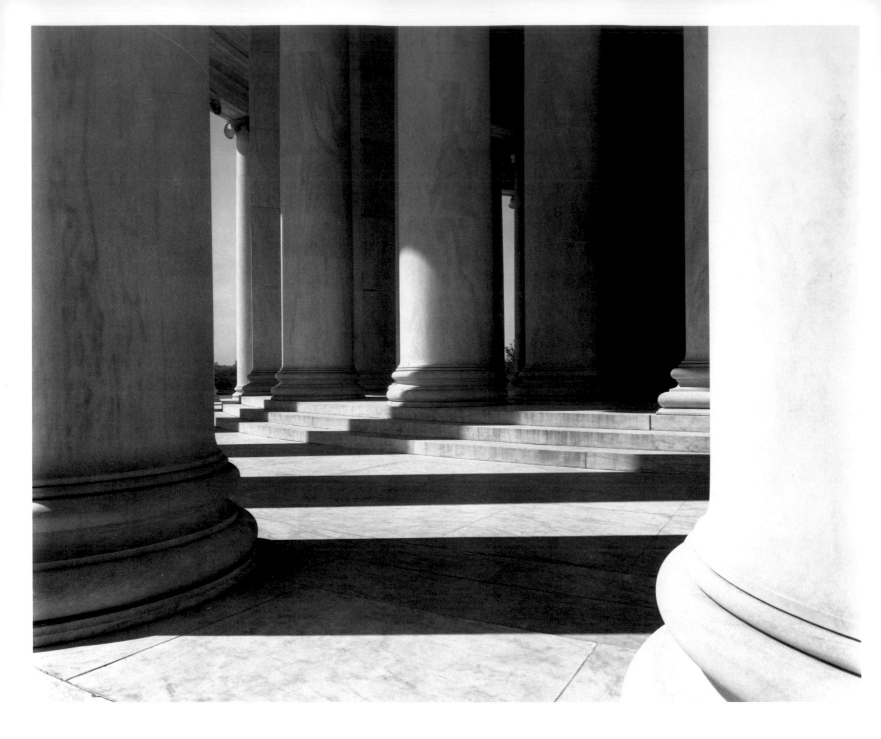

64 Bevan Davies *Washington, D.C., 1978*

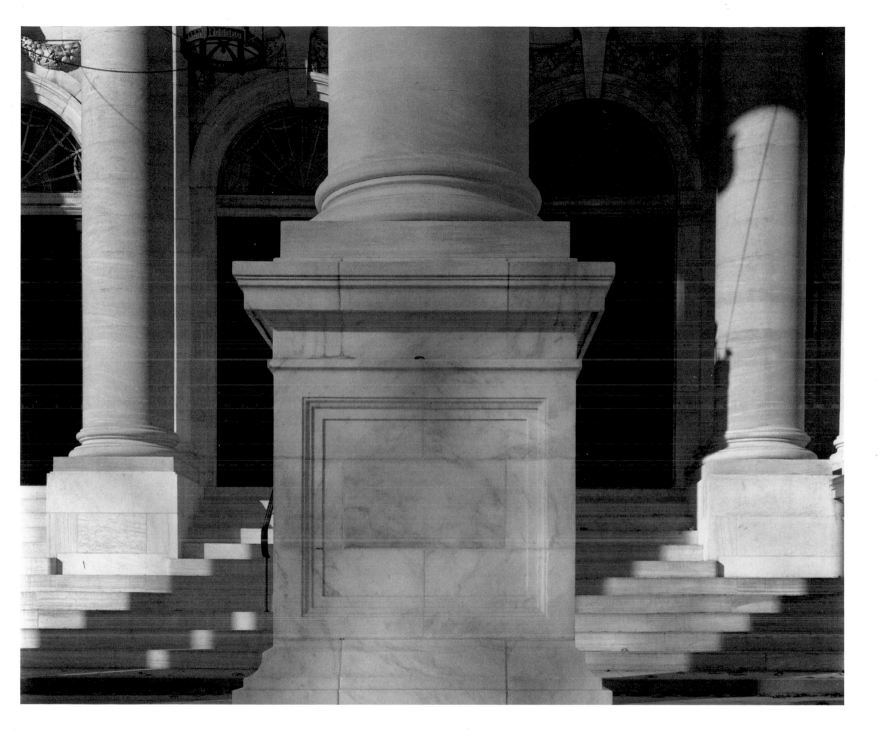

65 Bevan Davies *Washington, D.C., 1978*

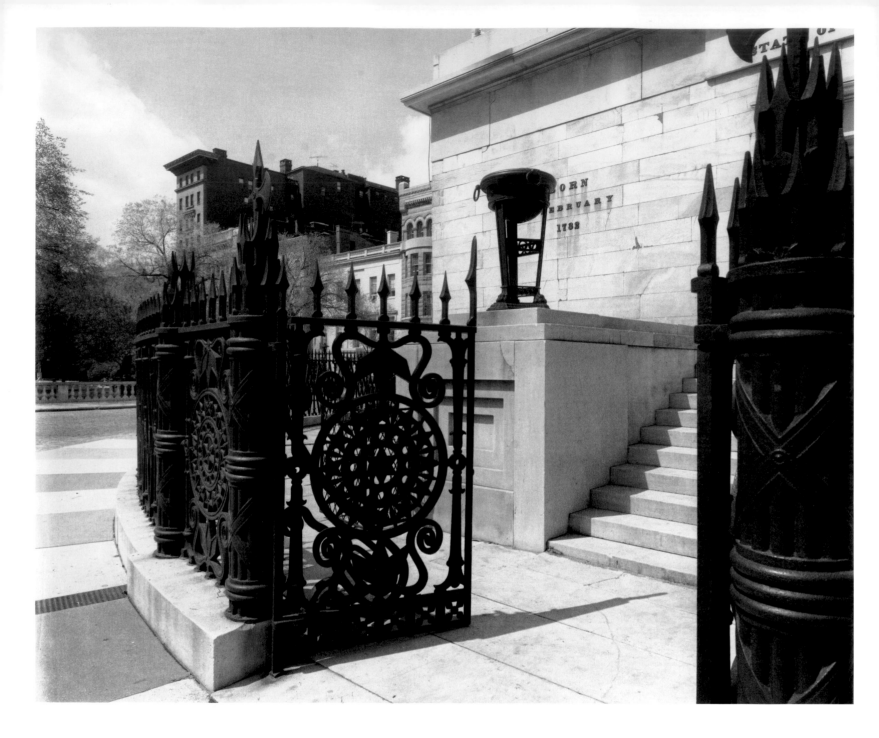

66 Bevan Davies *Baltimore, Maryland, 1978*

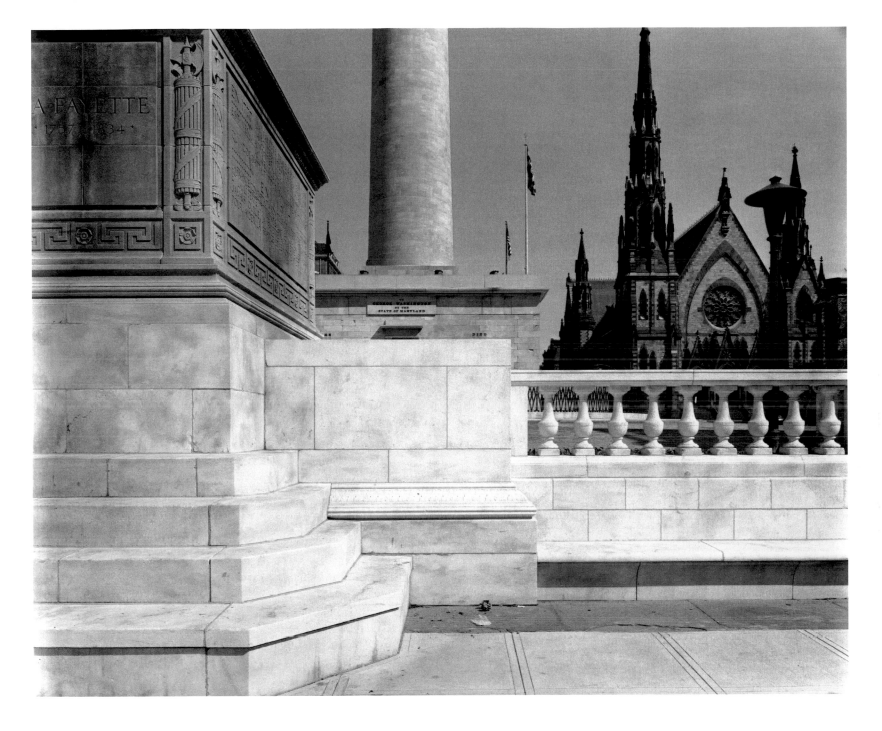

67 Bevan Davies *Baltimore, Maryland, 1978*

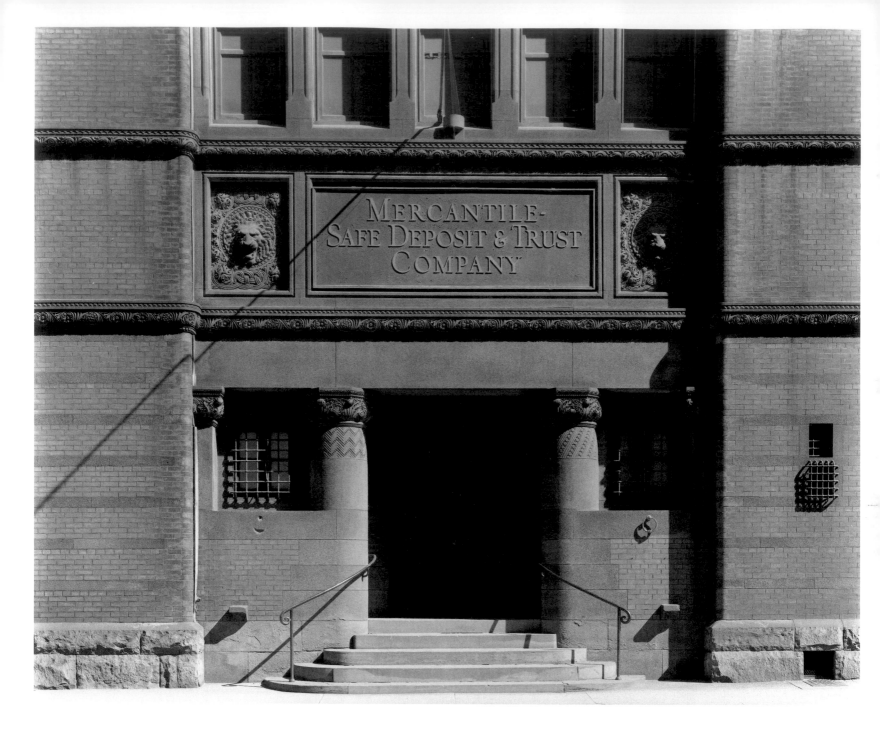

68 Bevan Davies *Baltimore, Maryland, 1978*

Born in 1941 in Chicago; now living in New York City.

Background
University of Chicago
Studied with Bruce Davidson
Instructor, Napier College, Edinburgh (Scotland), 1979
National Endowment for the Arts Photographer's Fellowship, 1978

Selected Individual Exhibitions
1969 Gotham Book Mart, New York
1976 Sonnabend Gallery, New York
 Broxton Gallery, Los Angeles
1977 George Eastman House, Rochester
 Palais des Beaux Arts, Brussels
1978 Galerie Forma, Genoa (Italy)
 Sonnabend Gallery, New York

Selected Group Exhibitions
1964 "Photography '64," George Eastman House, Rochester
1967 Witkin Gallery, New York
1976 "New York — Downtown Manhattan: Soho," Akademie der Kunst,
 Berlin
1977 "Contemporary American Photographic Works," Museum of Fine
 Arts, Houston
 Ringling Museum, Sarasota, Florida
1978 Sonnabend Gallery, New York

Roy DeCarava

Making a good photograph is a matter of keying one's feel-
ings to a situation and bringing both together in an image. My
photographs are subjective and personal — they're intended to
be accessible, to relate to people's lives, to communicate my
feelings about the world and what happens to it. I try to pho-
tograph things that are near to me because I work best among
the things I know. I'm not concerned with startling anyone or
discovering new forms; formal qualities are only tools to
help state my message. I'd like to feel that my photographs
can be of some use, can add insight to our experiences and
broaden our perspectives. People — their well-being and
survival — are the crux of what's important to me.

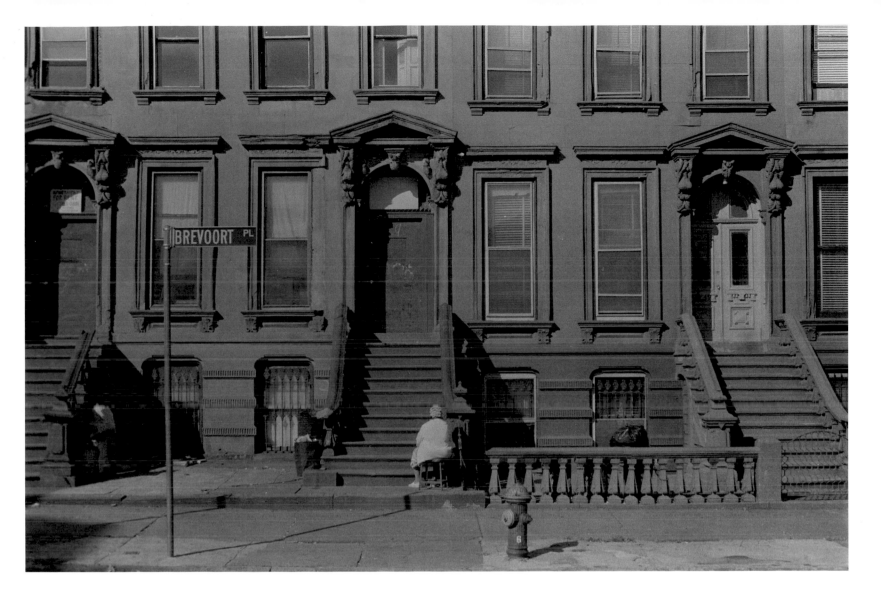

71 Roy DeCarava *Brevoort Place, 1978*

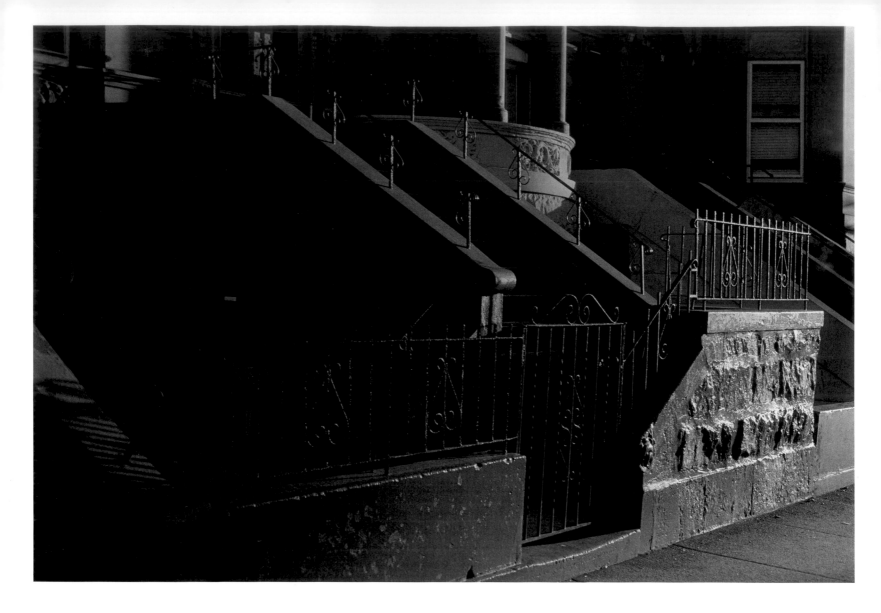

72 Roy DeCarava *Halsey Street, morning, 1978*

73 Roy DeCarava *Apartment for Rent, 1978*

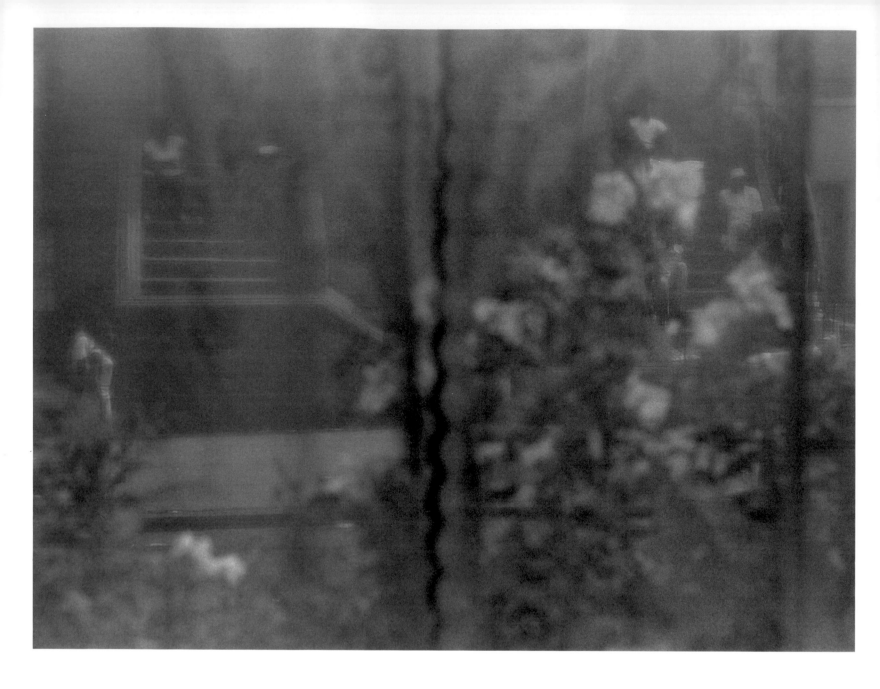

74 Roy DeCarava *Windows over a garden, 1978*

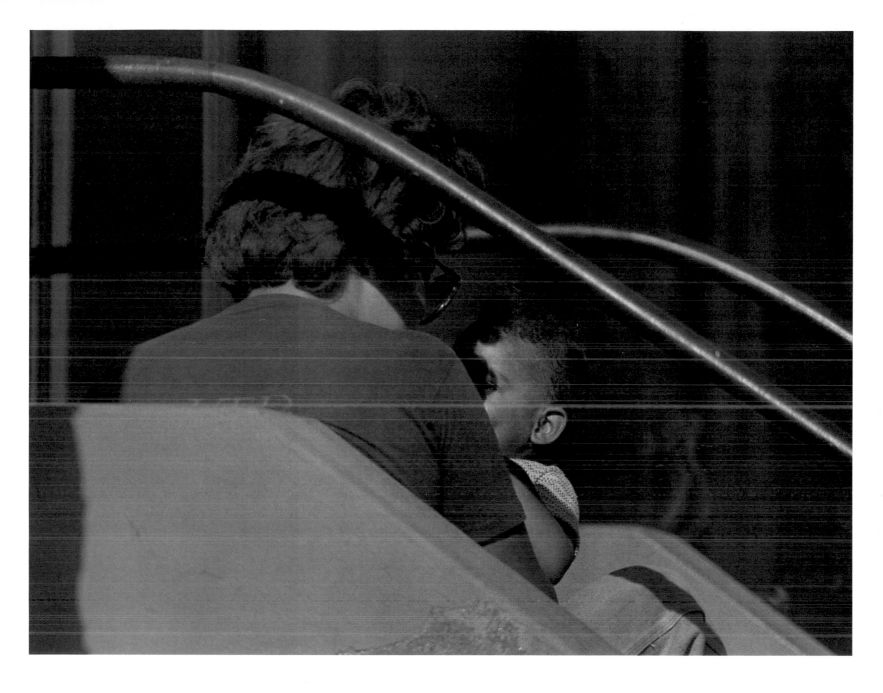

75 Roy DeCarava *Mother and child on stoop, 1978*

76 Roy DeCarava *Boy in print shirt, 1978*

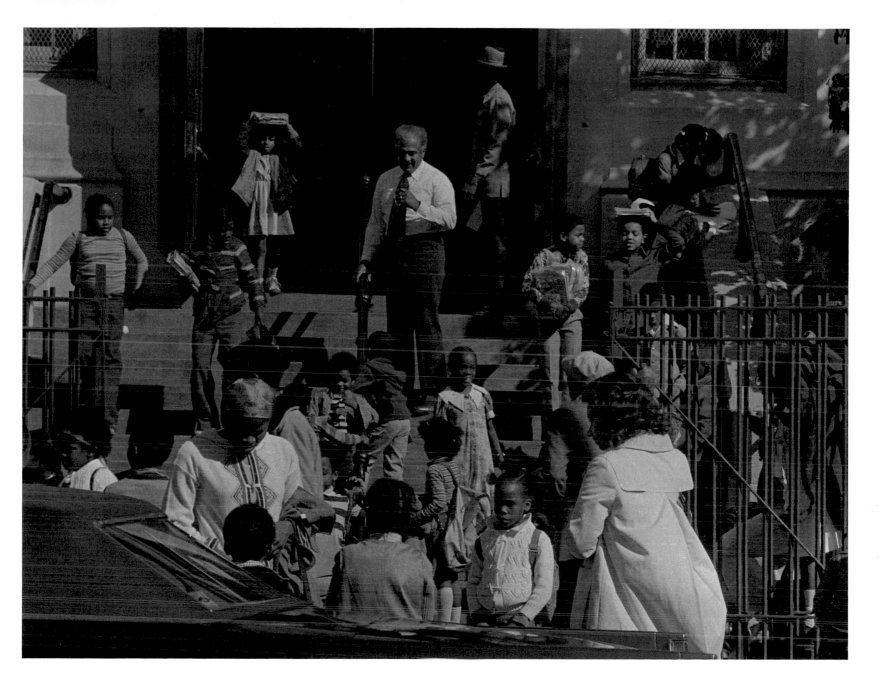

77 Roy DeCarava *Public school entrance, 1978*

78 Roy DeCarava *Man in a window, 1978*

Born in 1919 in New York City; now living there.

Background

Cooper Union, New York, 1938–1940
Harlem Art Center, New York, 1940–1942
George Washington Carver Art School, New York, 1944–1945
Adjunct Instructor in Photography, Cooper Union, New York, 1969–1972
Adjunct Professor of Art, Hunter College, New York, 1975–1978; Professor,
 1979–present
Founder and Director of Photographer's Gallery, New York, 1954–1956
Chairman of American Society of Magazine Photographers Committee to
 End Discrimination against Black Photographers; Director of Kamoinge
 Workshop for Black Photographers, New York, 1963–1966
Guggenheim Fellowship, 1952

Selected Individual Exhibitions

1950 Forty-fourth Street Gallery, New York
1951 Countee Cullen branch of the New York Public Library
1954 Little Gallery, New York Public Library
1955 Photographer's Gallery, New York
1956 Camera Club of New York
1967 Countee Cullen branch of the New York Public Library ("US")
1969 Studio Museum in Harlem (New York) ("Through Black Eyes")
1970 Sheldon Memorial Art Center, University of Nebraska, Lincoln
1974 University of Massachusetts, Boston
1975 Museum of Fine Arts, Houston
1976 Corcoran Gallery ("The Nation's Capital in Photographs")
 Benin Gallery, New York
1977 Witkin Gallery, New York

Selected Group Exhibitions

1953 "Always the Young Strangers," Museum of Modern Art, New York
 "Through the Lens," Caravan Gallery, New York
1955 "The Family of Man," Museum of Modern Art, New York
 "Eight Photographers," Photographer's Gallery, New York
1956 Group show, Photographer's Gallery, New York
1957 "Seventy Photographers Look at New York," Museum of Modern Art,
 New York
1958 "Six Modern Masters," IFA Galleries, New York
1960 "New Acquisitions," Museum of Modern Art, New York
1964 "The Photographer's Eye," Museum of Modern Art, New York
1965 "Fine Art Photographs," Museum of Modern Art, New York
1974 "Photography in America," Whitney Museum, New York

Collections

Addison Gallery, Phillips Academy, Andover, Massachusetts
Art Institute of Chicago
Atlanta University
Corcoran Gallery of Art, Washington, D.C.
Harlem Art Collection, New York State Office Building, Albany
Metropolitan Museum of Art, New York
Museum of Fine Arts, Houston
Museum of Modern Art, New York
Joseph E. Seagram Collection, New York
Sheldon Memorial Art Gallery, University of Nebraska, Lincoln

William Eggleston

These photographs were taken along the thirty-second parallel, where the southeastern coastal plain begins to be tropical. They're related in concept to a particular video piece I've been doing that's something like an unmanned probe, in that the camera travels along a certain path at a certain pace and produces information about whatever might be found there. The photographs are not meant to be "romantic" nor to be about the South—they're about the idea of landscape and a sense of location, about details seen close up and from a distance. And they're about taking color pictures.

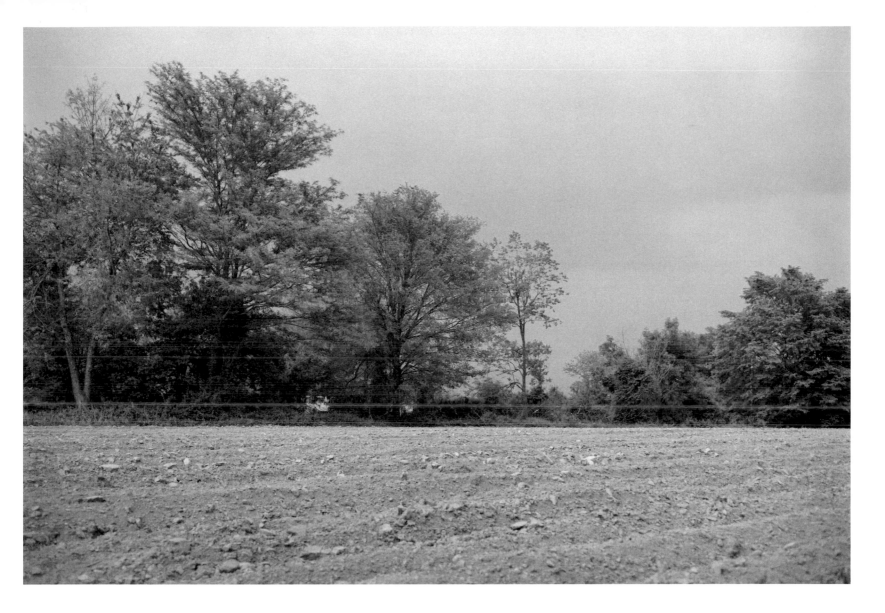

81 William Eggleston *Untitled, 1978*

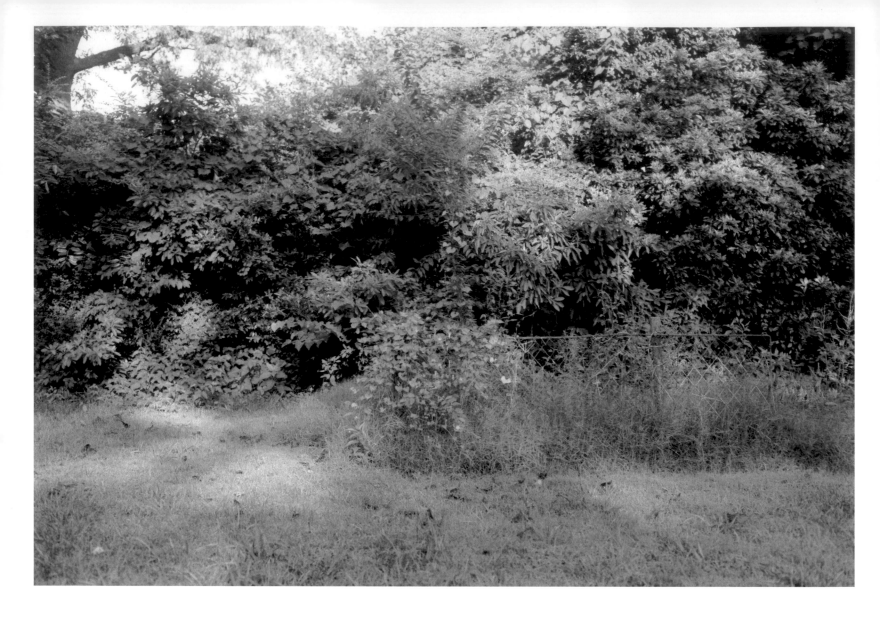

82 William Eggleston *Untitled, 1978*

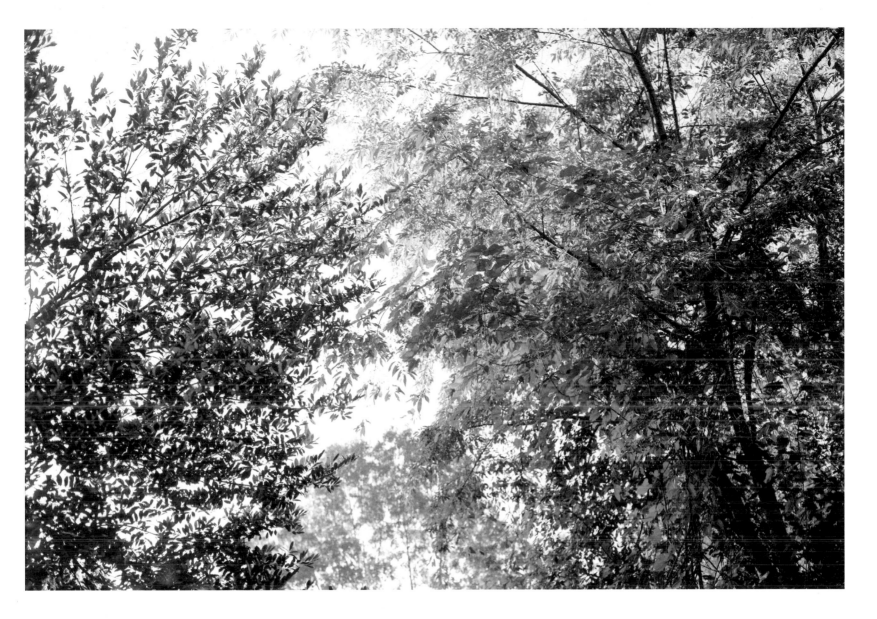

83 William Eggleston *Untitled, 1978*

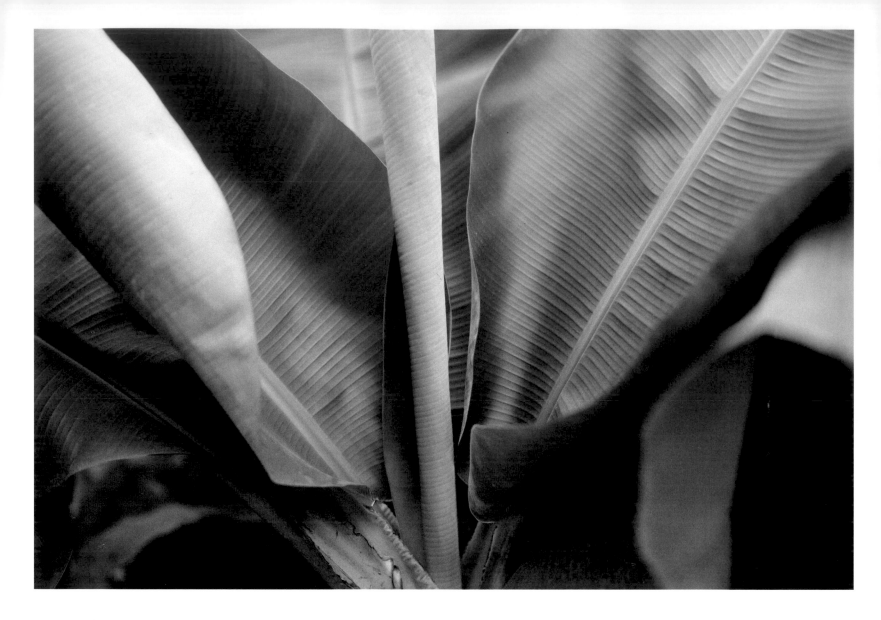

84 William Eggleston *Untitled, 1978*

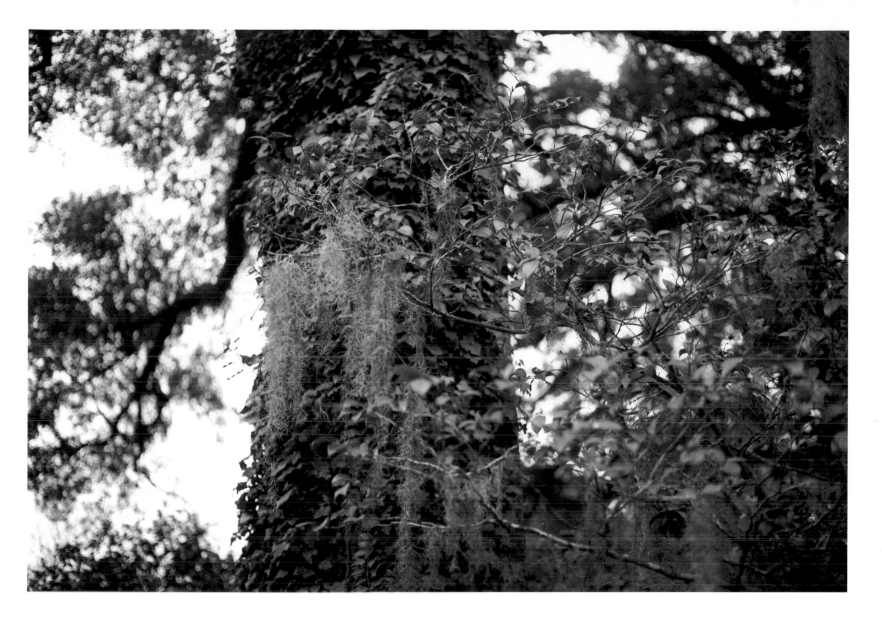

85 William Eggleston *Untitled, 1978*

86 William Eggleston *Untitled, 1978*

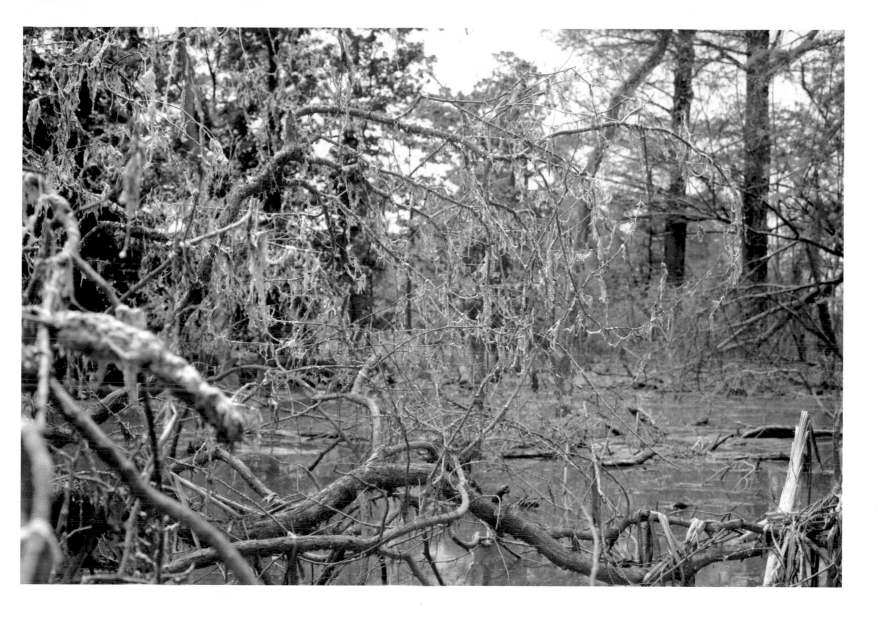

87 William Eggleston *Untitled, 1978*

88 William Eggleston *Untitled, 1978*

Born in 1939 in Memphis, Tennessee; now living there.

Background
Vanderbilt University, Nashville
Delta State College, Cleveland, Mississippi
University of Mississippi, Oxford
Lecturer in Visual and Environmental Studies, Harvard University,
 Cambridge, 1974
Guggenheim Fellowship, 1974
National Endowment for the Arts Photographer's Fellowship, 1975
National Endowment for the Arts Survey Grant, 1978
Researcher in color video at MIT, Cambridge, 1978–1979

Selected Individual Exhibitions
1974 Jefferson Place Gallery, Washington, D.C.
1975 Carpenter Center, Harvard University, Cambridge
1976 Museum of Modern Art, New York (traveling exhibition)
1977 Brooks Memorial Art Gallery, Memphis
 Castelli Graphics Gallery, New York
 Frumkin Gallery, Chicago
 Lunn Gallery, Washington, D.C.

Selected Group Exhibitions
1972 "Photography Workshop Invitational," Corcoran Gallery – Dupont
 Center, Washington, D.C.
1974 "Straight Color," Rochester Institute of Technology
1975 "14 American Photographers," Baltimore Museum (traveling
 exhibition)
 "Color Photography: Inventors and Innovators 1850 – 1975," Yale
 University Art Gallery, New Haven
 "Photography 2," Jack Glenn Gallery, Corona del Mar, California
1976 "Spectrum," Rochester Institute of Technology
 "Color Photography," Broxton Gallery, Los Angeles
1977 "The Contemporary South" (USIA traveling exhibition organized by
 the New Orleans Museum)
 "10 Photographes Contemporains/Tendances Actuelles aux Etats-
 Unis," Galerie Zabriskie, Paris
 "Contemporary Color Photography," Indiana University, Bloomington
 "William Eggleston/William Christenberry," Morgan Gallery,
 Shawnee Mission, Kansas
 "Some Color Photographs," Castelli Graphics Gallery, New York
 "Contemporary American Photographic Works," Museum of Fine
 Arts, Houston (traveling exhibition)
1978 "Color Photographs," Cronin Gallery, Houston (with Nick Nixon)
 "American Landscape Photography," Neue Sammlung, Munich
 "Mirrors and Windows," Museum of Modern Art, New York
 "The Quality of Presence," Lunn Gallery, Washington, D.C.

Elliott Erwitt

As in a theater, the scenes at the beach change continually.
In the summer, especially, people come and go, displaying
themselves, posing. I point my camera at whatever seems
interesting and try to compose the picture. I am just an
observer.

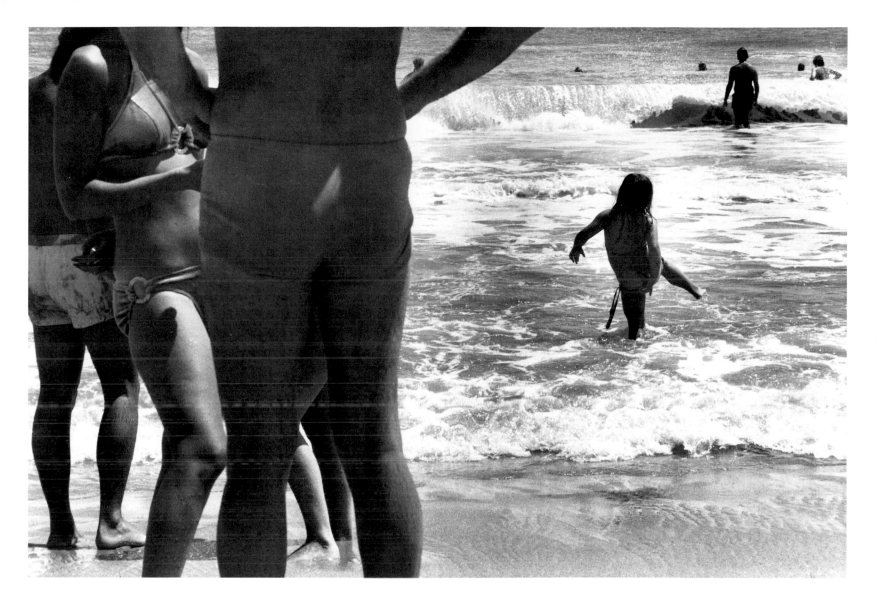

91 Elliott Erwitt *Untitled, 1978*

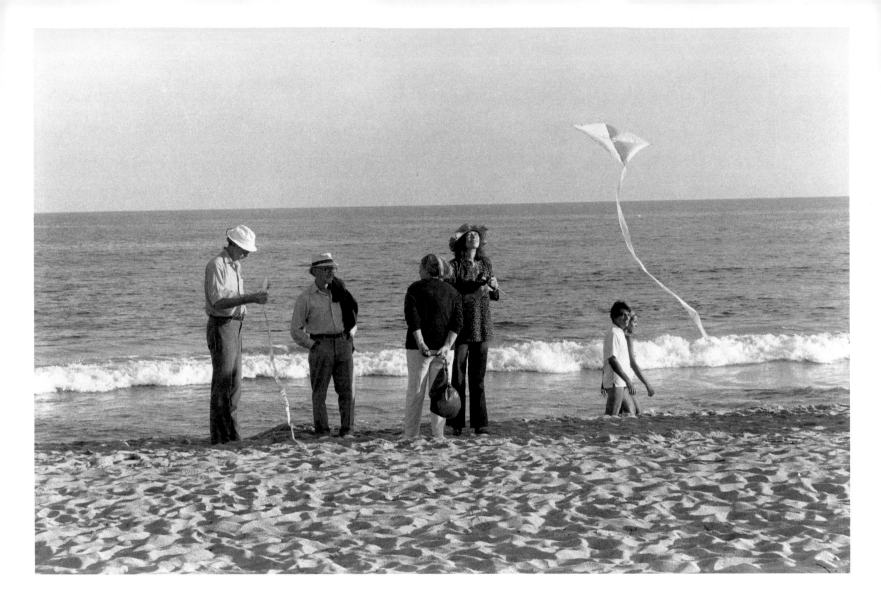

92 Elliott Erwitt *Untitled, 1978*

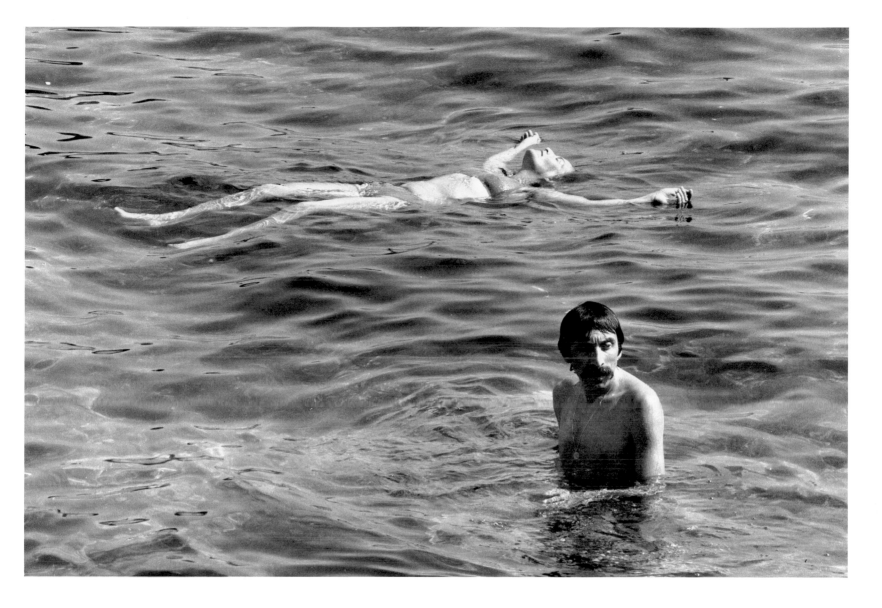

93 Elliott Erwitt *Untitled, 1978*

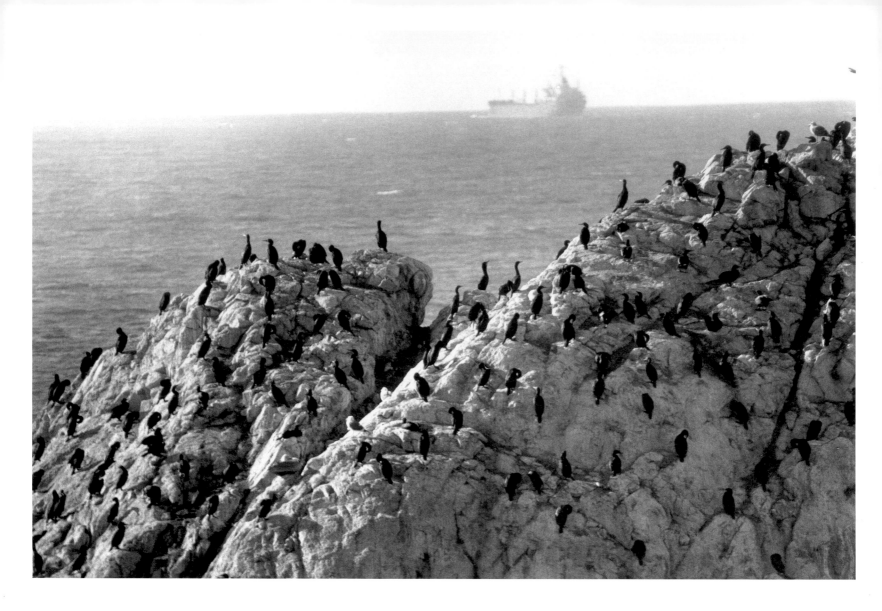

94 Elliott Erwitt *Untitled, 1978*

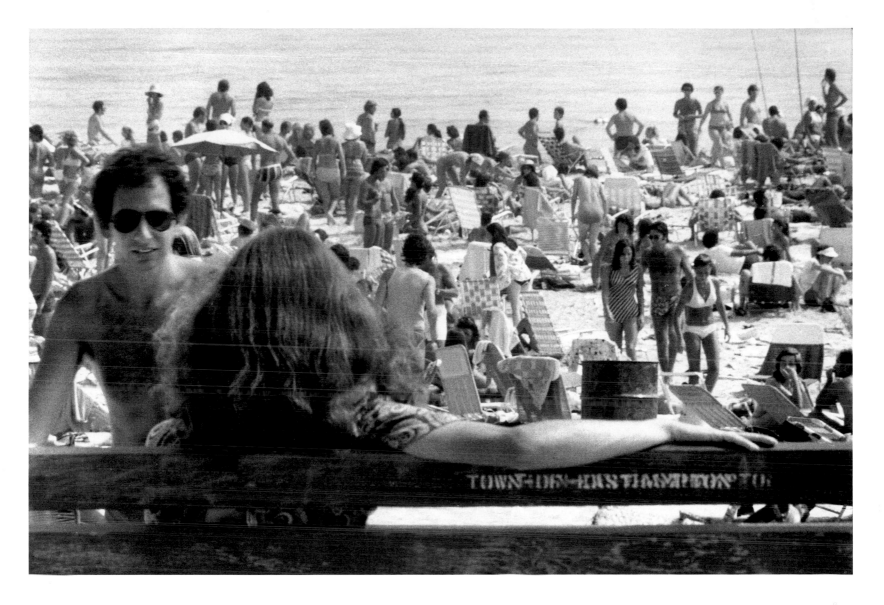

95 Elliott Erwitt *Untitled, 1978*

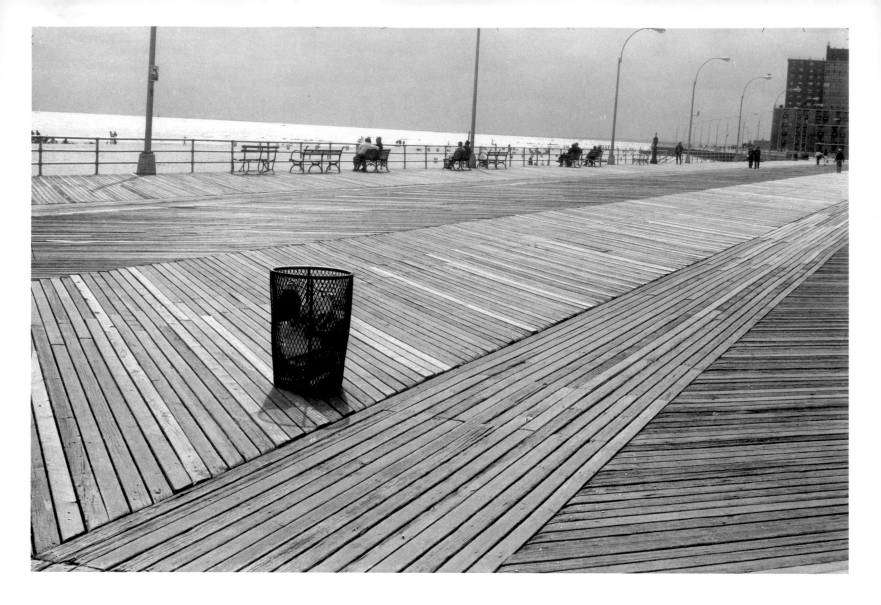

96 Elliott Erwitt *Untitled, 1978*

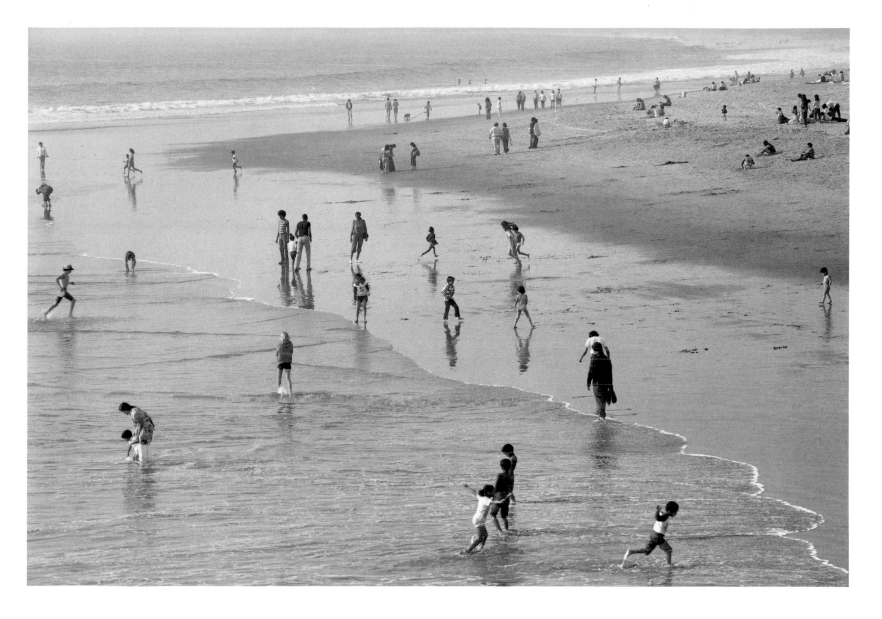

97 Elliott Erwitt *Untitled, 1978*

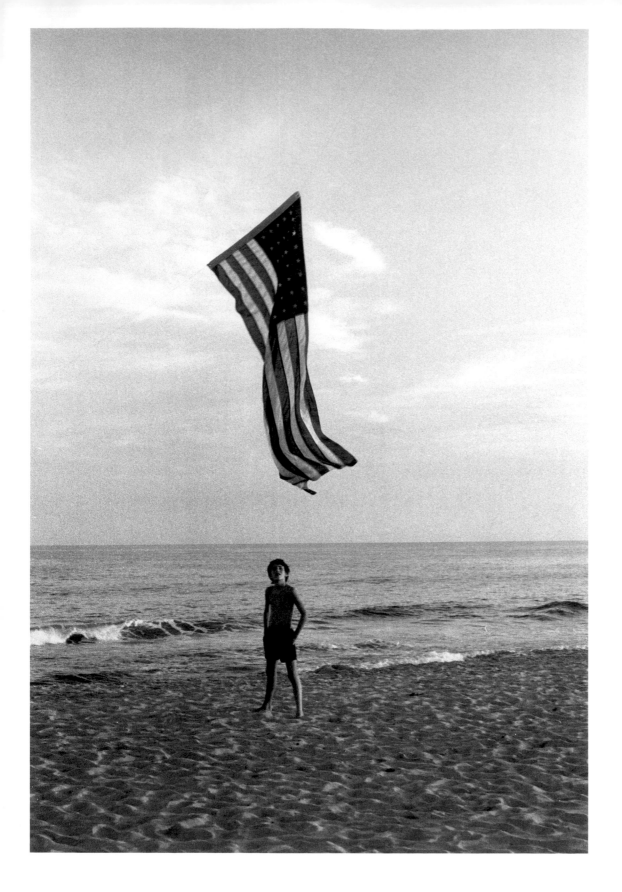

98 Elliott Erwitt *Untitled, 1978*

Born in 1928 in Paris; now living in New York City

Selected Individual Exhibitions
1963 Smithsonian Institution
1965 Museum of Modern Art, New York
1972 Art Institute of Chicago
1979 Kunsthaus, Zurich

Larry Fink

Through the years my photographs have taken on social
meanings; they're about life and posterity and my response
to that. I call it "sensual empathy". I try to involve myself as
closely as possible with the people I photograph and I don't
make personal judgments or bring along my own set of ethics
or politics. I look for high-energy situations, and when I
begin to respond intuitively to the people I'm observing,
when I feel like I could fit myself inside their heads, at that
moment I shoot the picture. What I said a few years ago about
my work is still true—I photograph from the inside, not the
outside; I become what I behold.

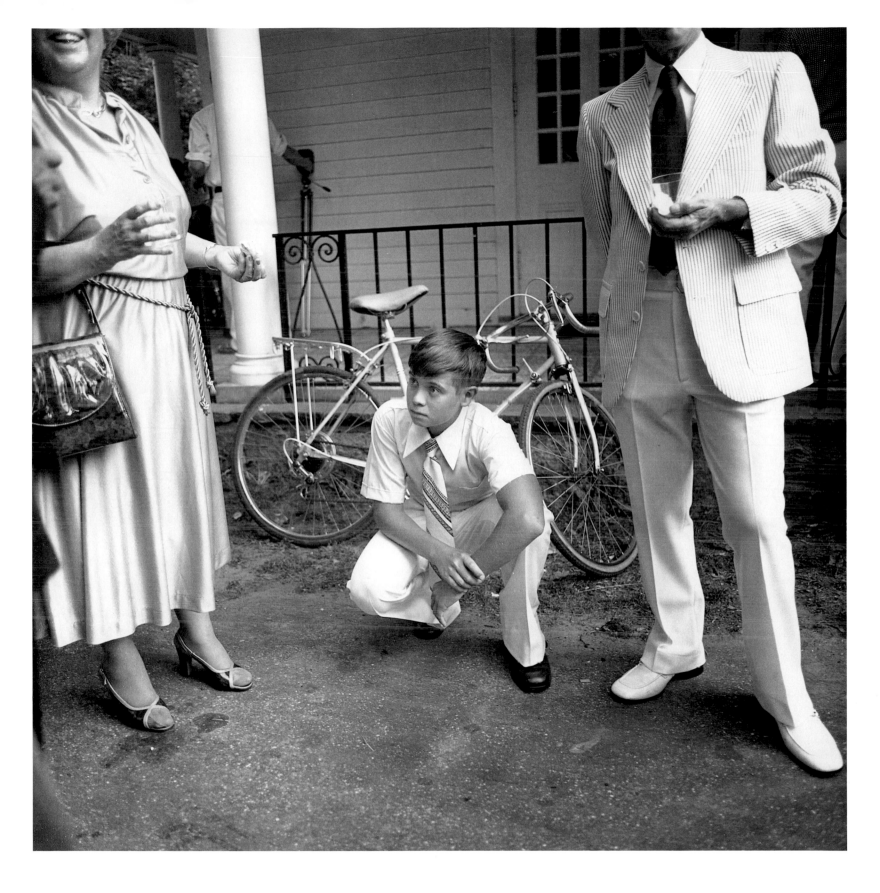

101 Larry Fink *Untitled, 1978*

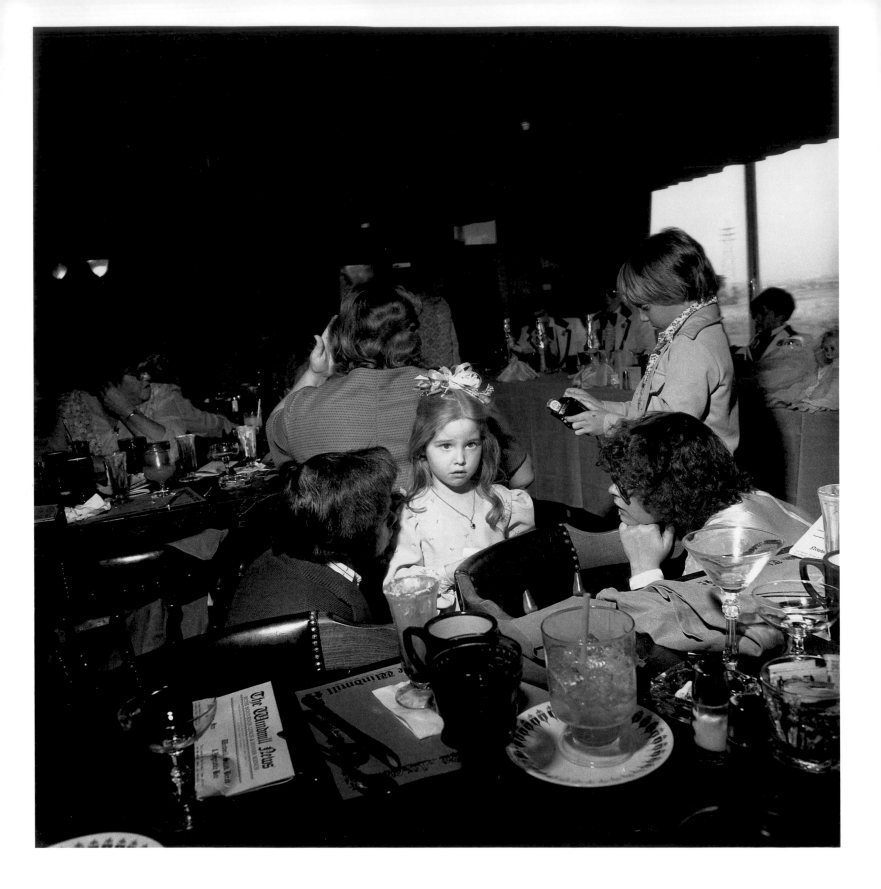

102 Larry Fink *Untitled, 1978*

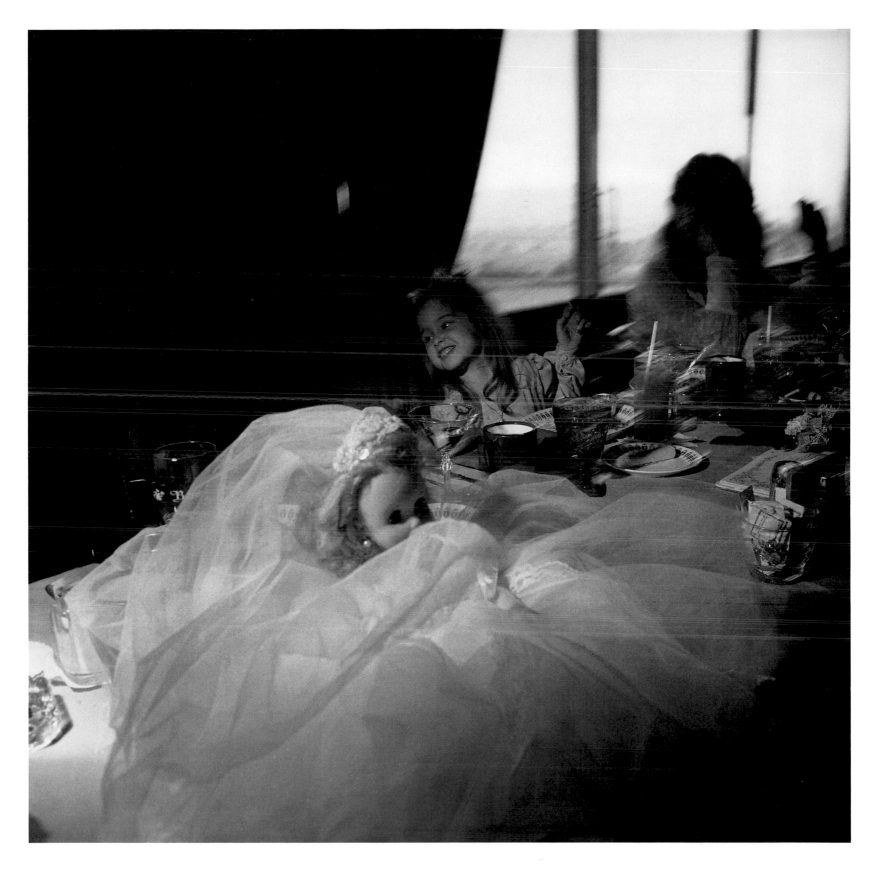

103 Larry Fink *Untitled, 1978*

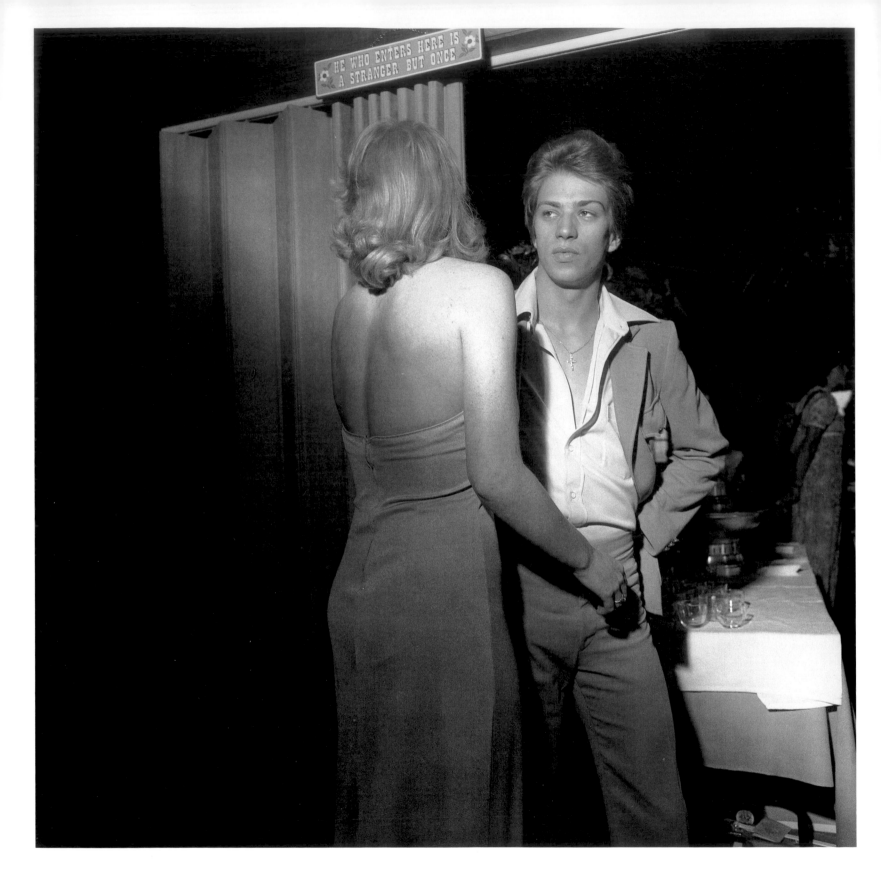

104 Larry Fink *Untitled, 1978*

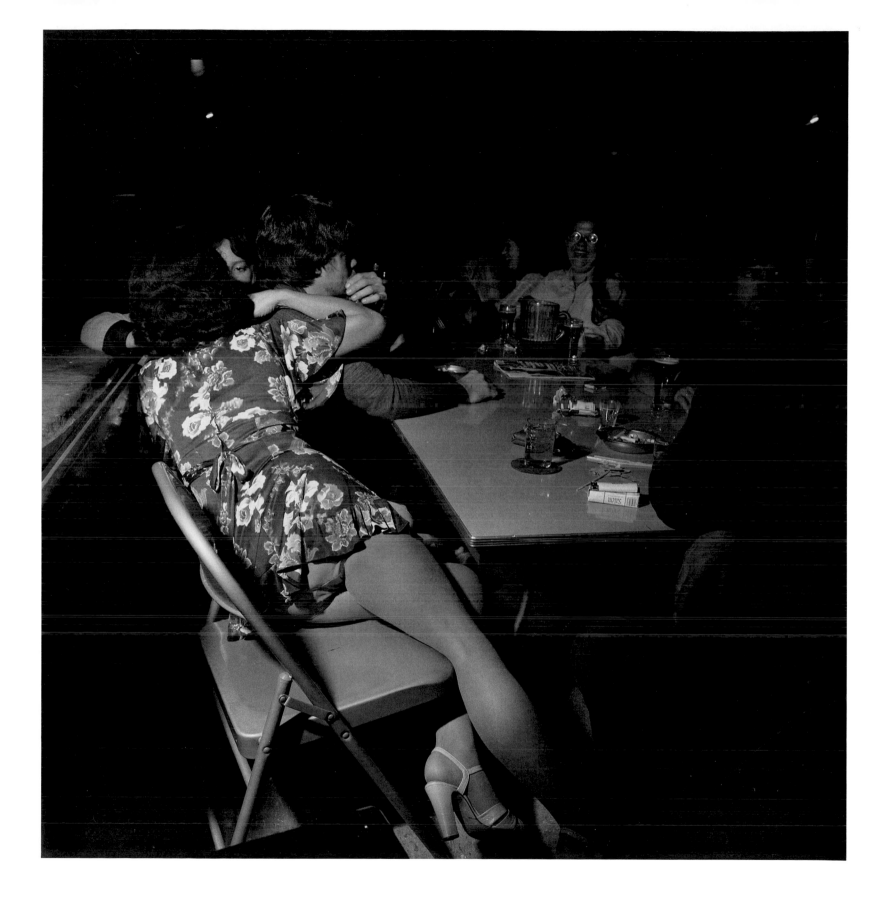

105 Larry Fink *Untitled, 1978*

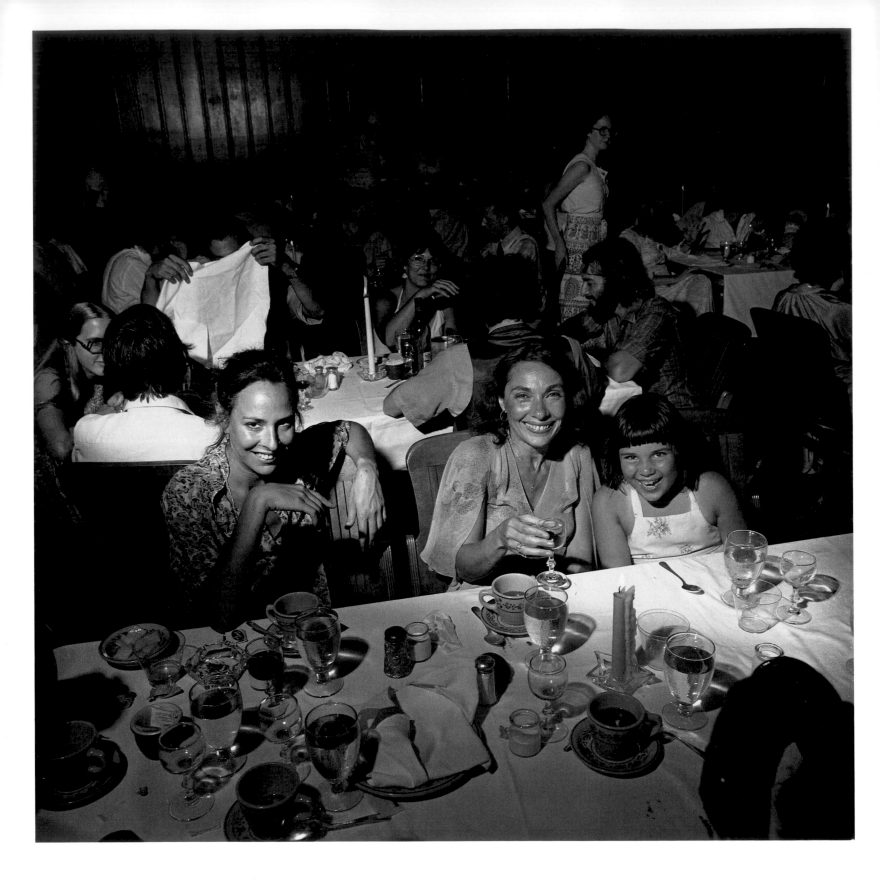

106 Larry Fink *Untitled, 1978*

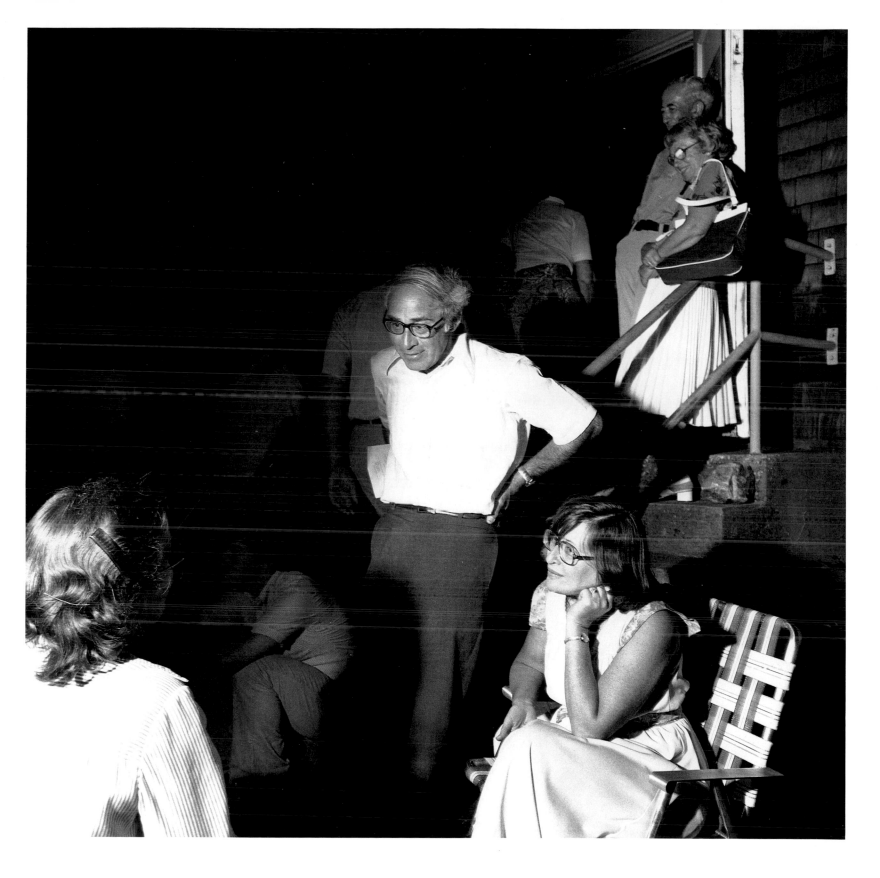

107 Larry Fink *Untitled, 1978*

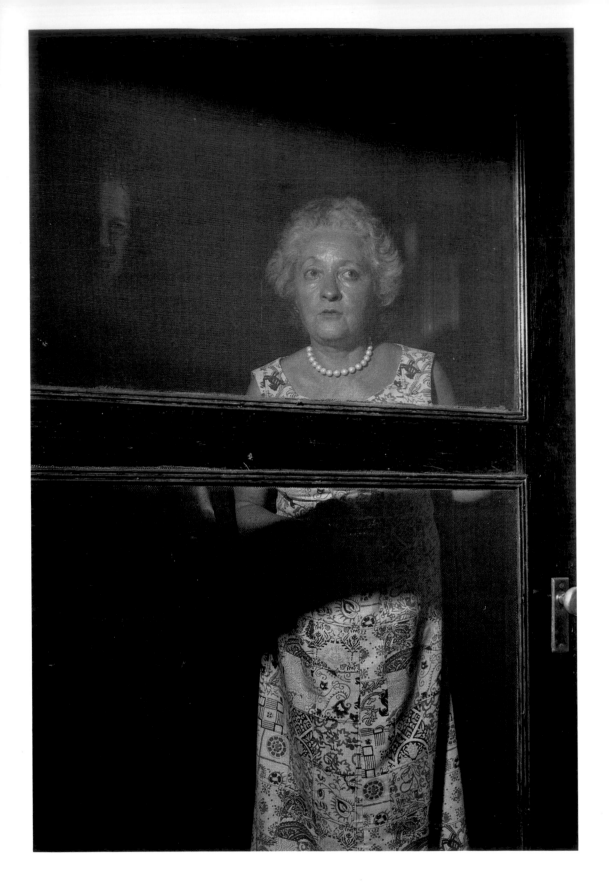

108 Larry Fink *Untitled, 1978*

Born in 1941 in Brooklyn, New York; now living in Martins Creek, Pennsylvania.

Background
New School for Social Research, New York
Studied with Lisette Model and Alex Brodovitch
Instructor at Lehigh University, Bethlehem, Pennsylvania, 1966–1967
Instructor at Parsons School of Design, New York, 1967–1972
Instructor at New School for Social Research, New York, 1968–1972
Assistant Professor at Kingsborough Community College, New York, 1969–1973
Assistant Professor, City University of New York, 1969–1973
Walker Evans Professor of Photography, Yale University, New Haven, 1977–1978
Professor at Yale Summer School, 1978
Instructor at International Center of Photography, New York, 1977
Instructor at Cooper Union, New York, 1979
New York State Council on the Arts C.A.P.S. Fellowships, 1970 and 1974
Guggenheim Fellowship, 1976 and 1979
National Endowment for the Arts Photographer's Fellowship, 1978

Selected Individual Exhibitions
1960 Cannes Film Festival
1971 Paley & Lowe Gallery, New York
1972 Harcus-Krakow Gallery, Boston
1973 Light Works, Syracuse, New York
Ohio Wesleyan University, Delaware, Ohio
Diana Gallery, New York
Yale Summer School, New Haven
1975 Muhlenberg College, Allentown, Pennsylvania
Cedar Crest College, Allentown, Pennsylvania
Kirkland College, Clinton, New York
Midtown Y Gallery, New York

1976 Bucks County Community College, Newtown, Pennsylvania
St. Lawrence University, Canton, New York
Light Works, Syracuse
Broxton Gallery, Los Angeles
Carl Solway Gallery, Cincinnati
1977 Yale University, New Haven
Center for Creative Photography, Tucson
1978 Sander Gallery, Washington, D.C.
Lehigh University, Bethlehem, Pennsylvania
Hayden Gallery, MIT, Cambridge

Selected Group Exhibitions
1968 "Great Photographs," Gallery of Creative Photography, American Society of Magazine Photographers, New York
1970 "Metropolitan Middle Class," Hayden Gallery, MIT, Cambridge
"New Acquisitions," Museum of Modern Art, New York
1972 *Transaction* Magazine — Architecture Department Exhibition, Princeton University
"Six Photographers," Hunterdon Art Center, Clinton, New Jersey
1973 "The Jew in New York," Midtown Y Gallery, New York
1975 "Attitudes," Floating Foundation of Photography, New York
"Coming of Age in America," Midtown Y Gallery, New York
Alfred Stieglitz Gallery, New York
Visual Studies Workshop, New York
1976 "Celebration," Floating Foundation of Photography, New York
Halsted 831 Gallery, Birmingham, Michigan
Ohio Wesleyan University, Delaware, Ohio
1978 "Summer Light," Light Gallery, New York
"Mirrors and Windows," Museum of Modern Art, New York (traveling exhibition)
Prakapas Gallery, New York

Collections
Corcoran Gallery of Art, Washington, D.C.
Museum of Fine Arts, Boston
Museum of Modern Art, New York

Frank Gohlke

Making pictures is a way of creating worlds within the frame that provide almost the same richness and pleasure as direct experience of the world – yet the world itself is never quite so clear as in a good photograph. There is something peculiar about the way we attribute the clarity of some photographs to the world itself. I try to reinforce that paradox by making photographs that convince the viewer that those revelations, that order, that potential for meaning, *are* coming from the world and not the photograph.

When I went back to Texas for this series of photographs, it was with a very deliberate ignorance of what I intended to do. I had some persistent images in my memory – certain houses in my hometown, for instance – but I had no plan for finding them and simply hoped to place myself in a setting that might trigger some powerful emotions and the shock and excitement of seeing things remembered as if for the first time. For me, making pictures is not a matter of trying to fit the external world into a form that exists from memory, though the power of pictures often derives from that very connection. Looking at them recently, the Texas pictures seem more and more like dreams to me.

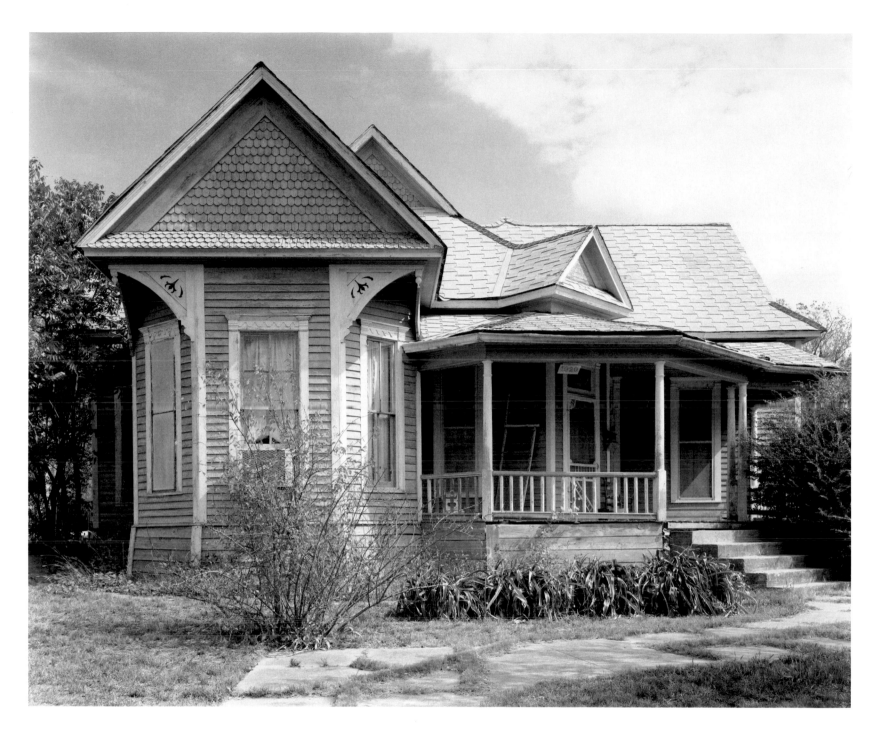

111 Frank Gohlke *House – Waxahachie, Texas, 1978*

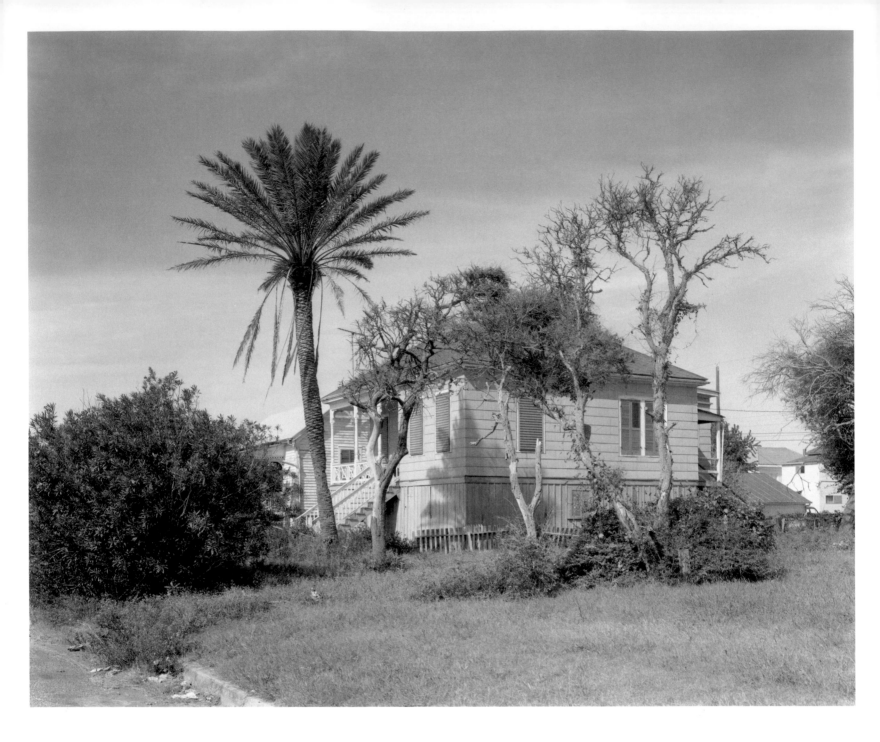

112 Frank Gohlke *House—Galveston, Texas, 1978*

113 Frank Gohlke *Marsh fire, Bolivar Peninsula, Texas, 1978*

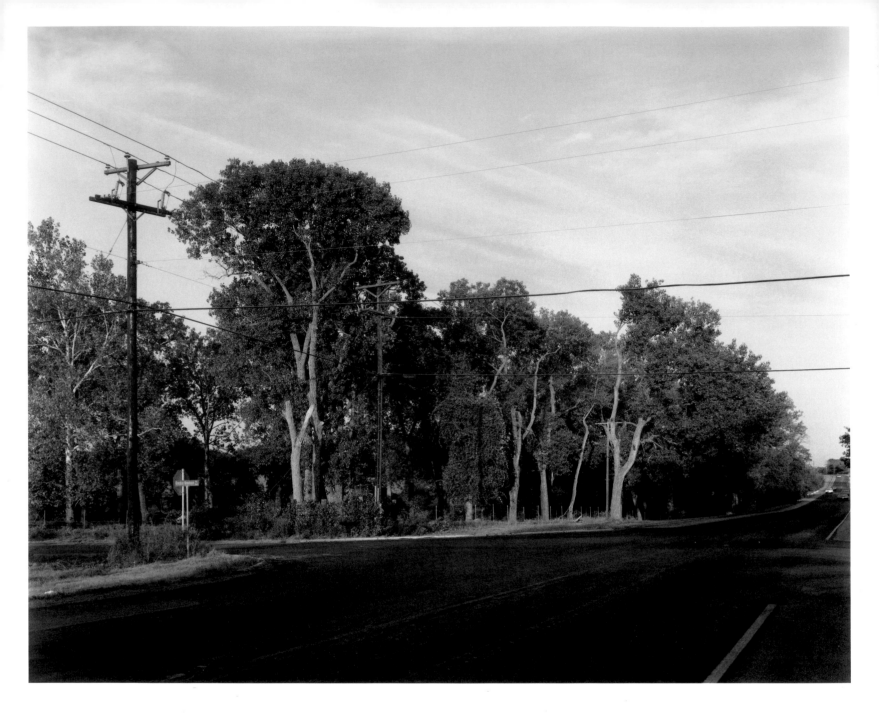

114 Frank Gohlke *Grove of trees near Ft. Worth, Texas, 1978*

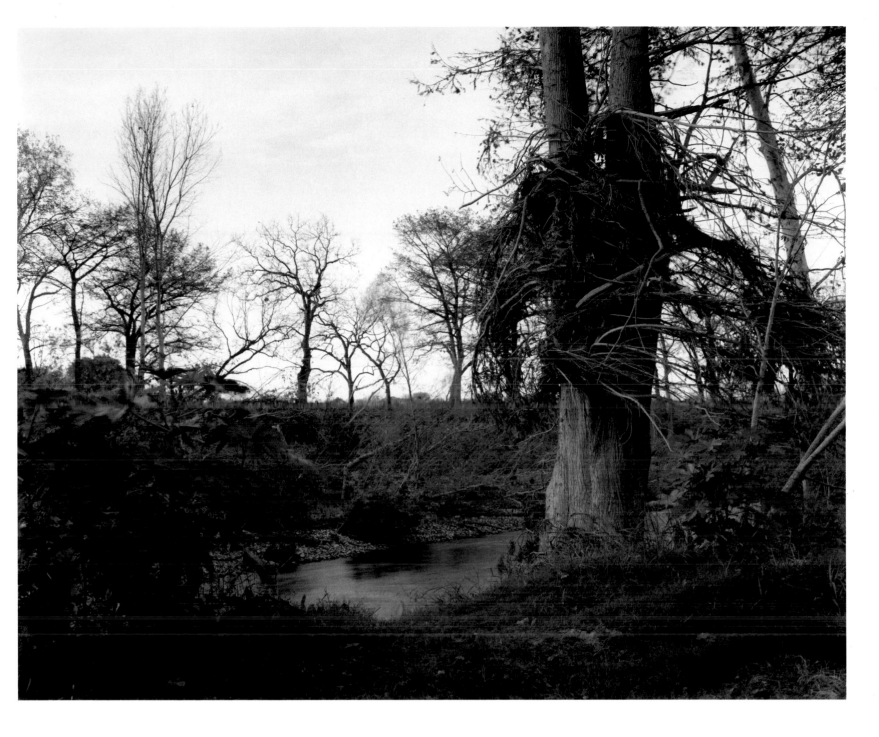

115　Frank Gohlke　*Flood debris caught in tree near Comfort, Texas, 1978*

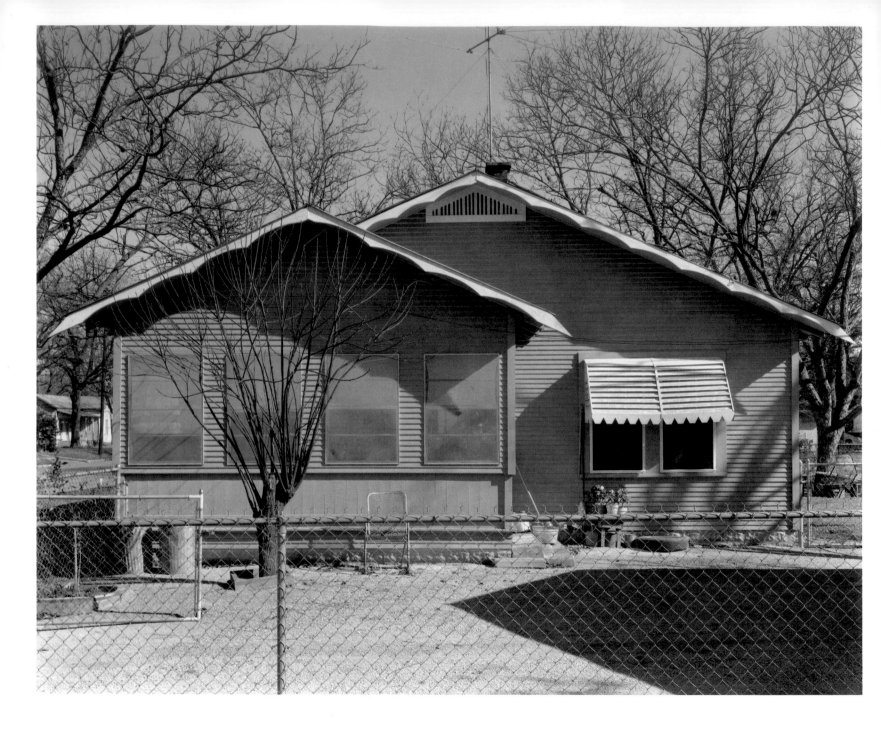

116 Frank Gohlke *House – New Braunfels, Texas, 1978*

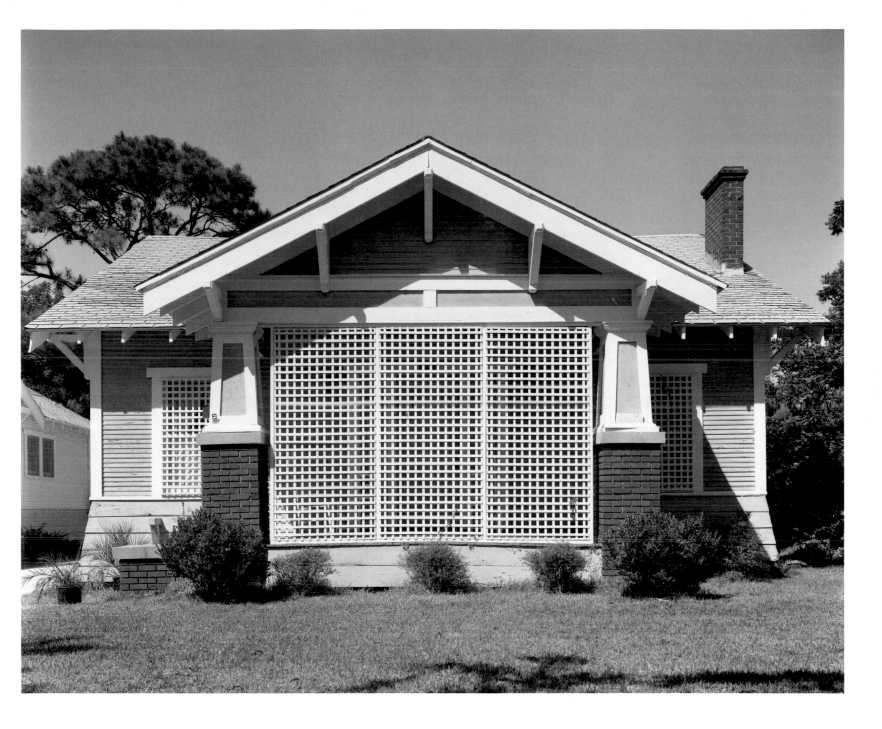

117 Frank Gohlke *House – Port Arthur, Texas, 1978*

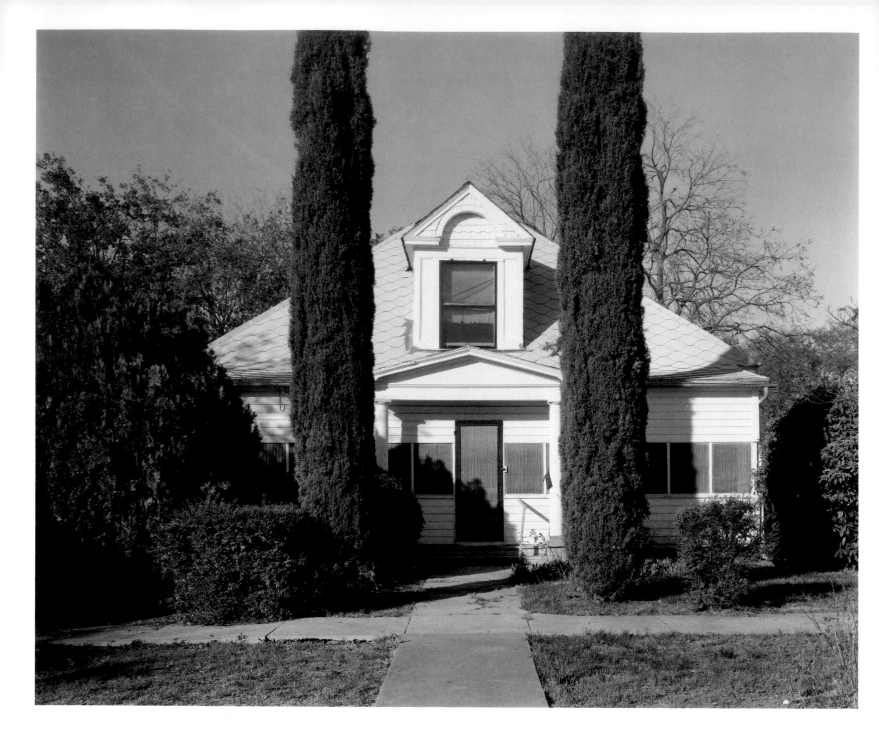

118 Frank Gohlke *House and cypress trees — Hillsboro, Texas, 1978*

Born in 1942 in Wichita Falls, Texas; now living in Minneapolis.

Background
Davidson College, North Carolina
University of Texas, Austin, B.A., 1964
Yale University, M.A., 1967
Studied with Paul Caponigro
Private instructor at Middlebury College in Vermont, 1968 – 1971
Minnesota State Arts Council Visual Arts Fellowship, 1973
Guggenheim Fellowship, 1975 – 1976
Seagram Bicentennial project commission: "Court House," 1975
National Endowment for the Arts Pilot Grant, 1976 – 1977
National Endowment for the Arts Photographer's Fellowship, 1977

Selected Individual Exhibitions
1969 Middlebury College (Vermont)
 University of Ohio, Zanesville
1970 Bennington College (Vermont)
1971 Underground Gallery, New York
1974 George Eastman House, Rochester
 Halsted 831 Gallery, Birmingham, Michigan
 Art Institute of Chicago
1975 Light Gallery, New York
 Amon Carter Museum, Fort Worth
1977 Viterbo College, La Crosse, Wisconsin
 Boston Museum School
1978 Light Gallery, New York
 Museum of Modern Art, New York
 Sheldon Memorial Art Gallery, University of Nebraska, Lincoln

Selected Group Exhibitions
1970 "Contemporary Photographers VI," George Eastman House, Rochester
1972 "60s Continuum," George Eastman House, Rochester
 Martin Gallery, Minneapolis
 Polaroid Gallery, Cambridge
1973 "Photographers: Midwest Invitational," Walker Art Center, Minneapolis

1974 "Light and Substance," University of New Mexico, Albuquerque
1975 "12 Photographers: Minnesota Invitational," Minneapolis Institute of Arts
 "Young American Photographers," Kalamazoo Institute of Arts (traveling exhibition)
 "New Topographics," George Eastman House, Rochester (traveling exhibition)
1976 "Photography for Collectors," Museum of Modern Art, New York
 "Recent Acquisitions," Art Institute of Chicago
 "Recent American Still Photography," Fruitmarket Gallery of the Scottish Arts Council, Edinburgh
 "Six American Photographers," Thomas Gibson Fine Arts, Ltd., London
1977 "Court House," Museum of Modern Art, New York
1978 "Minnesota Survey: 6 Photographers," Minneapolis Institute of Arts
 "American Landscape Photography," Neue Sammlung, Munich
 "Mirrors and Windows," Museum of Modern Art, New York
1979 "American Photography of the '70s," Art Institute of Chicago

Collections
Amon Carter Museum of Western Art, Fort Worth
Art Institute of Chicago
Exchange National Bank of Chicago
Federal Reserve Bank, Minneapolis
International Museum of Photography at George Eastman House, Rochester
Kalamazoo Institute of Arts
David and Reva Logan Foundation, Chicago
Minneapolis Institute of Arts
Museum of Modern Art, New York
Neue Sammlung, Staatliches Museum fur Angewandte Kunst, Munich
Polaroid Corporation, Cambridge
Joseph E. Seagram Collection, New York
Sheldon Memorial Art Gallery, University of Nebraska, Lincoln
University of Kansas Art Museum, Lawrence
University of Massachusetts, Amherst
University of New Mexico, Albuquerque

John Gossage

The photographer prefers not to make a statement about his work.

121 John Gossage *Ornamentals, Georgetown, 1978*

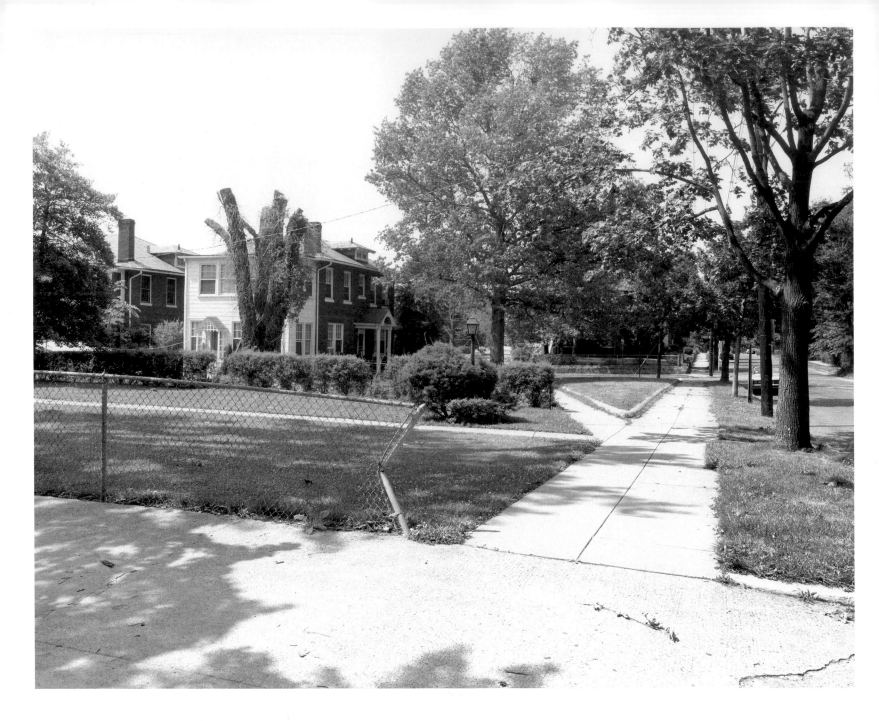

122 John Gossage *Home No. 1, Chevy Chase, Maryland, 1978*

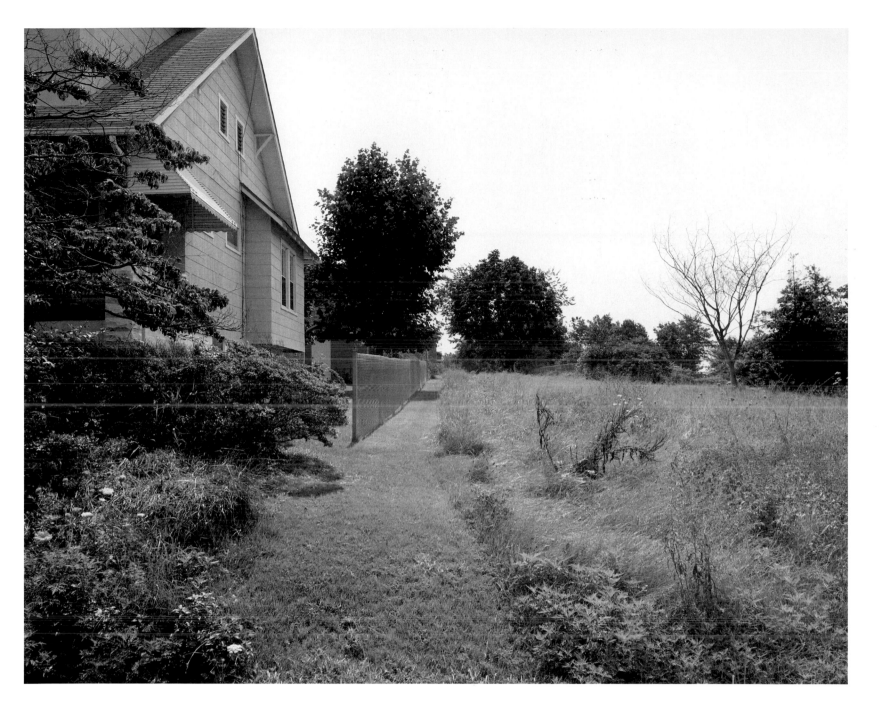

123 John Gossage *Baltimore, Maryland, 1978*

124 John Gossage *Home No. 3, Chevy Chase, Maryland, 1978*

125 John Gossage *Roland Park, Baltimore, 1978*

126 John Gossage *Ornamentals, Georgetown, 1978*

127 John Gossage *Chevy Chase, Maryland, 1978*

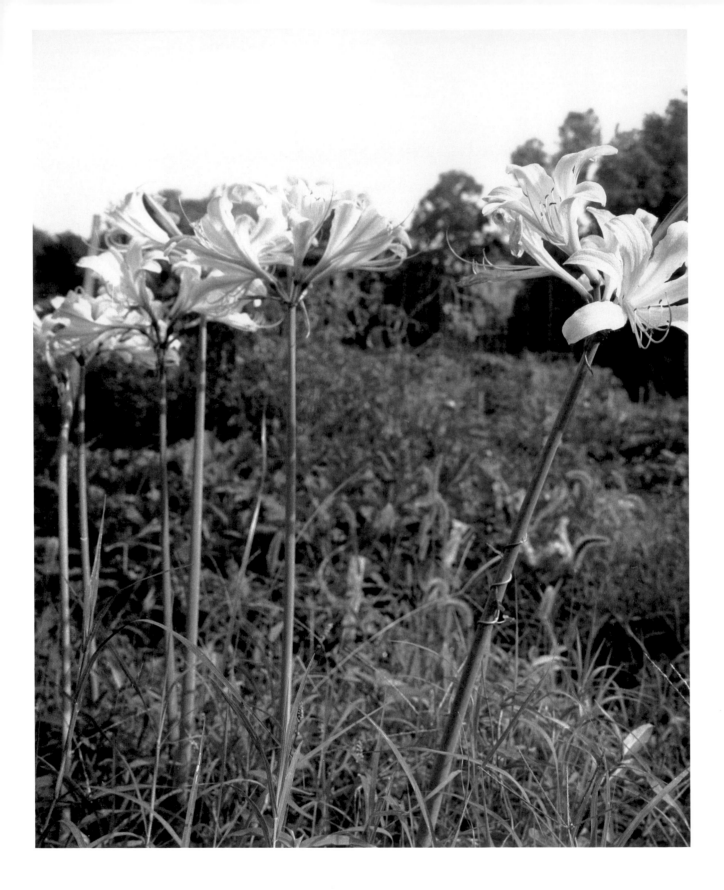

128 John Gossage *Ornamentals II, 1978*

Born in 1946 in New York City; now living in Washington, D.C.

Background
Studied with Lisette Model, Alex Brodovitch, and Bruce Davidson
Instructor of Photography, University of Maryland, College Park,
 1976 – present
Washington Gallery of Modern Art Grants, 1969 and 1970
National Endowment for the Arts Short-Term Project Grant, 1973
National Endowment for the Arts Photographer's Fellowships, 1974 and 1978
Stern Family Foundation Grant, 1974

Selected Individual Exhibitions
1963 Camera Infinity Gallery, New York
1968 Hinkley Brohel Gallery, Washington, D.C.
1971 Ohio University, Athens
1972 Pyramid Gallery, Washington, D.C.
1974 Jefferson Place Gallery, Washington, D.C.
1976 Castelli Graphics Gallery, New York
 Max Protetch Gallery, Washington, D.C.
 Corcoran Gallery, Washington, D.C.
1978 Castelli Graphics Gallery, New York

Selected Group Exhibitions
1969 "Joe Cameron – John Gossage," Corcoran Gallery – Dupont Center,
 Washington, D.C.
1970 "San Francisco Art Institute Invitational"
1971 "Workshop," Corcoran Gallery, Washington, D.C.
 "11 Photographers," Maryland Institute, Baltimore – Corcoran
 Gallery, Washington, D.C.
1972 "Photography Here and Now," University of Maryland Art Gallery,
 College Park
1973 "Photography at the Jefferson Place Gallery," Washington, D.C.
1975 "14 American Photographers," Baltimore Museum (traveling
 exhibition)
 Art Fair, Basel (Switzerland)
 "Photography 2," Jack Glenn Gallery, Corona del Mar, California

1976 "The American Landscape," Philadelphia Print Club
 "Color Photography," Broxton Gallery, Los Angeles
 Art Fair, Basel (Switzerland)
 "Peculiar to Photography," University of New Mexico Art Gallery,
 Albuquerque
 "Portraits," Castelli Graphics Gallery, New York
1977 "Contemporary American Photographic Works," Museum of Fine
 Arts, Houston (traveling exhibition)
 "Photographic Landscapes," George Eastman House, Rochester
 "10th Biennale," Musée d'Art Moderne, Paris
 University of Maryland Art Gallery, College Park
 "Eye of the West," Hayden Gallery, MIT, Cambridge
1978 Chicago Center for Contemporary Photography
 "23 Photographers – 23 Directions," Walker Art Gallery, Liverpool
 (England)
1979 "The Nation's Capital in Photographs," Cranbrook Academy,
 Bloomfield Hills, Michigan
 "Still Life," Corcoran Gallery, Washington, D.C.

Collections
Corcoran Gallery of Art, Washington, D.C.
International Museum of Photography at George Eastman House, Rochester
Library of Congress, Washington, D.C.
Miami-Dade Community College (Florida)
Museum of Fine Arts, Houston
Museum of Modern Art, New York
National Endowment for the Arts, Washington, D.C.
Pan American Union, Washington, D.C.
Pasadena Art Museum (California)
Philadelphia Museum of Art
Princeton University Art Museum
Smithsonian Institution, Washington, D.C.
University of Massachusetts Art Gallery, Amherst
University of New Mexico Art Gallery, Albuquerque
Wheaton College (Illinois)

Jonathan Green

These are photographs about seeing the world in color. I am fascinated by the color of hot cities, the long, low spotlight sun of late summer afternoons. This is the light that reveals, that saturates, that makes the world intense and radiant. The objects in my photographs say something about contemporary American decorative values, our tendency toward the ornate, the brazenly colorful, the plastic. They also tell about unanticipated conjunctions of shapes, of old and new, of actual and illusionary. But most of all, these photographs are about the vocabulary, tone, continuity, syntax, and breadth of color. Their chief function is to reduce to the picture plane momentary truths of visible reality — the color of an instant.

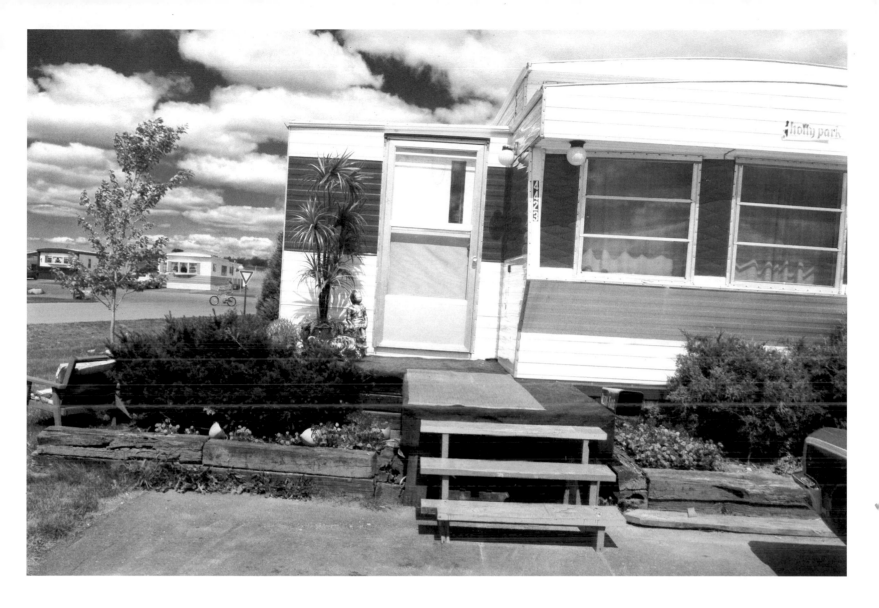

131 Jonathan Green *Traverse City, 1978*

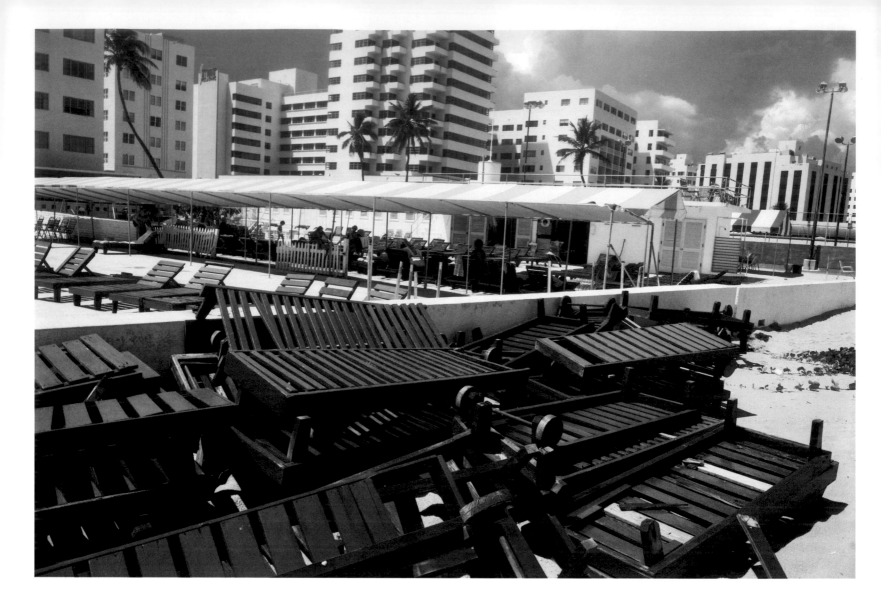

132 Jonathan Green *Miami Beach, 1978*

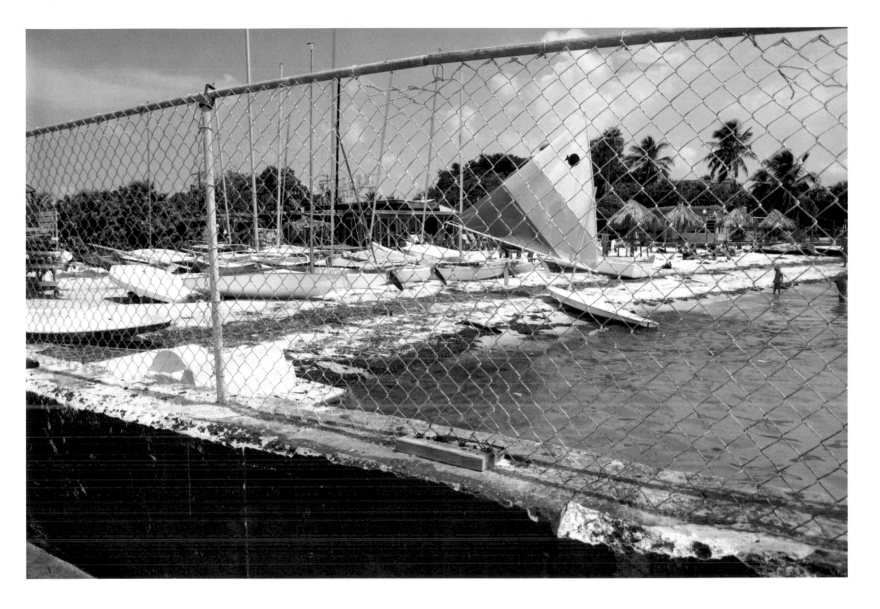

133 Jonathan Green *Key West, 1978*

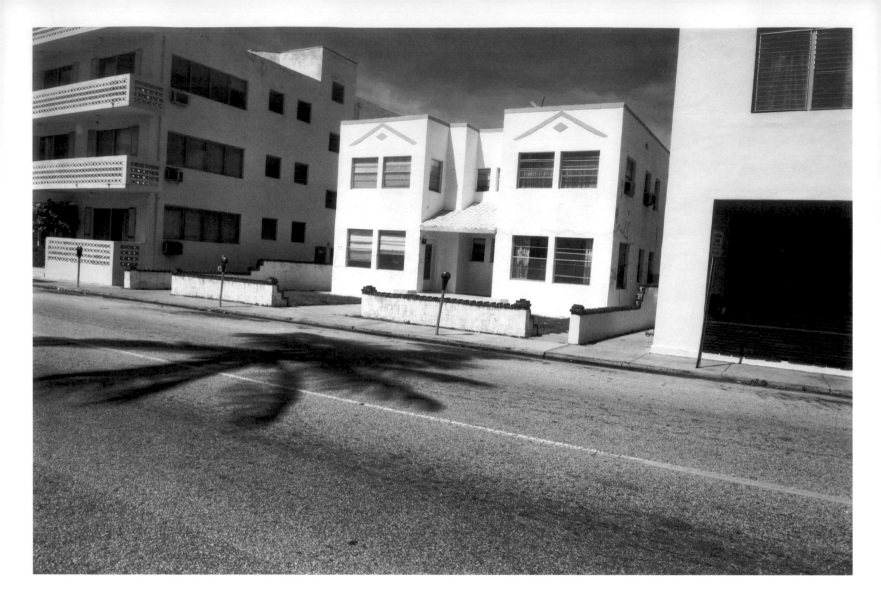

134 Jonathan Green *Miami Beach, 1978*

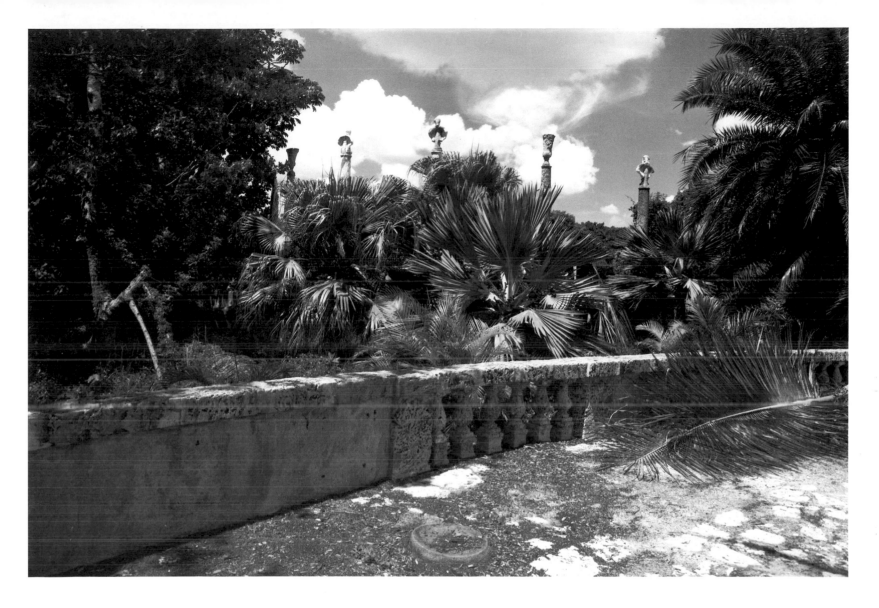

135 Jonathan Green *Miami, 1978*

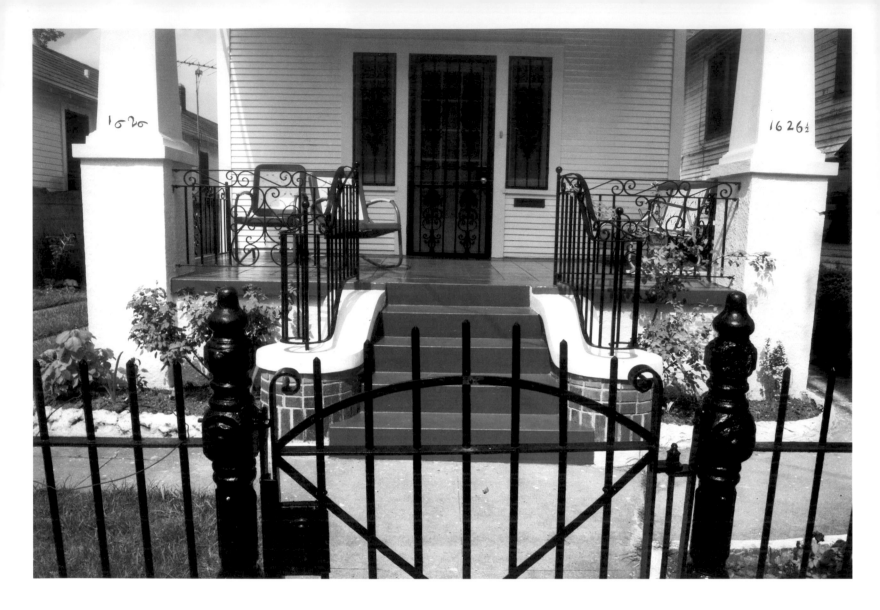

136 Jonathan Green *New Orleans, 1978*

137 Jonathan Green *Key West, 1978*

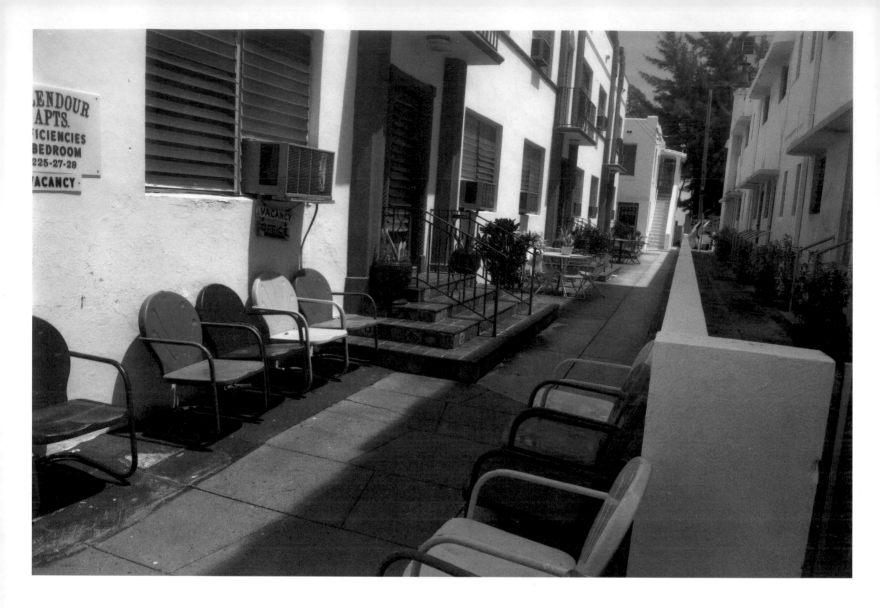

138 Jonathan Green *Miami Beach, 1978*

Born in 1939 in Troy, New York; now living in Galena, Ohio.

Background
Massachusetts Institute of Technology, 1958–1960
Hebrew University of Jerusalem, 1960–1961
Brandeis University, Waltham, Massachusetts, B.A., 1963 (doctoral study to 1967)
Harvard University, Cambridge, M.A., 1967
National Endowment for the Arts Photographer's Fellowship, 1977
Photographer with Ezra Stoller, Mamaroneck, New York, 1967–1969
Instructor of Photography, MIT, 1968–1969; Assistant Professor, 1969–1973; Associate Professor, 1973–1975
Editorial Consultant, *Aperture*, 1972–1973; Associate Editor, 1974–1976
Acting Director, Creative Photography Laboratory, MIT, Cambridge, 1974–1976
Proposal Reviewer for National Endowment for the Humanities, Division of Research Grants, 1975–1976
Review Panelist and Consultant, National Endowment for the Arts, 1975–1976
Consultant, Polaroid Corporation, 1976
Associate Professor of Photography, Ohio State University, Columbus, 1976–present

Selected Individual Exhibitions
1972 Carl Siembab Gallery, Boston
1976 Carl Siembab Gallery, Boston
 Hayden Gallery, MIT, Cambridge
1977 Antioch College, Yellow Springs, Ohio

Selected Group Exhibitions
1967 "New Group" exhibition, Hayden Gallery, MIT, Cambridge
1970 Paul Rudolph exhibition, Museum of Modern Art, New York
 "Metropolitan Middle Class," Hayden Gallery, MIT, Cambridge
 "The Innermost House," Hayden Gallery, MIT, Cambridge (traveling exhibition)

1971 "Photography '72," J.B. Speed Art Museum, Louisville
1973 "Photo Vision '72," Boston Center for the Arts (traveling exhibition)
 "Photography Maine 1973," Maine State Museum, Augusta
1974 "Four Contemporary Photographers," Fogg Art Museum, Harvard University, Cambridge
 "Celebrations," Hayden Gallery, MIT, Cambridge
 "Twentieth-Century Photography from the Collection," Museum of Fine Arts, Boston
1975 "National Photography Invitational," Anderson Gallery, Virginia Commonwealth University, Richmond
 "Photographs from the United States," Fotografiska Museet, Stockholm
 "New England Architecture," DeCordova Museum, Lincoln, Massachusetts
 Opening group show, Cronin Gallery, Houston
1977 Color exhibition, Columbus Institute for Contemporary Art (Ohio)
 Color exhibition, Enjay Gallery, Boston
1978 "Year in Review," Cleveland Museum
 "Tusen och en bild" (one thousand and one), Moderna Museet, Stockholm
 "130 Years of Ohio Photography," Columbus Gallery of Fine Arts (Ohio)

Collections
Cleveland Museum of Art
De Saisset Art Gallery and Museum, University of Santa Clara (California)
Fotografiska Museet, Stockholm
Massachusetts Institute of Technology, Cambridge
Museum of Fine Arts, Boston
Princeton University Art Museum
Virginia Museum of Fine Arts, Richmond

Jan Groover

I don't know why I chose forks—I just took my camera to the kitchen sink....Actually, I have a notion that everything can be pictured, that content is not that relevant. I think it's lovely that a knife can be pink. Its shape can be molded by light, the silver surface picks up and reflects bits of color—it's all very liquid. And the kind of information that is possible in a small space, like that created by the borders of these pictures, can be so crystal clear and appropriate—the issue is really about pushing some thing, some form, into a space that it seems to belong in. In the real world, these forks and kitchen implements can have many associations and functions; in the photographs, it doesn't matter. Formalism is everything.

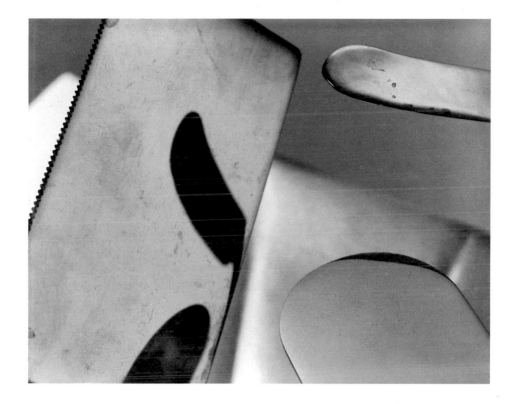

141 Jan Groover *Tybee Forks and Starts (O), 1978*

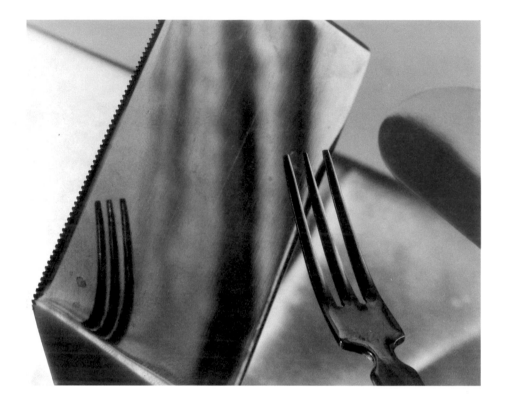

142 Jan Groover *Tybee Forks and Starts (J), 1978*

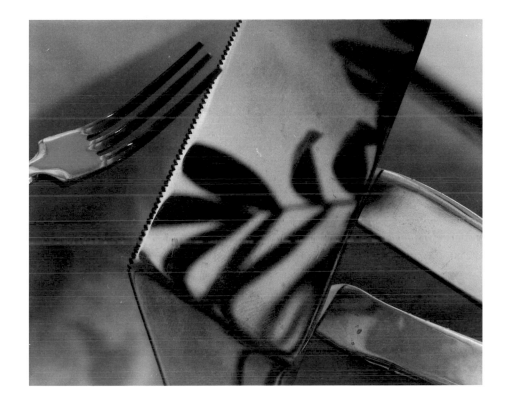

143 Jan Groover *Tybee Forks and Starts (K), 1978*

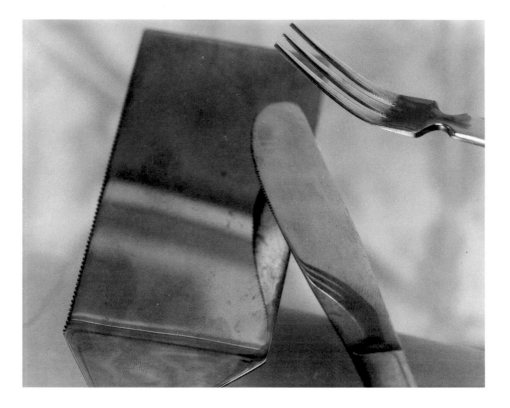

144 Jan Groover *Tybee Forks and Starts (E), 1978*

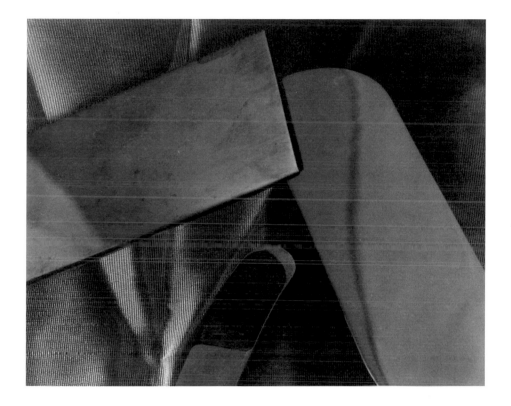

145 Jan Groover *Tybee Forks and Starts (M), 1978*

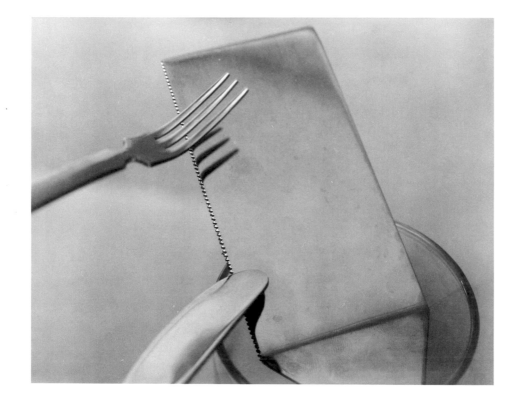

146 Jan Groover *Tybee Forks and Starts (A), 1978*

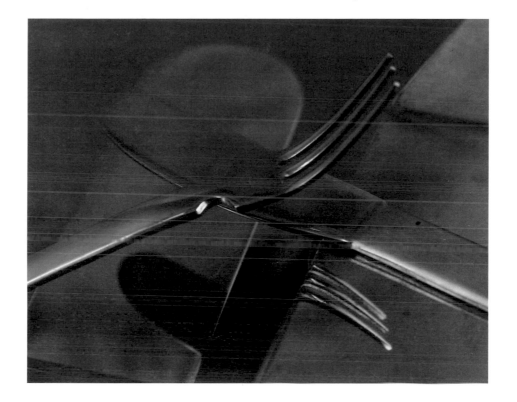

147 Jan Groover *Tybee Forks and Starts (I), 1978*

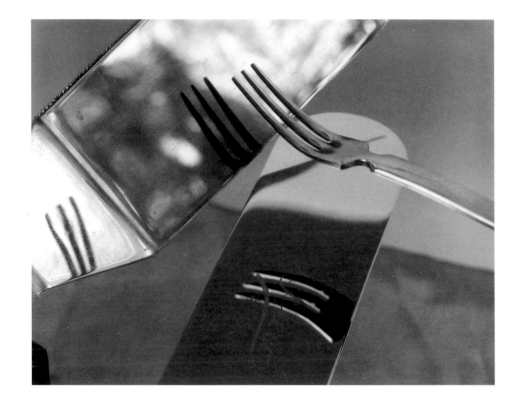

148 Jan Groover *Tybee Forks and Starts (L), 1978*

Born in 1943 in Plainfield, New Jersey; now living in New York City

Background
Pratt Institute, New York, B.F.A., 1965
Ohio State University, Columbus, M.F.A., 1970
Instructor, University of Hartford, 1970–1973
New York State Council on the Arts C.A.P.S. Grants, 1974 and 1977
National Endowment for the Arts Photographer's Fellowship, 1978
Guggenheim Fellowship, 1979

Selected Individual Exhibitions
1974 Light Gallery, New York
1976 Max Protetch Gallery, New York
 Corcoran Gallery, Washington, D.C.
 George Eastman House, Rochester
1977 Sonnabend Gallery, New York
 Baltimore Museum
1978 Sonnabend Gallery, New York

Selected Group Exhibitions
1975 "Time and Transformation," Lowe Art Gallery, University of Miami, Coral Gables
 "(photo) (photo)2...(photo)n," University of Maryland, College Park; San Francisco Museum of Art
1976 "Photographer's Choice," Witkin Gallery, New York
 "Sequences," Broxton Gallery, Los Angeles; Max Protetch Gallery, New York
 "New Directions in Color Photography," Miami-Dade Community College, San Francisco Museum of Art
1977 "Locations in Time," George Eastman House," Rochester
 "Contemporary American Photographic Works," Museum of Fine Arts, Houston (traveling exhibition)
1978 "Jan Groover/David Haxton," Whitney Museum, New York
 "Mirrors and Windows," Museum of Modern Art, New York

Collections
Baltimore Museum of Art
Metropolitan Museum of Art, New York
Museum of Fine Arts, Houston
Museum of Modern Art, New York
Whitney Museum of American Art, New York

Mary Ellen Mark

I met Jeanette and Victor in Central Park early in June of 1978. He was fourteen; she was fifteen and seven and a half months pregnant. I was struck by her youth—she looked about twelve. I took her picture and sent her a print. She called to thank me and I asked if I could spend more time photographing her and Victor.

I photographed her often during the final one and a half months of her pregnancy, and we became good friends. Since the birth of Chastity Sandy Orellanes, I have been photographing Jeanette's and Victor's adjustment to their teenage parenthood and the adjustment of their families and friends.

I have spent so much time with these families that they have pretty much forgotten my camera. I can simply arrive at their homes and take pictures. We've become extremely close and I've tried to reflect that in the intimate character of the photographs.

These fifteen prints are part of a documentary project—an extended photographic essay—that I plan to do over the next five years with several Puerto Rican families living in the Fort Green section of Brooklyn.

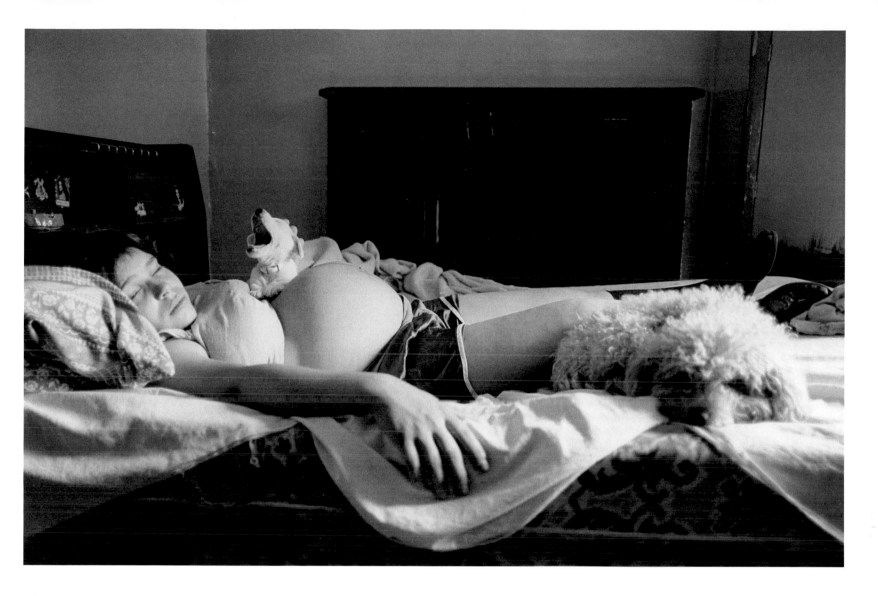

151 Mary Ellen Mark *Jeanette asleep with Lucas, June 1978*

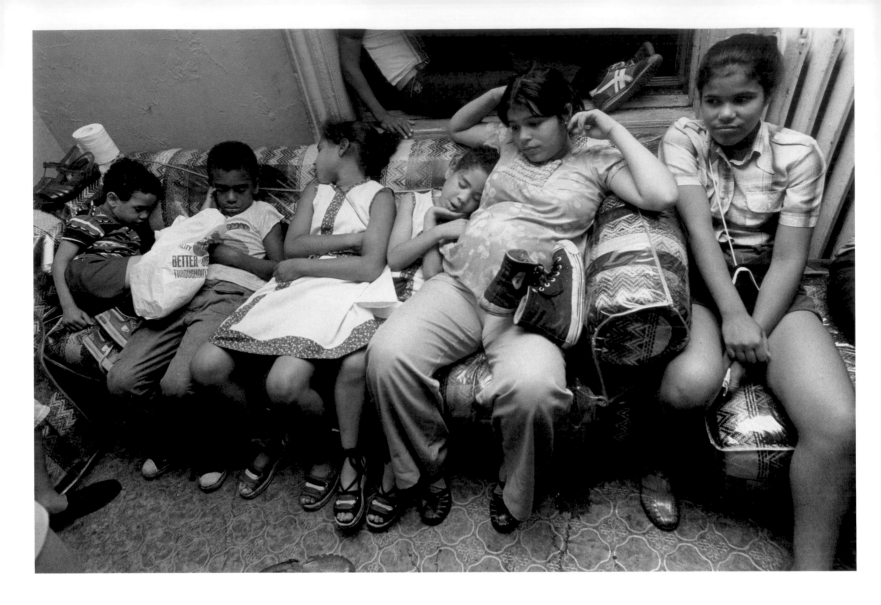

152 Mary Ellen Mark *3 a.m. Saturday evening after a voodoo ceremony, July 1978*

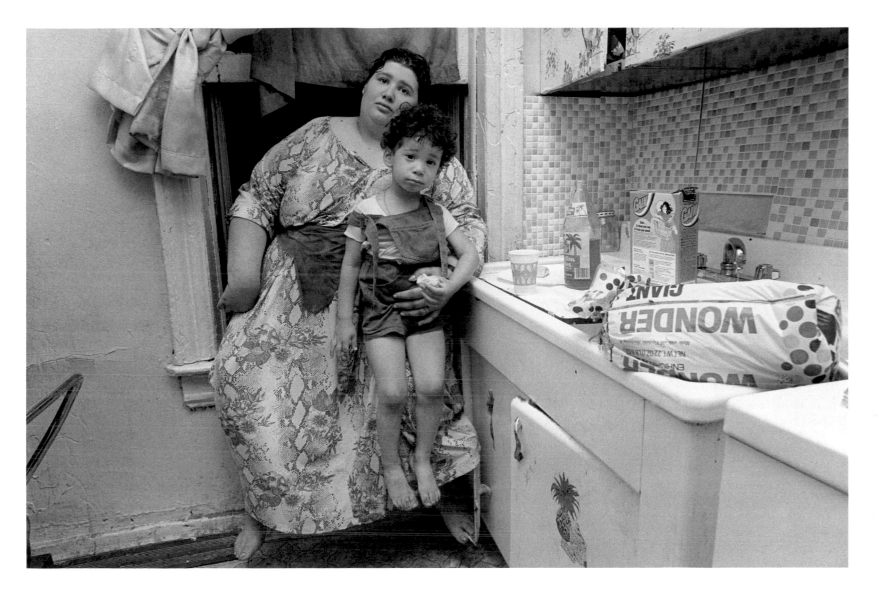

153 Mary Ellen Mark *Jeanette's neighbor Gladys with her son, July 1978*

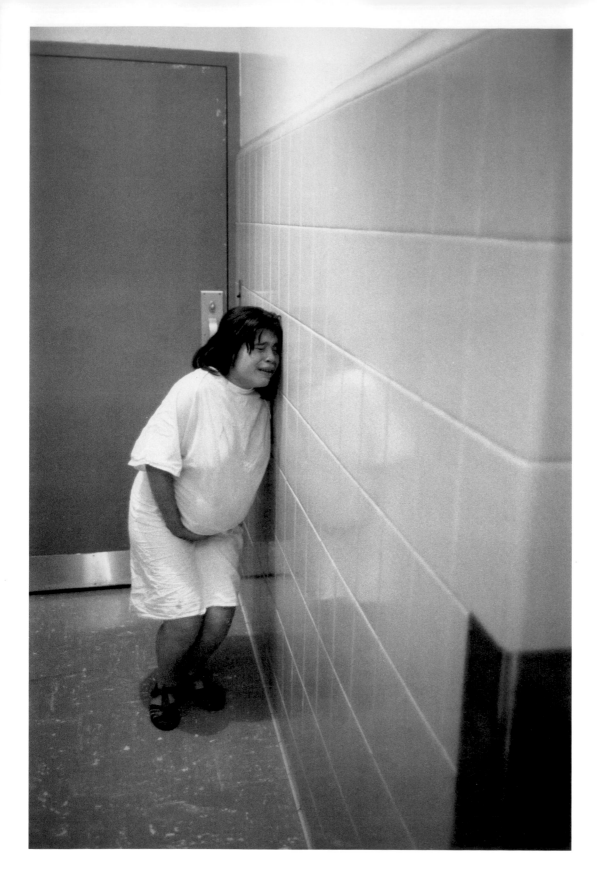

154 Mary Ellen Mark *The beginning of Jeanette's labor, July 19, 1978*

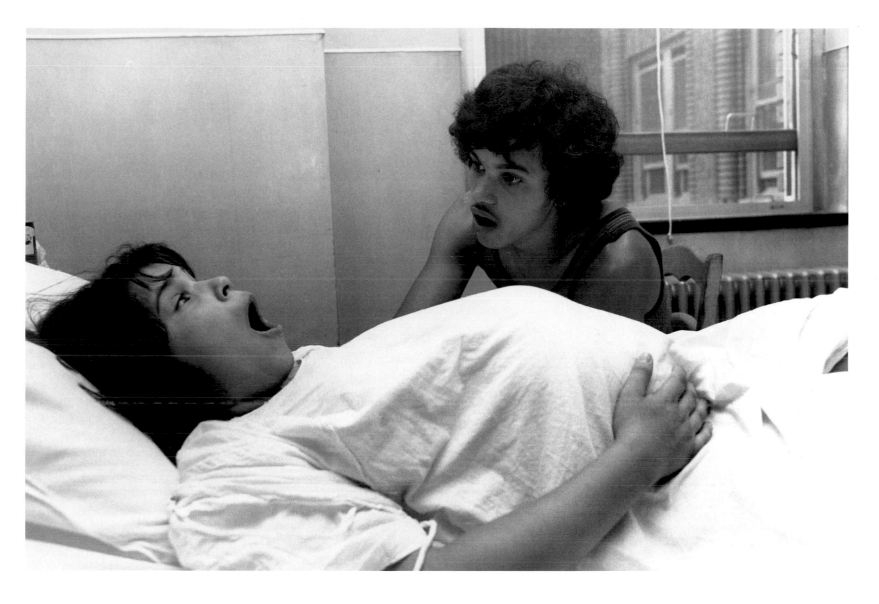

155 Mary Ellen Mark *Victor and Jeanette during her early stages of labor, July 19, 1978*

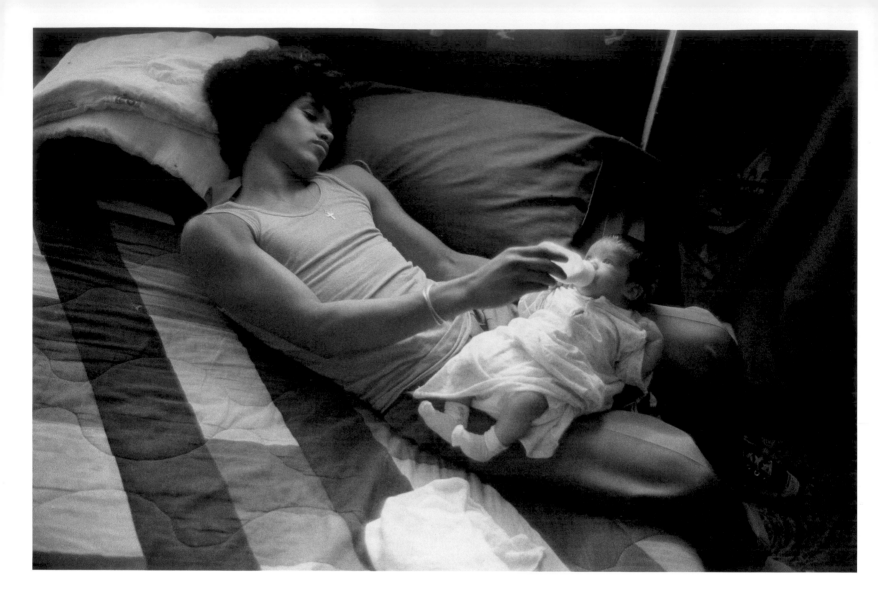

156 Mary Ellen Mark *Victor feeding Chastity Sandy Orellanes, July 1978*

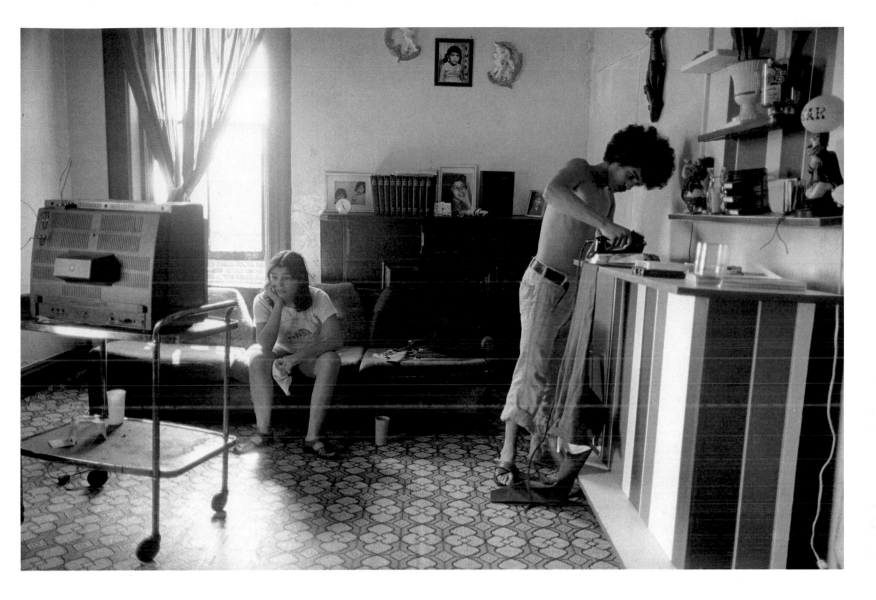

157 Mary Ellen Mark *Relaxing at home, August 1978*

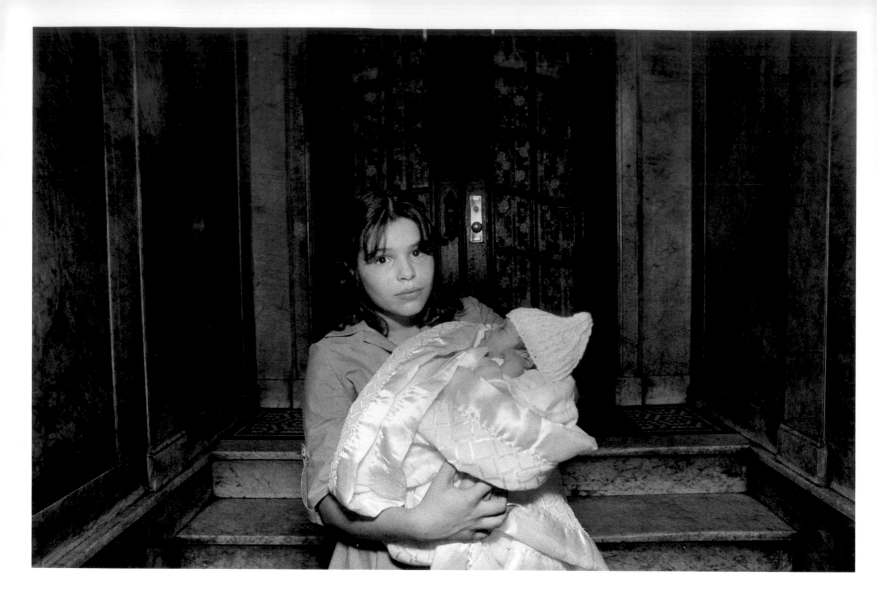

158 Mary Ellen Mark *Jeanette and Chastity Sandy, August 1978*

Born in Philadelphia; now living in New York City.

Background

University of Pennsylvania, B.F.A., 1962

Annenberg School of Communications, University of Pennsylvania,
 M.A., 1964

Fulbright Scholarship (to photograph in Turkey), 1965–1966

U.S.I.A. Grant (to lecture and exhibit in Yugoslavia), 1975

National Endowment for the Arts Fellowship, 1977

New York State Council on the Arts C.A.P.S. Grant, 1977

Lecturer at Ohio University, Athens, and Brooks Institute, Santa Barbara,
 1976

Lecturer at Brooks Institute, Santa Barbara; "Aperture 77," Durham,
 California; Women's Interart Center, New York; Bard College, Annandale-
 on-Hudson, New York; New School for Social Research, New York;
 International Center of Photography, New York; Yale University; and
 School of Visual Arts, New York, 1977

Selected Individual Exhibitions

1976 Photographer's Gallery, London
 Forum Stadtpark, Graz (Austria)

1977 Bibliothèque Nationale, Paris
 Santa Barbara Museum

1978 Castelli Graphics Gallery, New York
 Boise Gallery (Idaho)

Selected Group Exhibitions

1975 Exhibition of women photographers, Neikrug Gallery, New York
 "Women of Photography," San Francisco Museum of Art
 U.S.I.A. traveling exhibition of American Photography
 Photopia Gallery, Philadelphia (with Ralph Gibson)

1976 "Women of Photography," Sidney Janis Gallery, New York

1977 "Eight American Female Photographers," Iran-America Society,
 Cultural Center, Tehran
 Hayden Gallery, MIT, Cambridge (with Burk Uzzle)

Joel Meyerowitz

As a New Yorker, I have always been aware of the presence of the Empire State Building. Like Fuji, it rises majestically and forms the background for the life unfolding beneath it. This presence, sometimes hidden in mist or clouds, or etched in silver one day and gilded by sunlight the next, seems to preside over life in the city, if that's how you care to see it.

In spite of my daily familiarity with the "Empire," it still takes me by surprise, makes me catch my breath. It occurred to me that perhaps this was a subject that would be both fresh and familiar, a starting point for looking at other aspects of the city. To me, one of the most immediate surprises and pleasures of the city is seeing the counterpoints between architectural styles. The terminal and the warehouse, the diner and the brownstone, the colloquial and classical, eclectic and modern — this dictionary of forms is made more clearly visible when seen against the poise of the Empire State Building.

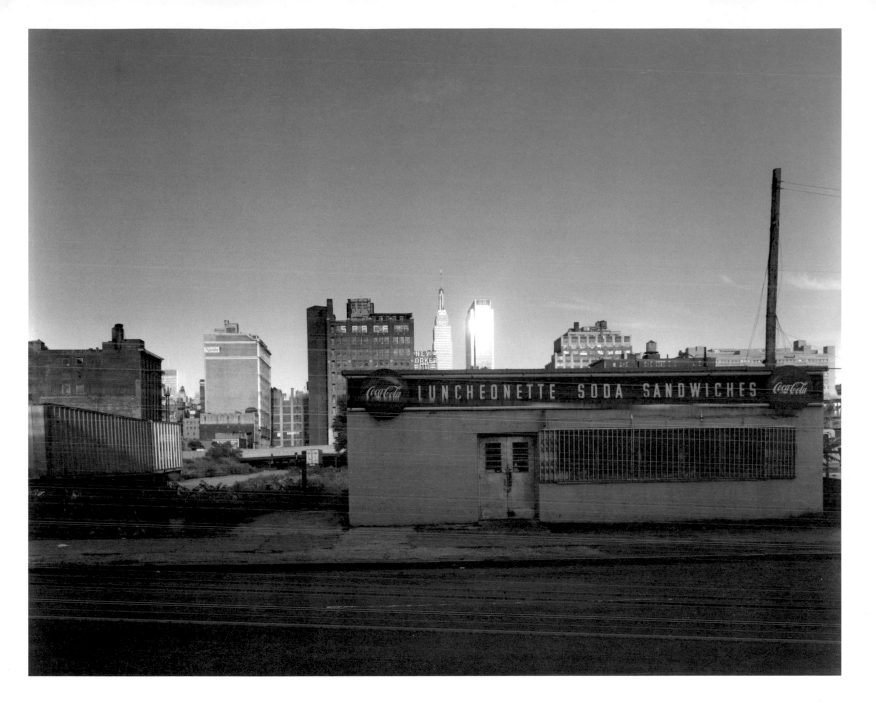

161 Joel Meyerowitz *12th Ave. between 34th and 35th Sts., 1978*

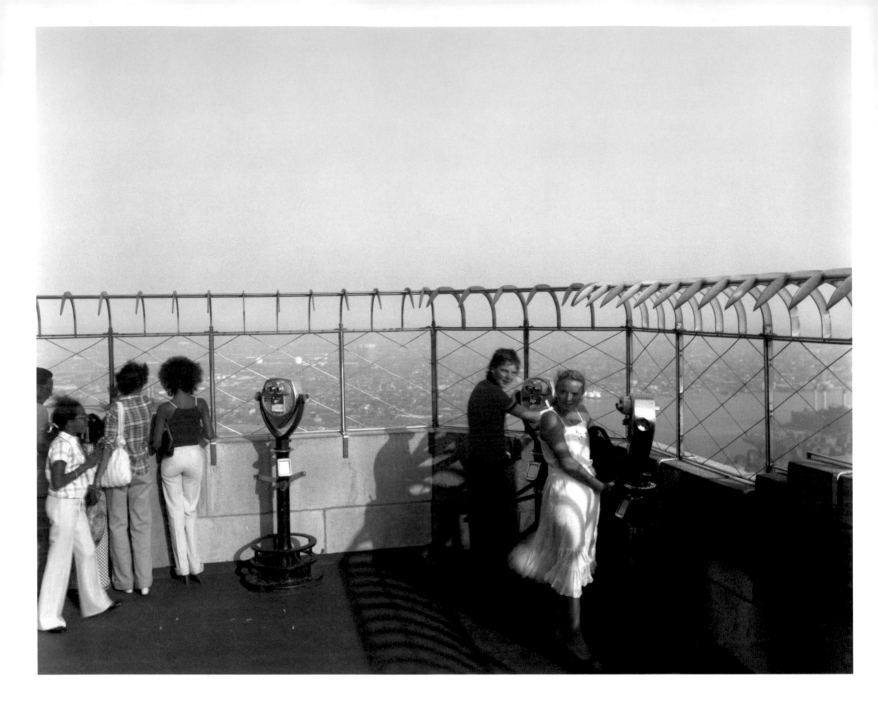

162 Joel Meyerowitz *Observation Deck, 1978*

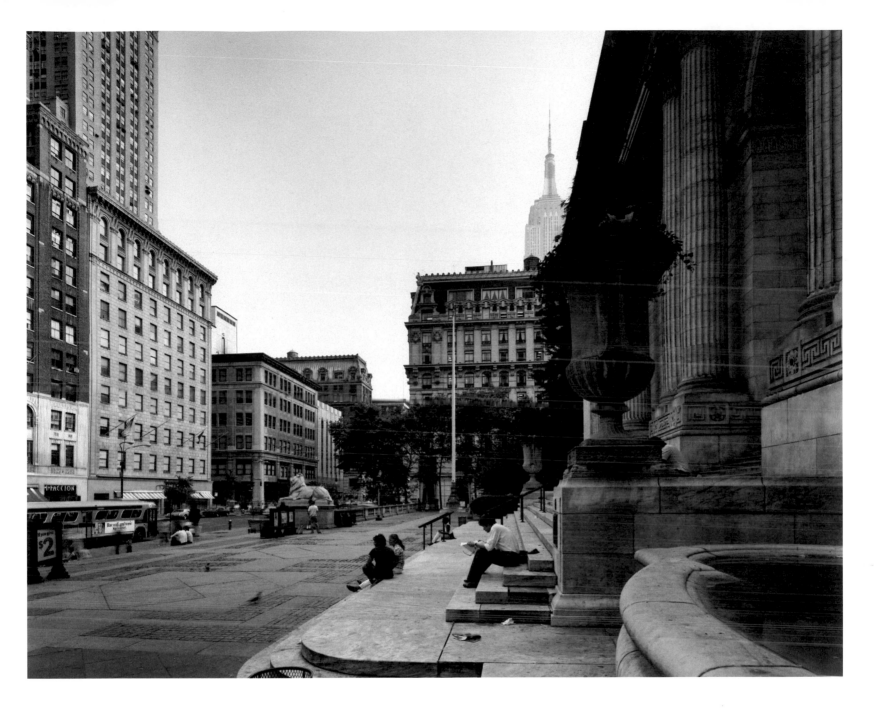

163 Joel Meyerowitz *New York Public Library, 1978*

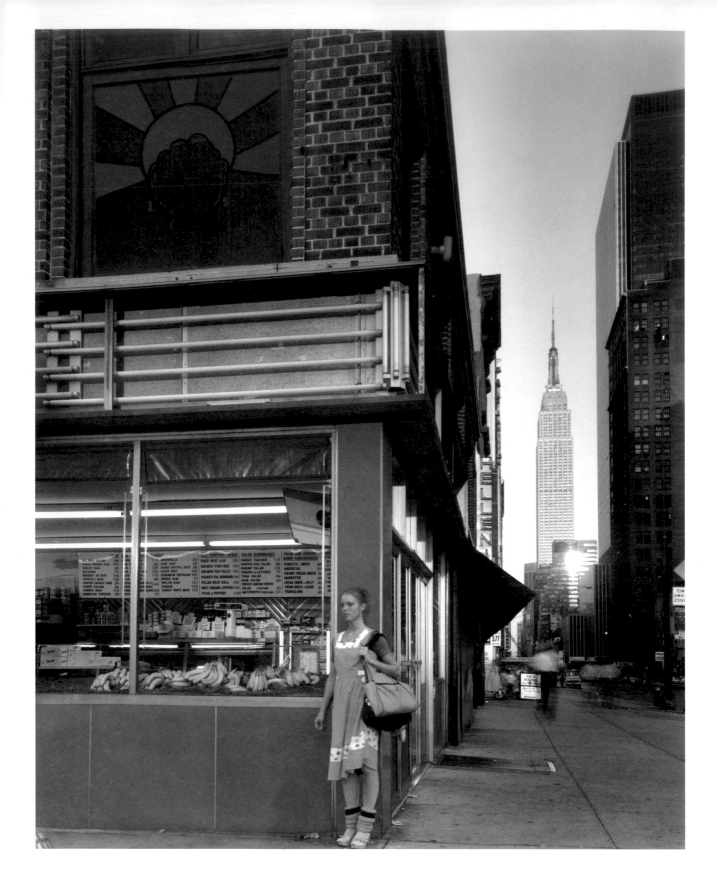

164 Joel Meyerowitz *Young Dancer, 34th and 9th Ave., 1978*

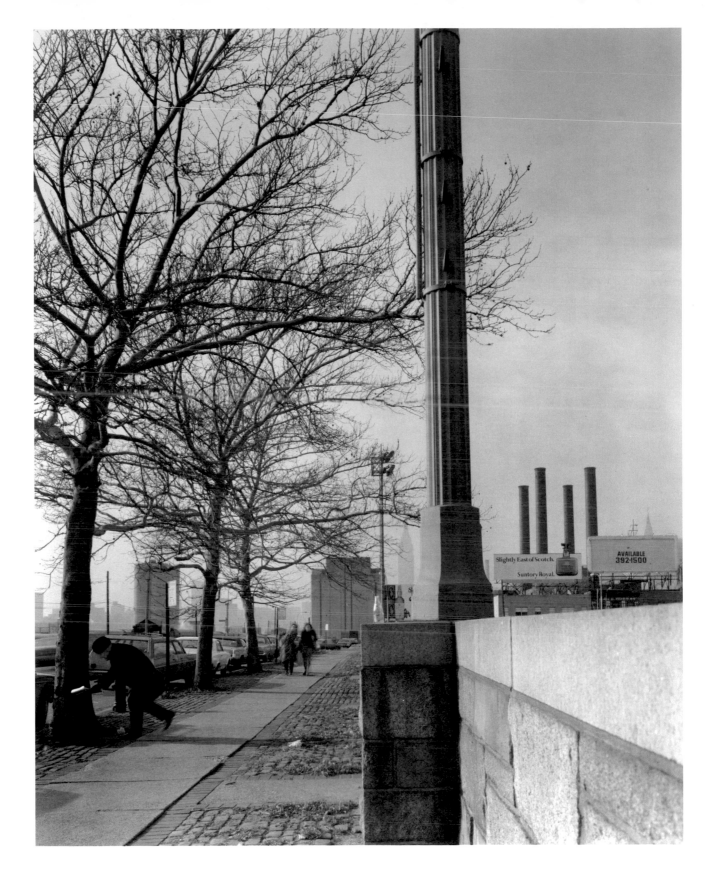

165 Joel Meyerowitz *Man measuring trees above Midtown Tunnel, Queens, 1978*

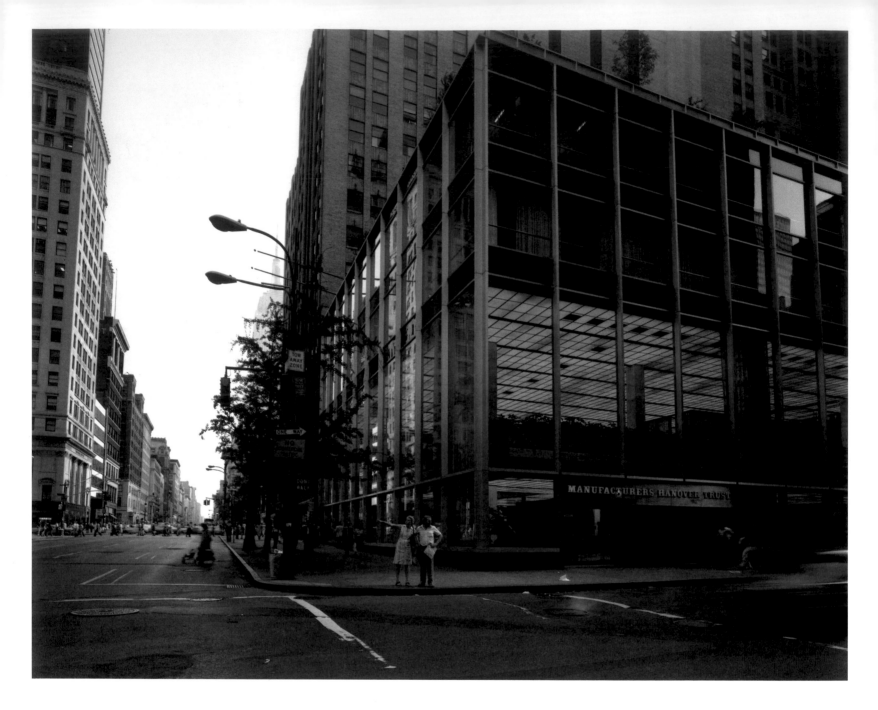

166 Joel Meyerowitz *5th Ave. and 43rd St., 1978*

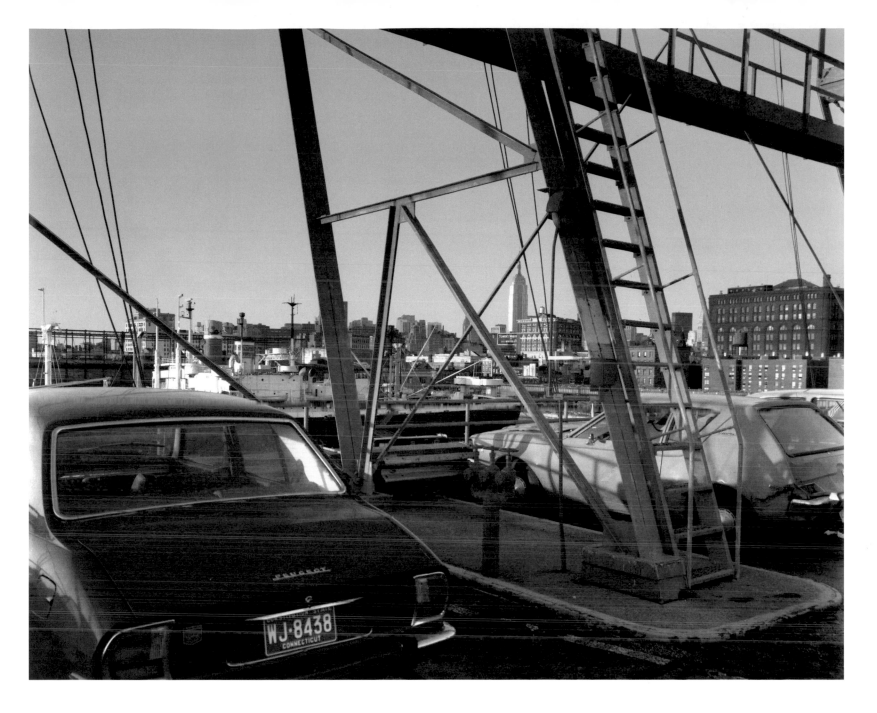

167 Joel Meyerowitz *Empire from parking pier in Hudson, 1978*

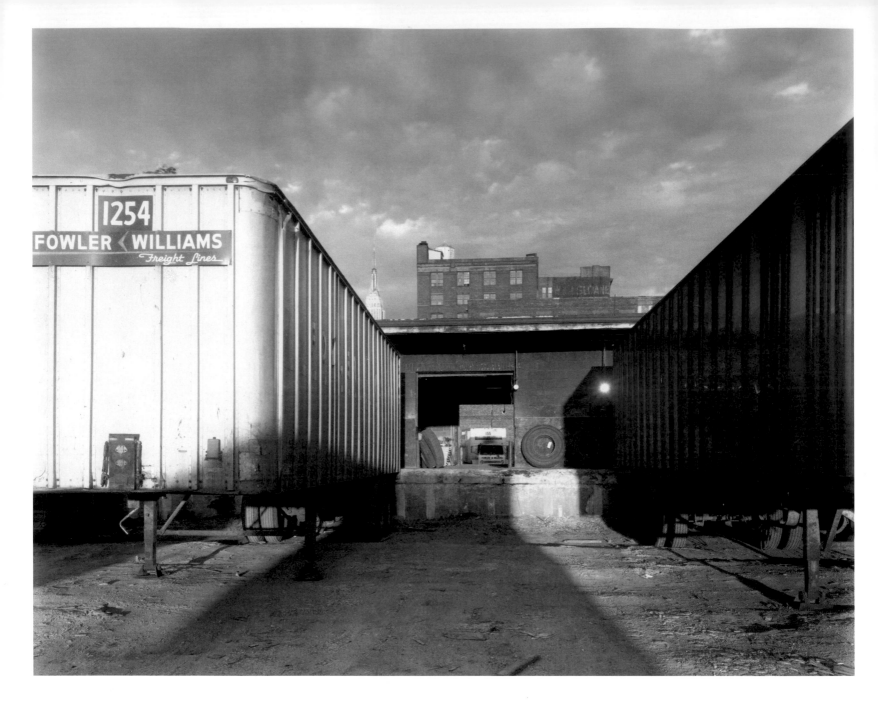

168 Joel Meyerowitz *29th St. and 12th Ave., 1978*

Born in 1938 in New York City; now living there.

Background

Ohio State University, B.F.A., 1959
Guggenheim Fellowships, 1970 and 1978
New York State Council on the Arts C.A.P.S. Grant, 1976
St. Louis Art Museum commission: "St. Louis and the Arch," 1977
National Endowment for the Arts Photographer's Fellowship, 1978
National Endowment for the Humanities Grant (with Colin Westerbeck, Jr.),
 1978-1980
Adjunct Professor of Photography at Cooper Union, New York,
 1971 – present
Mellon Lecturer in Photography at Cooper Union, New York, 1977
Associate Professor of Photography, Princeton University, 1977

Selected Individual Exhibitions

1966 George Eastman House, Rochester
1968 Museum of Modern Art, New York ("My European Trip")
1978 Museum of Fine Arts, Boston ("Cape Light") (traveling exhibition)
1979 Akron Art Institute (Ohio)

Selected Group Exhibitions

1963 "The Photographer's Eye," Museum of Modern Art, New York
1968 Ben Schultze Memorial, Museum of Modern Art, New York
 Group show, Smithsonian Institution, Washington, D.C.
1970 "Portraits," Museum of Modern Art, New York
 "10 Americans," U.S. Pavilion, Japan Expo
1971 "New American Photography," Museum of Modern Art, New York
 (traveling exhibition)
1974 Group show, Virginia Museum, Richmond
1975 "New Acquisitions," Museum of Fine Arts, Boston
1976 "Wedding Group," Carpenter Center, Harvard University, Cambridge
 Group show, Princeton University Art Museum
 "Warm Truths; Cool Deceits" (traveling exhibition organized by
 Max Kozloff)
1977 "Inner Light," Museum of Fine Arts, Boston
1978 "Mirrors and Windows," Museum of Modern Art, New York
 "Art from Corporate Collections," Whitney Museum, New York

Collections

City Art Museum of St. Louis
International Museum of Photography at George Eastman House, Rochester
Museum of Fine Arts, Boston
Museum of Modern Art, New York
Philadelphia Museum of Art
Joseph E. Seagram Collection, New York

Richard Misrach

By arbitrarily thrusting the camera into the jungle at night when I can't see ninety percent of what I'm shooting, I can create a new ordering of visual information. Instead of the clichéd images of jungles that we seem to possess from pictures on old postcards or in the *National Geographic*, these photographs take a step closer: you literally can't see the forest for the trees. The camera does the selecting, editing, composing, and framing virtually without discrimination. Detail is obscured and layered, and your eye is constantly engaged, constantly moving over the surface of the image. I think the photographs create a kind of subconscious vertigo because they're not based on normal landscape perspectives, the color isn't intended to be conventionally beautiful, the image is chaotic and claustrophobic. If you look at enough examples of this apparent chaos, though, order eventually emerges, becomes internalized, and starts to reshape your patterns of visual perception.

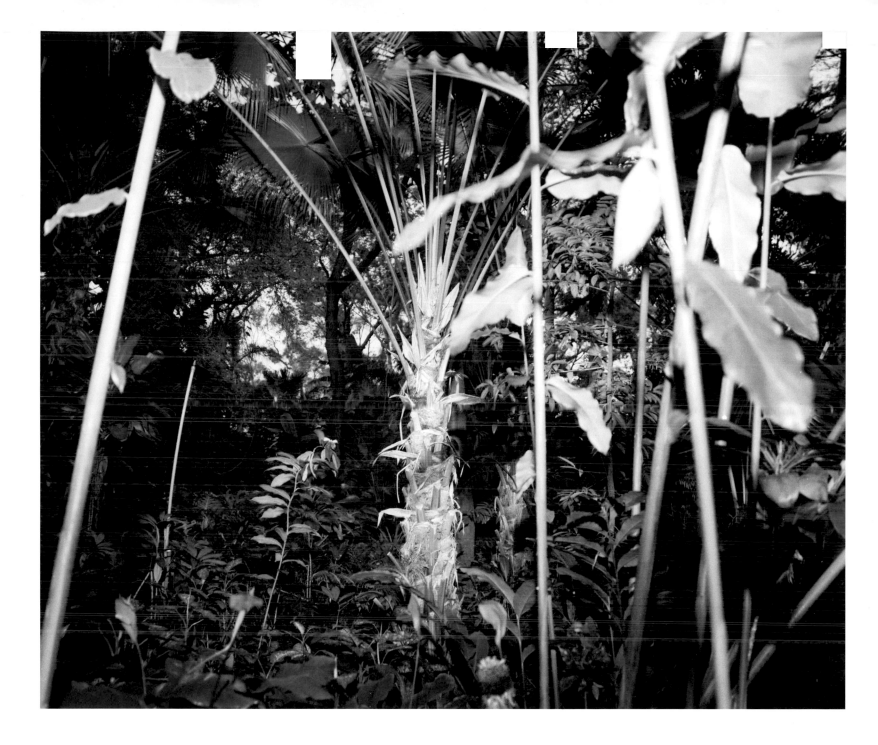

171 Richard Misrach *Hawaii V, 1978*

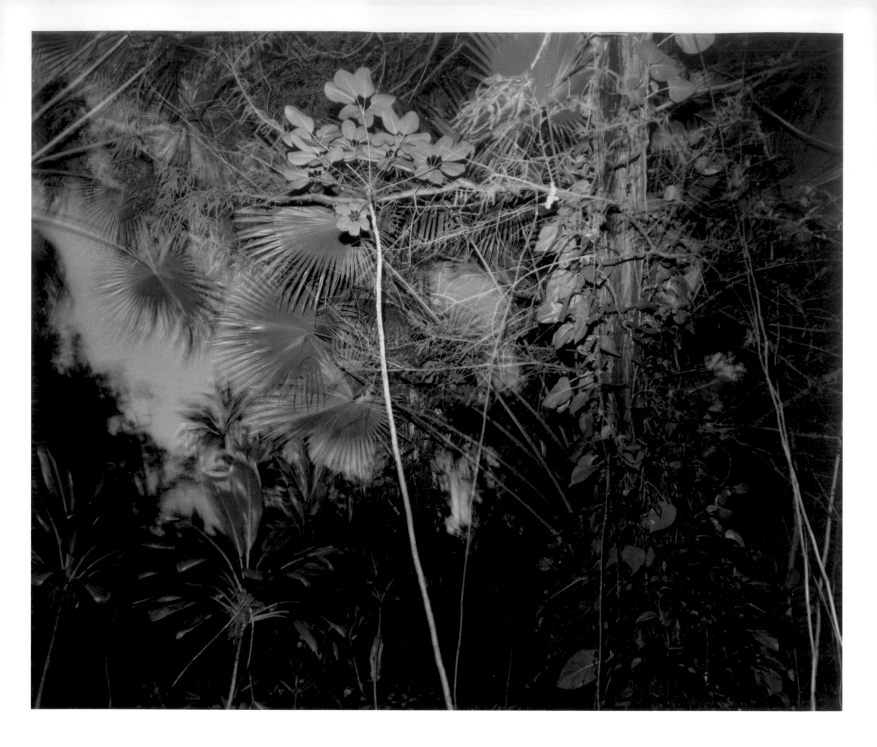

172 Richard Misrach *Hawaii III, 1978*

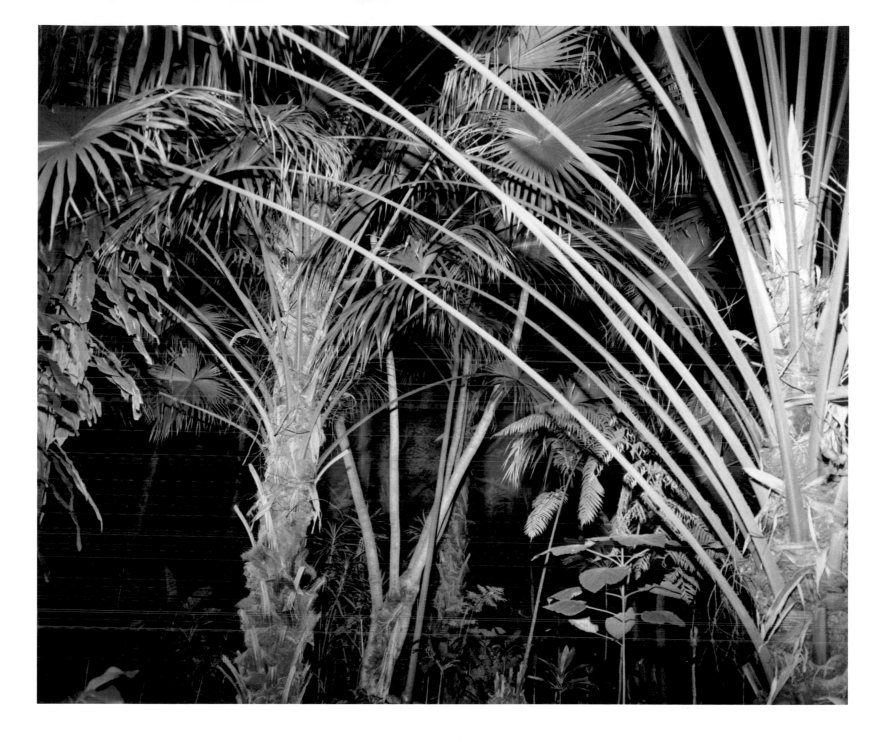

173 Richard Misrach *Hawaii IV, 1978*

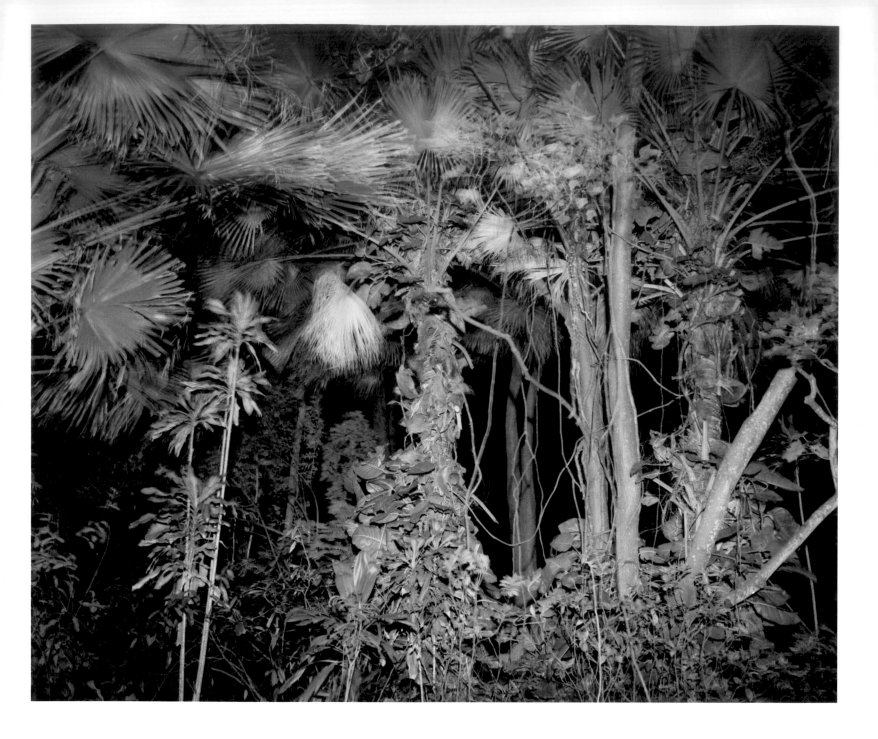

174 Richard Misrach *Hawaii XI, 1978*

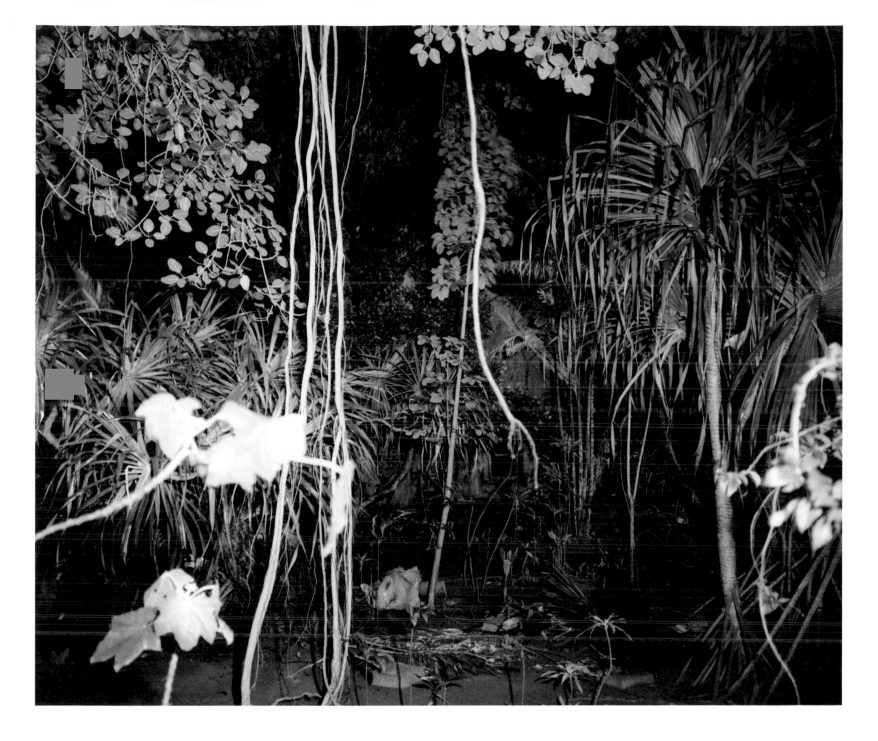

175 Richard Misrach *Hawaii XII, 1978*

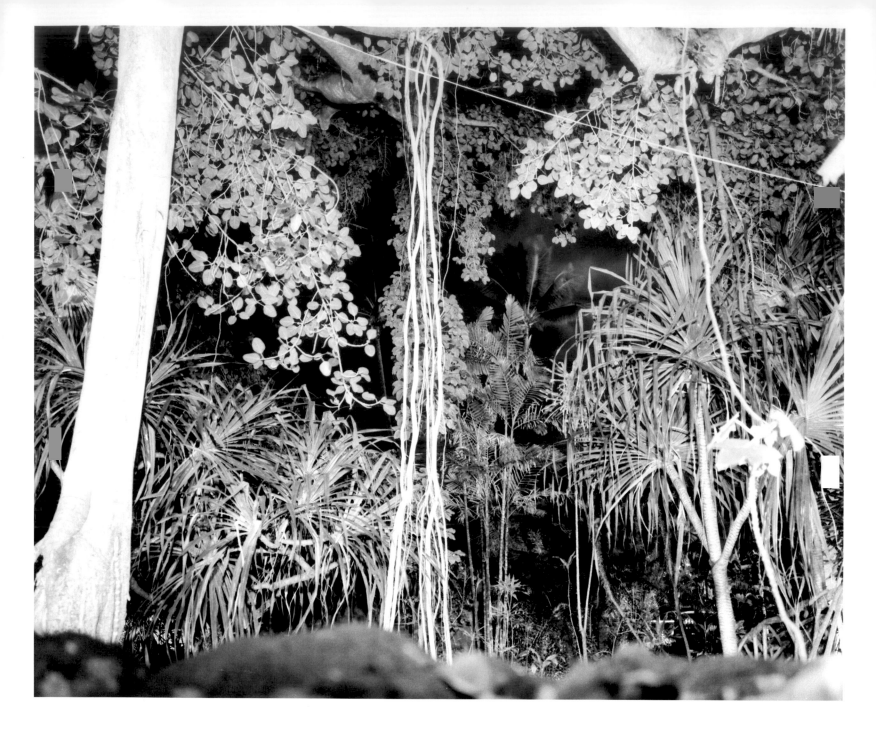

176 Richard Misrach *Hawaii IX, 1978*

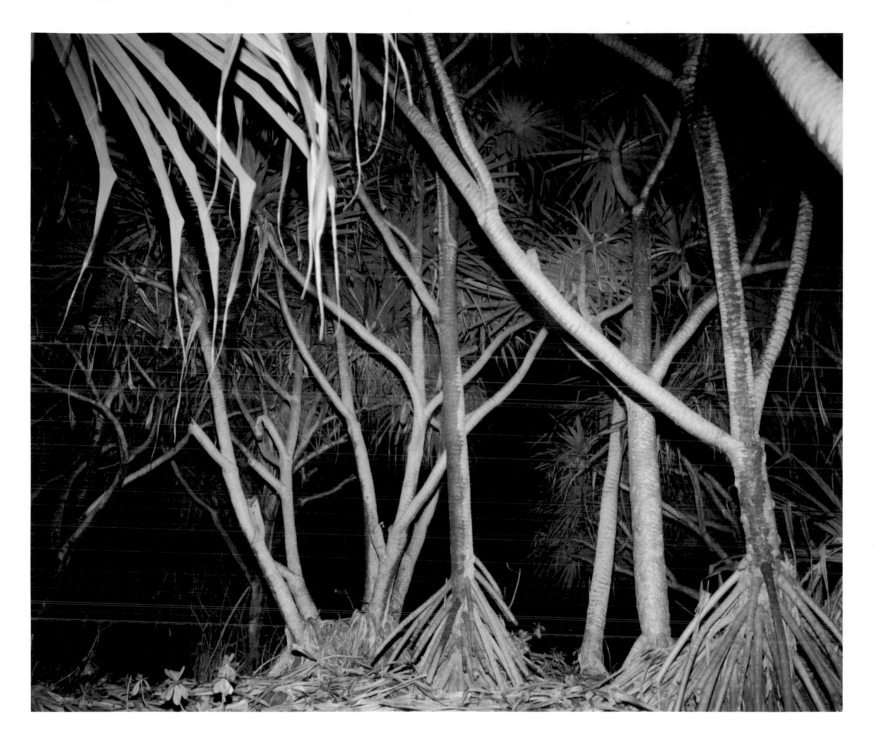

177 Richard Misrach *Hawaii VII, 1978*

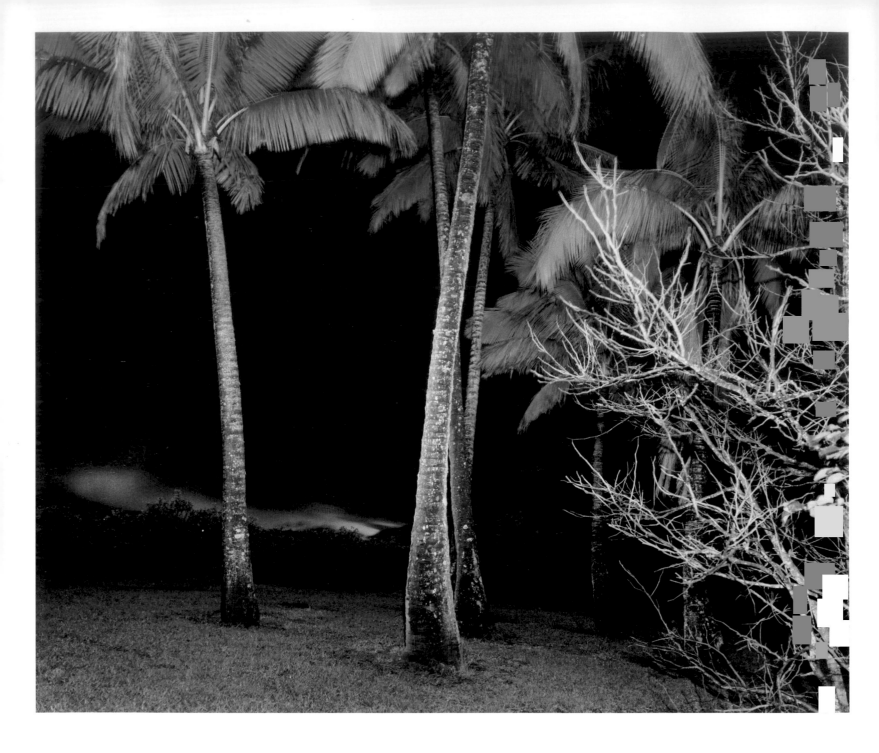

178 Richard Misrach *Hawaii XIV, 1978*

Born in 1949 in Los Angeles; now living in Emeryville, California.

Background

Photography staff member, ASUC Studio, University of California, Berkeley, 1972–1977

Instructor at University of California, Berkeley (extension classes), 1977 and 1979

National Endowment for the Arts Photographer's Fellowships, 1973 and 1977

Western Books Award (for *Telegraph 3 A.M.*), 1975

Ferguson Grant, 1976

Guggenheim Fellowship, 1978

Polaroid Project Commission ("8 x 10"), 1978

Selected Individual Exhibitions

1975 Darkroom Workshop Gallery, Berkeley
 International Center for Photography, New York
 Shado Gallery, Oregon City, Oregon
1976 Madison Art Center (Wisconsin)
1977 ARCO Center for Visual Arts, Los Angeles
1978 Silver Image Gallery, Seattle
 University of Oregon Art Museum (Eugene)
1979 Grapestake Gallery, San Francisco
 Centre Georges Pompidou, Musée d'Art Moderne, Paris

Selected Group Exhibitions

1973 "Places," San Francisco Art Institute
1975 "Young American Photographers," Kalamazoo Institute of Arts (traveling exhibition)
1976 "Contemporary Photography," Fogg Art Museum, Harvard University, Cambridge
 "Contemporary West Coast Photography," Australian Center for Photography (traveling exhibition)
1977 "Summer Light," Light Gallery, New York
 "The Night Landscape," Oakland Museum (California)
1978 Group show, Santa Barbara Museum of Art
 "Mirrors and Windows," Museum of Modern Art, New York (traveling exhibition)
 "Photographers in Mexico," Mexico City (traveling exhibition)

Collections

ARCO Center for the Visual Arts, Los Angeles
Kalamazoo Institute of Arts
Library of Congress, Washington, D.C.
Madison Art Center (Wisconsin)
Museum of Fine Arts, Houston
Museum of Fine Arts, Springfield, Massachusetts
Museum of Modern Art, New York
Oakland Art Museum (California)
Smithsonian Institution, Washington, D.C.

Nicholas Nixon

I love to photograph people: their skin, their stances, the space around them. The picture is the point; the clearer and more beautiful the better.

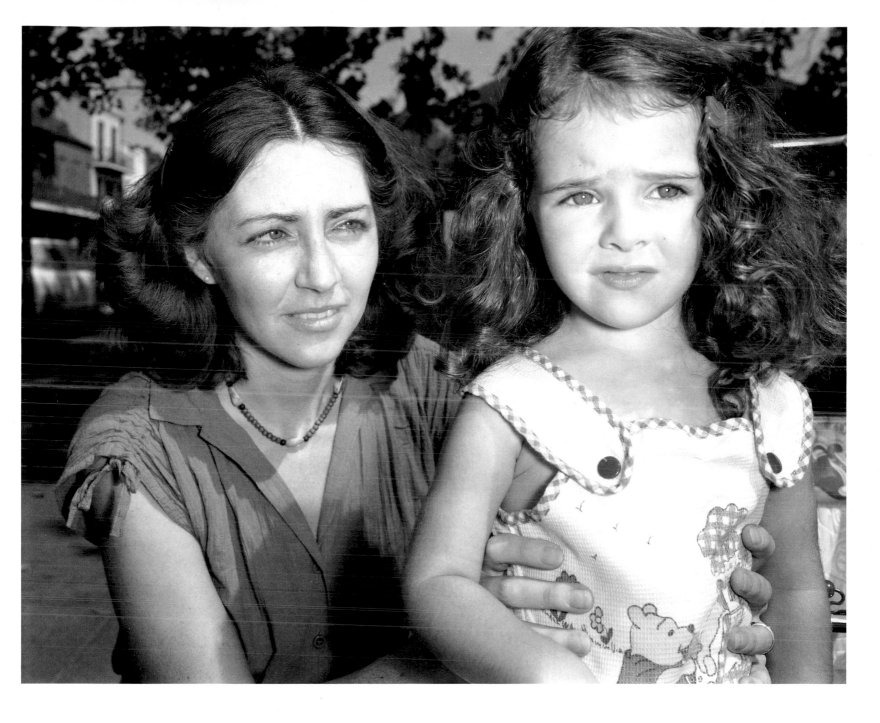

181 Nicholas Nixon *New Orleans, 1978*

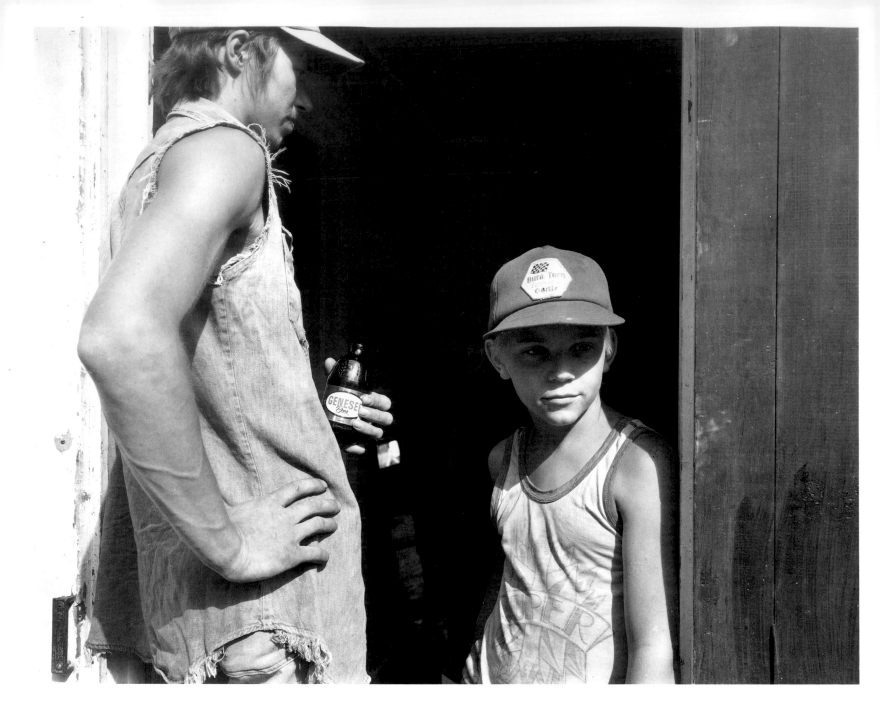

182 Nicholas Nixon *Poultney, Vermont, 1978*

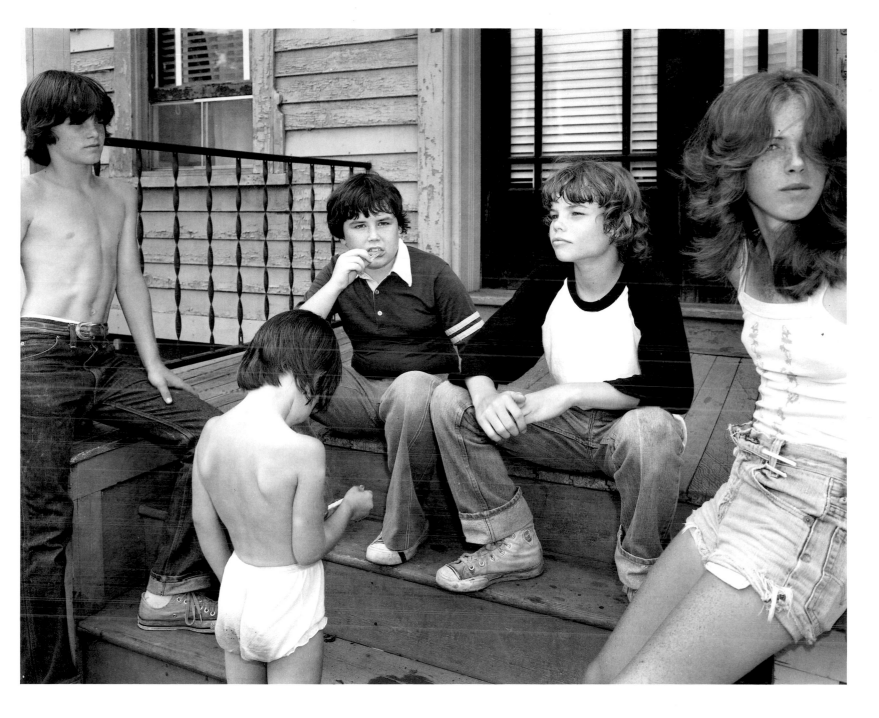

183 Nicholas Nixon *Troy, New York, 1978*

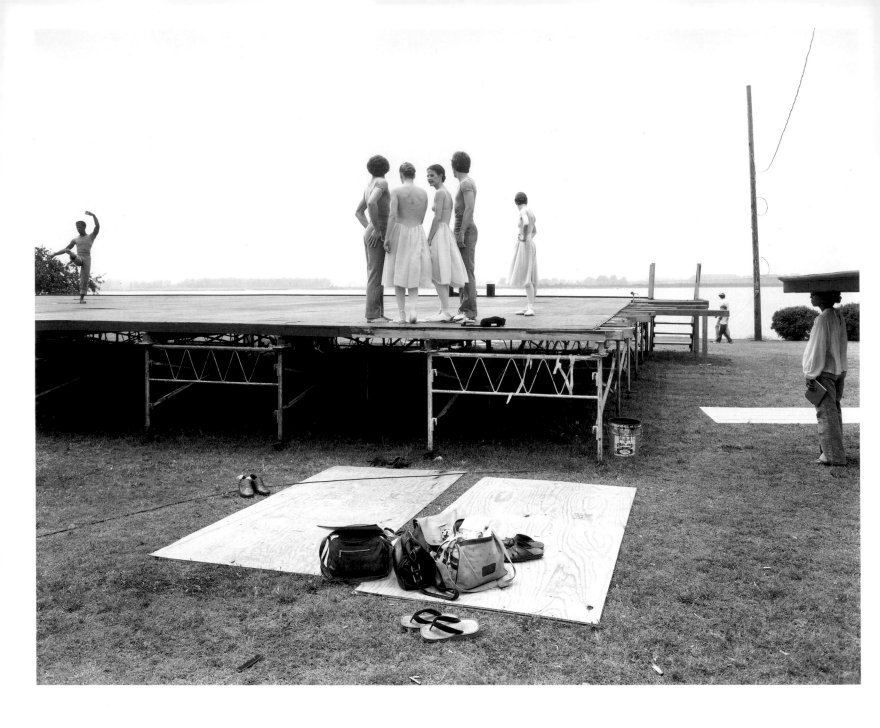

184 Nicholas Nixon *Memphis, 1978*

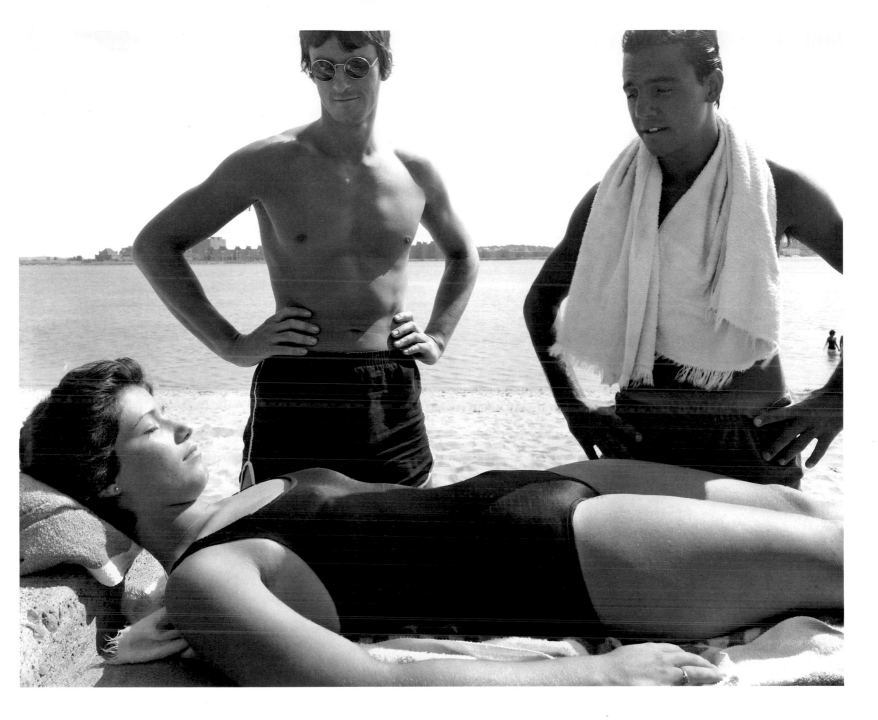

185 Nicholas Nixon *South Boston, 1978*

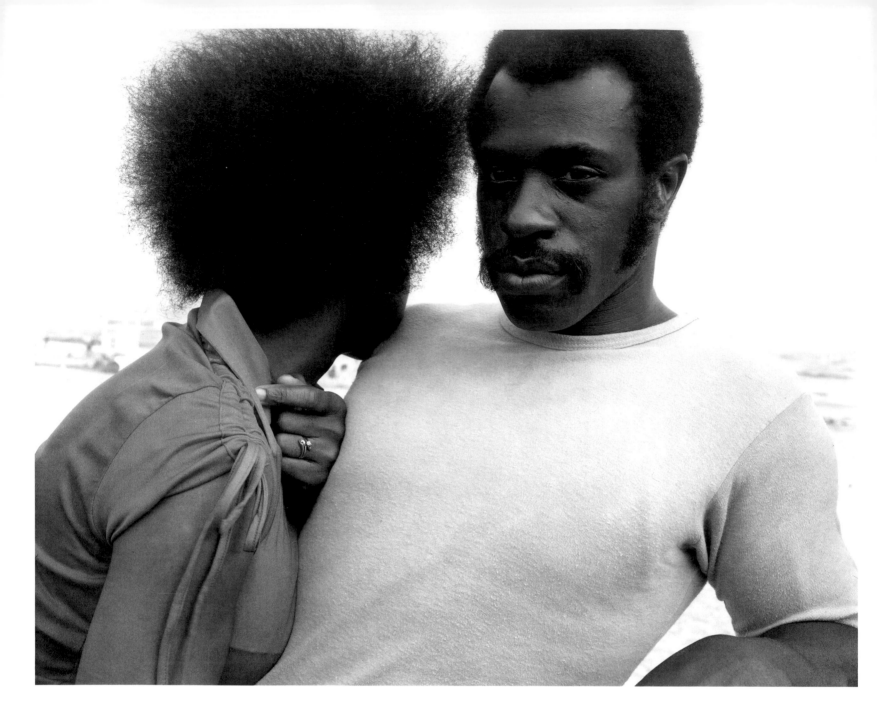

186 Nicholas Nixon *Atlantic City, 1978*

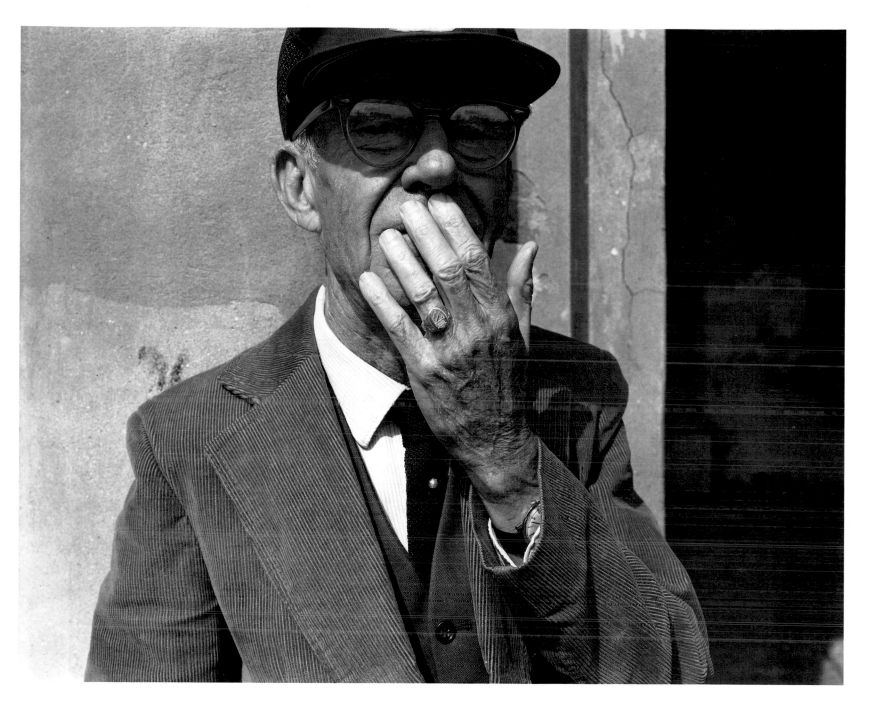

187 Nicholas Nixon *New Orleans, 1978*

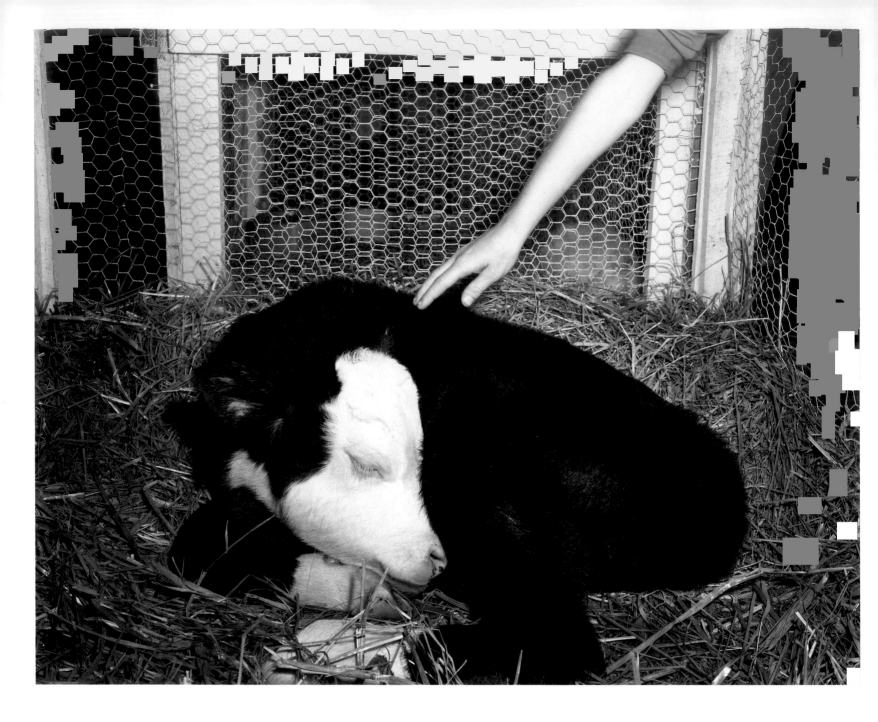

188 Nicholas Nixon *West Springfield, Massachusetts, 1978*

Born in 1947 in Detroit, Michigan; now living in Cambridge, Massachusetts.

Background
University of Michigan, B.A., 1969
University of New Mexico, M.F.A., 1974
National Endowment for the Arts Photographer's Fellowship, 1976
Guggenheim Fellowship, 1977
Assistant Professor, Massachusetts College of Art, 1975 – present

Selected Individual Exhibitions
1976 Museum of Modern Art, New York
1977 Vision Gallery, Boston
1978 Light Gallery, New York

Selected Group Exhibitions
1975 "New Topographics," George Eastman House, Rochester (traveling exhibition)
1976 "Recent Acquisitions," Museum of Modern Art, New York
1977 Worcester Art Museum (Massachusetts) (with Stephen Shore)
 "Contemporary American Photographic Works," Museum of Fine Arts, Houston (traveling exhibition)
1977 "Court House," Museum of Modern Art, New York
1978 "Mirrors and Windows," Museum of Modern Art, New York (traveling exhibition)
 Cronin Gallery, Houston

Collections
Art Institute of Chicago
Fogg Art Museum, Harvard University, Cambridge
International Museum of Photography at George Eastman House, Rochester
Minneapolis Institute of Arts
Museum of Fine Arts, Boston
Museum of Fine Arts, Houston
Museum of Modern Art, New York
Joseph E. Seagram Collection, New York
Worcester Art Museum (Massachusetts)

Tod Papageorge

Without pressing the point, I think that part of what these pictures are about is the difference between our preconceptions of a place and what, when we get there, that place turns out to be. We all carry a picture of Hollywood around in our minds, picked up from the movies and the shreds of scandals we've heard about. And if we're men and under forty, even the best of us treasures an image of the California surfer girl. What I wanted to do on this project was examine those preconceptions and describe what two semi-myths — Hollywood and the life of southern California beaches — really looked like.

To describe a place yet at the same time reinvent it is a double intention on the part of the photographer that we should be used to by now when we look at and think about photographs. It seems to be a contradiction built into interesting pictures, if not the medium of photography itself. With the California pictures, I worked with the belief that the closer I came to describing the literal nature of the place I was photographing, the more surprising the photograph could be. The casual, ramshackle lunacy you can see in southern California changes in these pictures. In the beach photographs particularly, it seems that the rampant sense of adolescent physicality you find along the coast has been transformed into something more charged and sensual.

I'm speaking of what I hope for from the photographs, of course — they may not describe these things at all. But whether I'm right or wrong about these particular pictures, it should go without saying that a good photograph must, in some sense, distinguish what it describes.

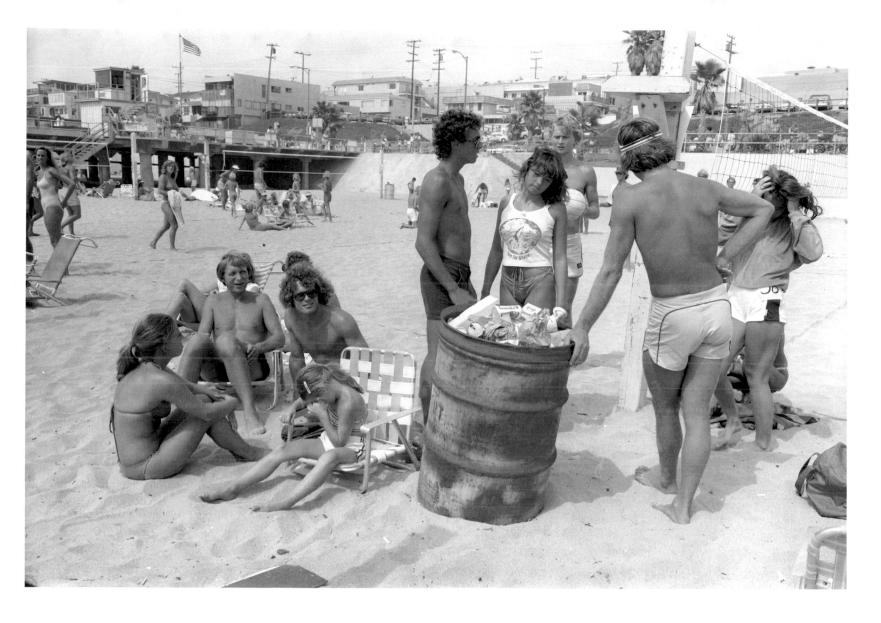

191 Tod Papageorge *Hermosa Beach #7, 1978*

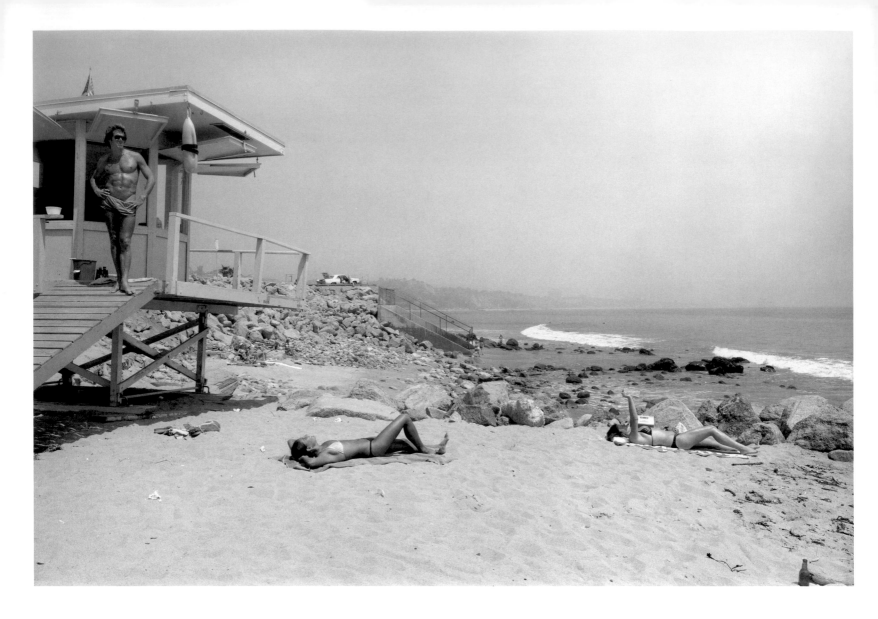

192 Tod Papageorge *Malibu Beach #5, 1978*

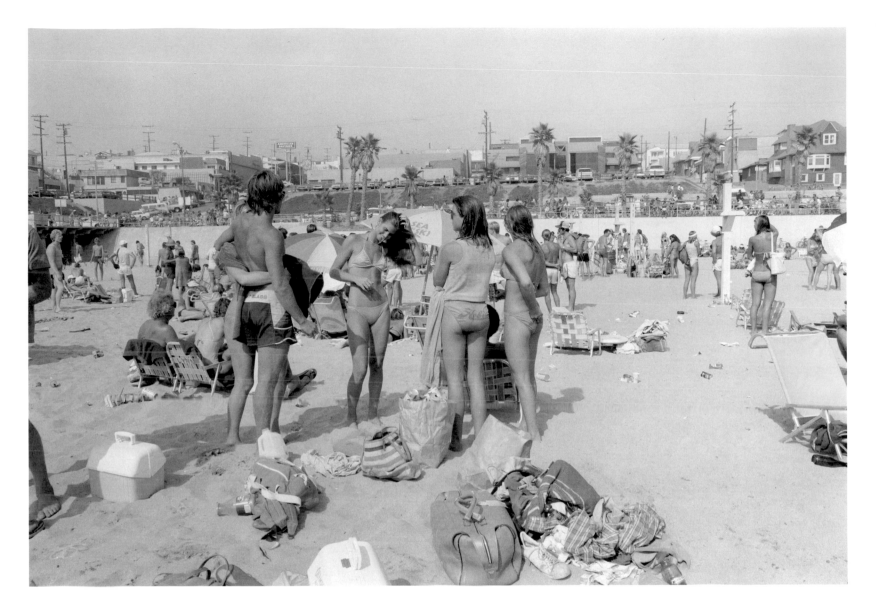

193 Tod Papageorge *Hermosa Beach, 1978*

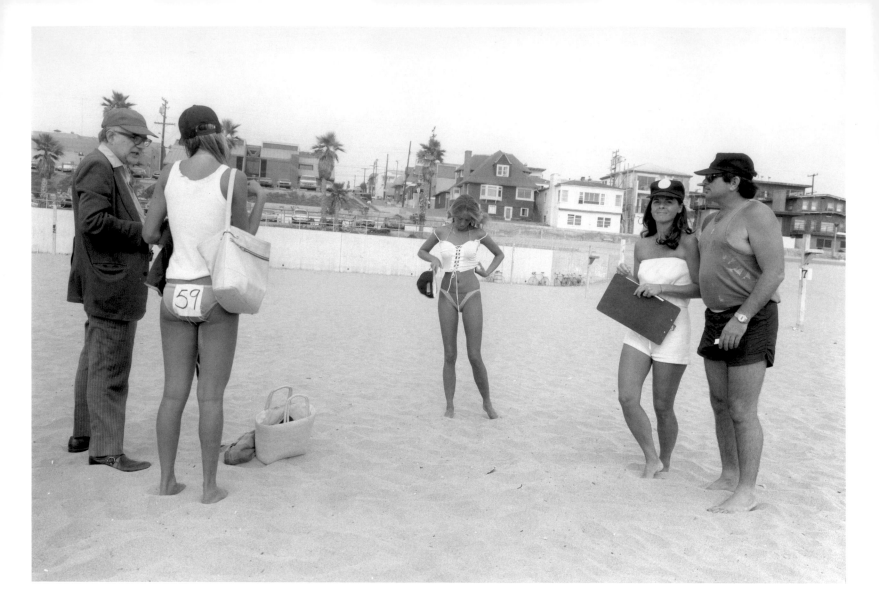

194 Tod Papageorge *Hermosa Beach #6, 1978*

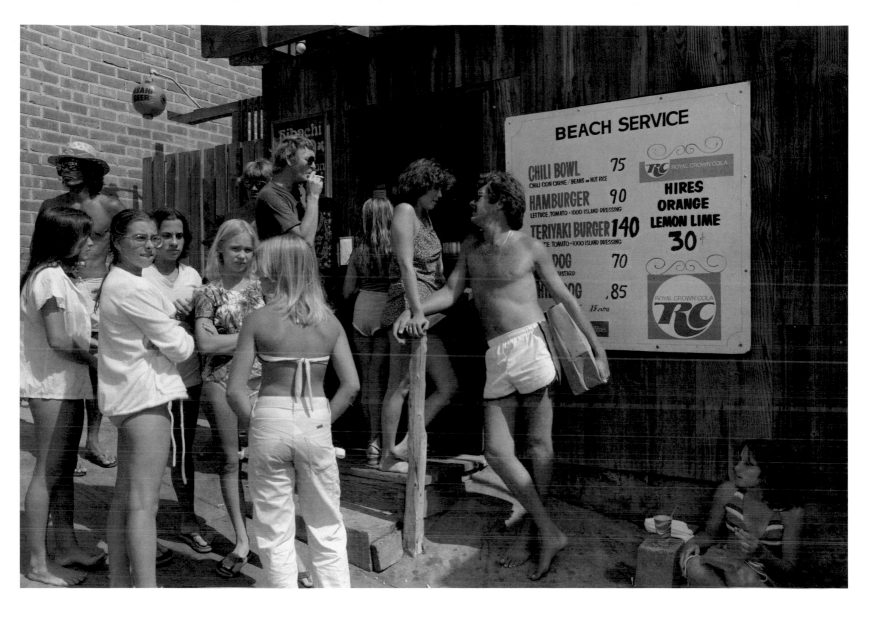

195 Tod Papageorge *Manhattan Beach, 1978*

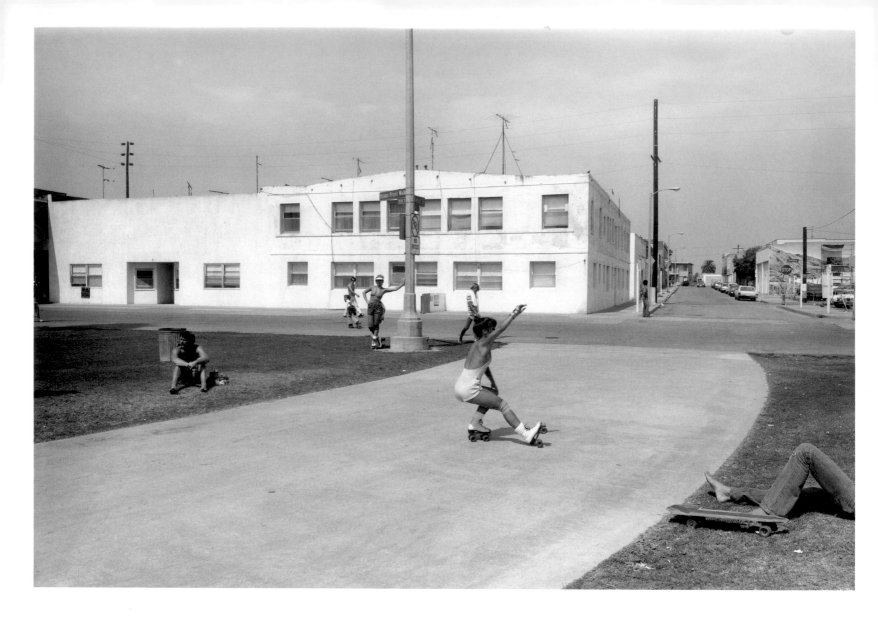

196 Tod Papageorge *Ocean Front Walk, Venice, 1978*

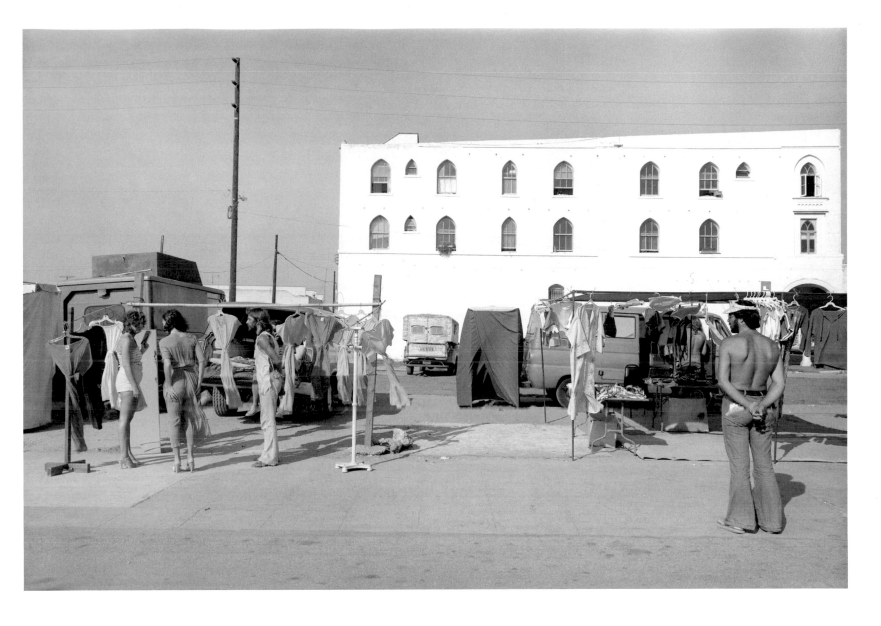

197 Tod Papageorge *Ocean Front Walk, Venice #4, 1978*

198 Tod Papageorge *Downtown Pasadena, 1978*

Born in 1940 in Portsmouth, New Hampshire; now living in New York City.

Background
University of New Hampshire, B.A., 1962
Visiting Instructor in Photography, Parsons School of Design, New York, 1969–1972
Visiting Instructor in Photography, Cooper Union, New York, 1971–1974
Visiting Instructor in Photography, Pratt Institute, New York, 1971–1974
Adjunct Lecturer in Photography, Queens College, New York, 1972–1974
Lecturer on Photography, MIT, 1974–1975
Lecturer on Visual Studies, Harvard University, 1975–1976
Walker Evans Professor of Photography, Yale University, 1978–present
Guggenheim Fellowships, 1970 and 1977
National Endowment for the Arts Photographer's Fellowships, 1973 and 1976

Selected Individual Exhibitions
1973 Light Gallery, New York
1977 Cronin Gallery, Houston
1978 Art Institute of Chicago

Selected Group Exhibitions
1969 "Vision and Expression," George Eastman House, Rochester (traveling exhibition)
1971 "Recent Acquisitions," Museum of Modern Art. New York
1973 "Sharp Focus Realism," Pace Gallery, New York
 "Recent Acquisitions," Museum of Modern Art, New York
1974 "Public Landscapes," Museum of Modern Art, New York
1975 "14 American Photographers," Baltimore Museum (traveling exhibition)

1976 "Contemporary American Photography," Thomas Gibson Fine Arts, Ltd., London
 "American Photography," Edinburgh International Festival
 "One Hundred Master Photographs," Museum of Modern Art, New York (traveling exhibition)
1977 "Court House," Museum of Modern Art, New York
 "10 Photographes Contemporains," Galerie Zabriskie, Paris
 "The Great West," University of Colorado (traveling exhibition)
1978 "Mirrors and Windows," Museum of Modern Art, New York (traveling exhibition)
1979 "American Photography in the '70s," Art Institute of Chicago

Collections
Art Institute of Chicago
Bibliothèque Nationale, Paris
Dallas Museum of Fine Arts
International Museum of Photography at George Eastman House, Rochester
Massachusetts College of Art, Boston
Museum of Fine Arts, Boston
Museum of Fine Arts, Houston
Museum of Modern Art, New York
National Exchange Bank, Chicago
Princeton University
Joseph E. Seagram Collection, New York
University of Colorado, Boulder
Yale University Art Gallery, New Haven

Stephen Shore

Photographing the New York Yankees during spring training was something I had always wanted to do. It's a time when the players relax and enjoy the fun of the game without the pressures of the competitive season, and they're usually more receptive to being photographed. Besides, I like baseball during the day — the way the field and equipment look, the way the sun feels — and I knew I'd really enjoy my subject.

I used my regular 8 x 10 camera, which very few people are used to seeing on a baseball field because it can't really shoot action pictures. But the rituals of the game lend themselves to long exposure, and there are plenty of natural lulls, passages when people are standing perfectly still, moments of great potential energy to document — like after the pitcher has wound up for the pitch, but before he delivers the ball. I wanted to document what spring training looks like from a variety of perspectives, and shooting landscapes and portraits, still lifes, and studies of architecture has changed the way I respond to the game.

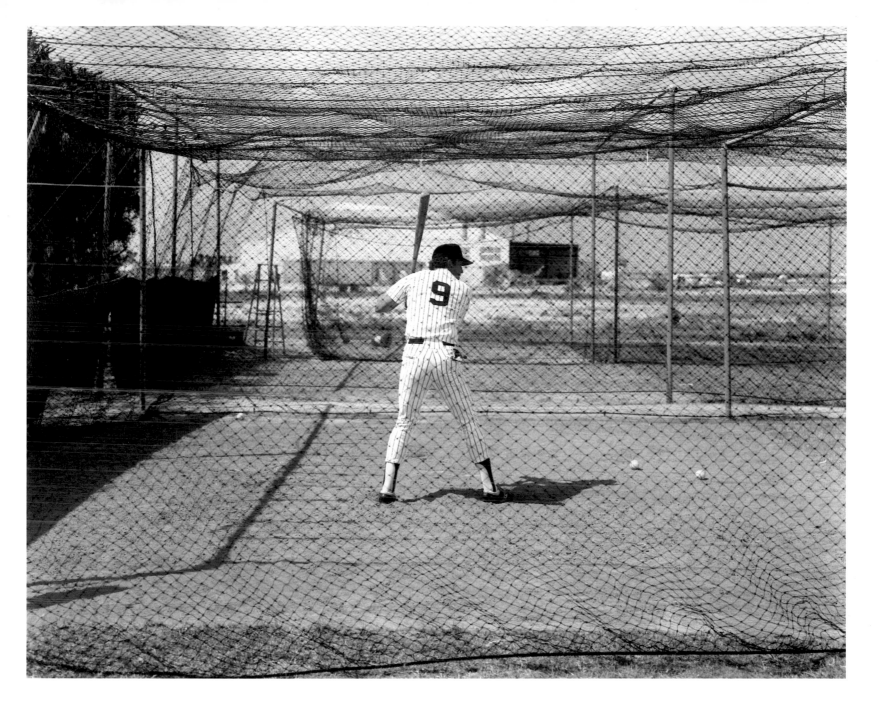

201 Stephen Shore *Graig Nettles, Ft. Lauderdale Yankee Stadium, Ft. Lauderdale, Florida, 1978*

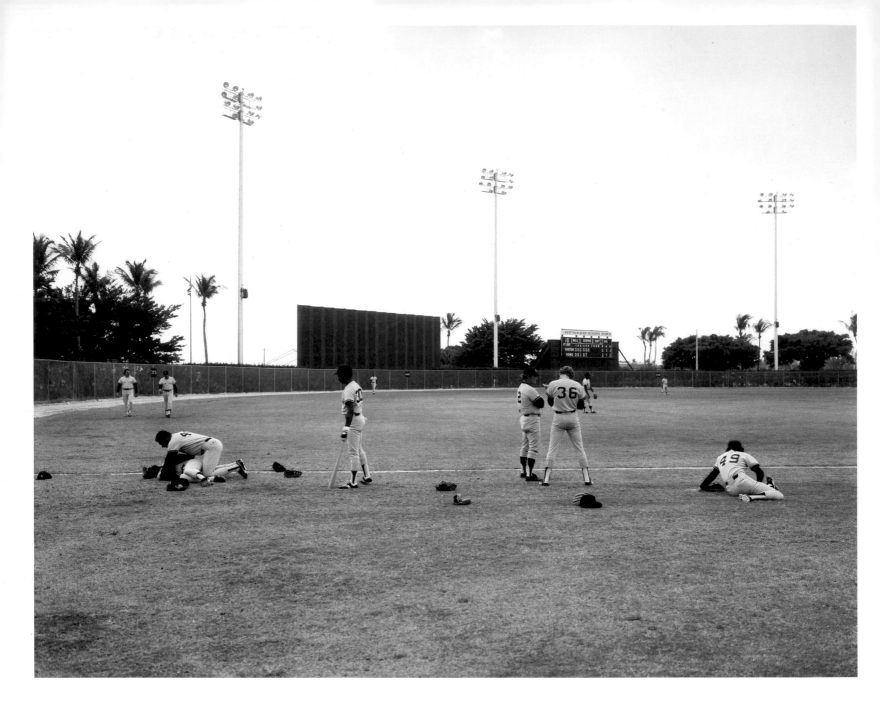

202 Stephen Shore *West Palm Beach Stadium, West Palm Beach, Florida, 1978*

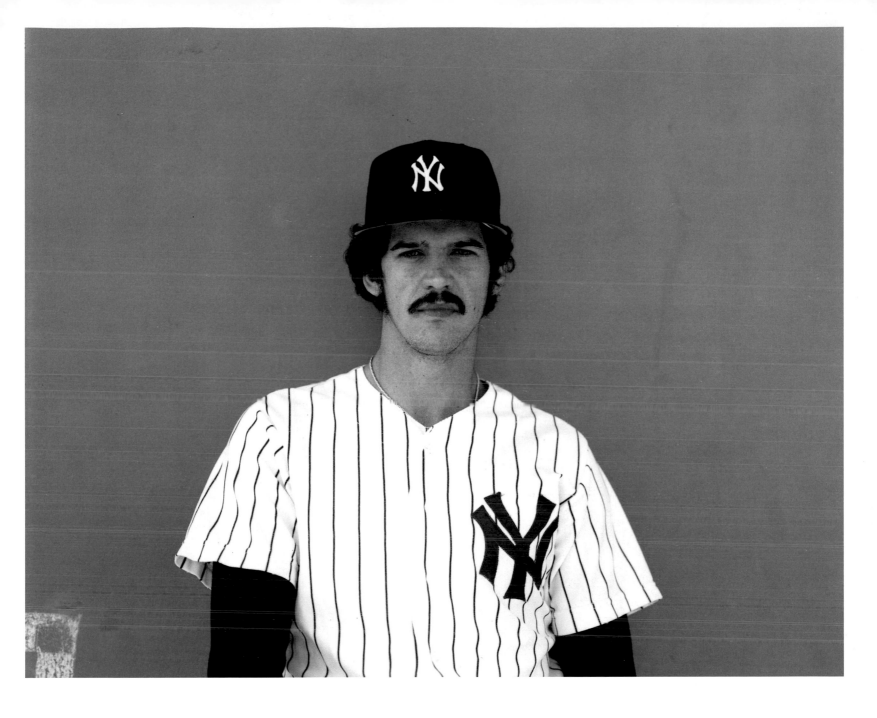

203 Stephen Shore *Ron Guidry, Ft. Lauderdale Yankee Stadium, Ft. Lauderdale, Florida, 1978*

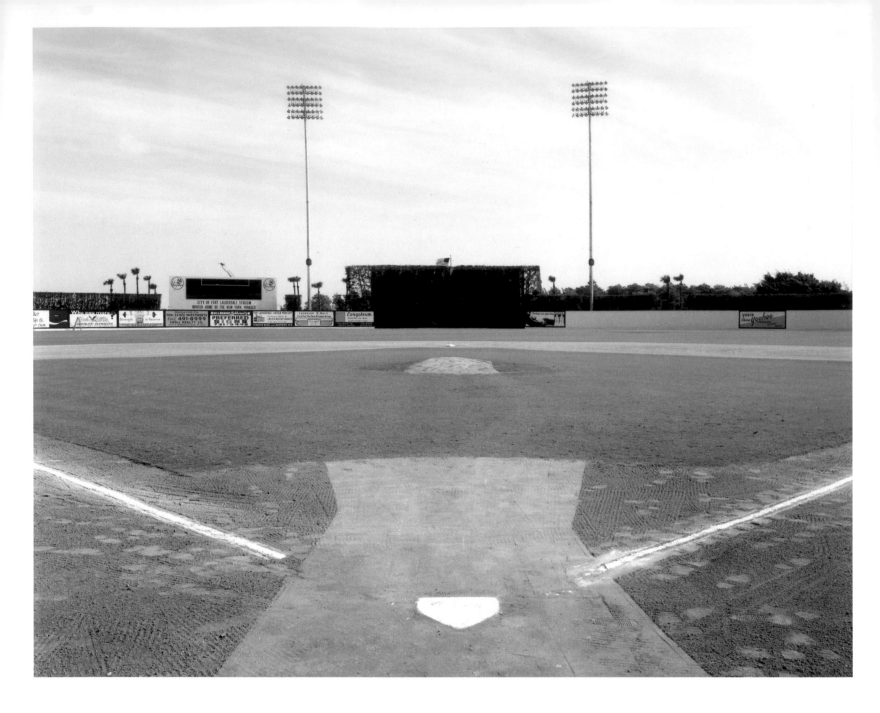

204 Stephen Shore *Ft. Lauderdale Yankee Stadium, Ft. Lauderdale, Florida, 1978*

205 Stephen Shore *Catfish Hunter, Ft. Lauderdale Yankee Stadium, Ft. Lauderdale, Florida, 1978*

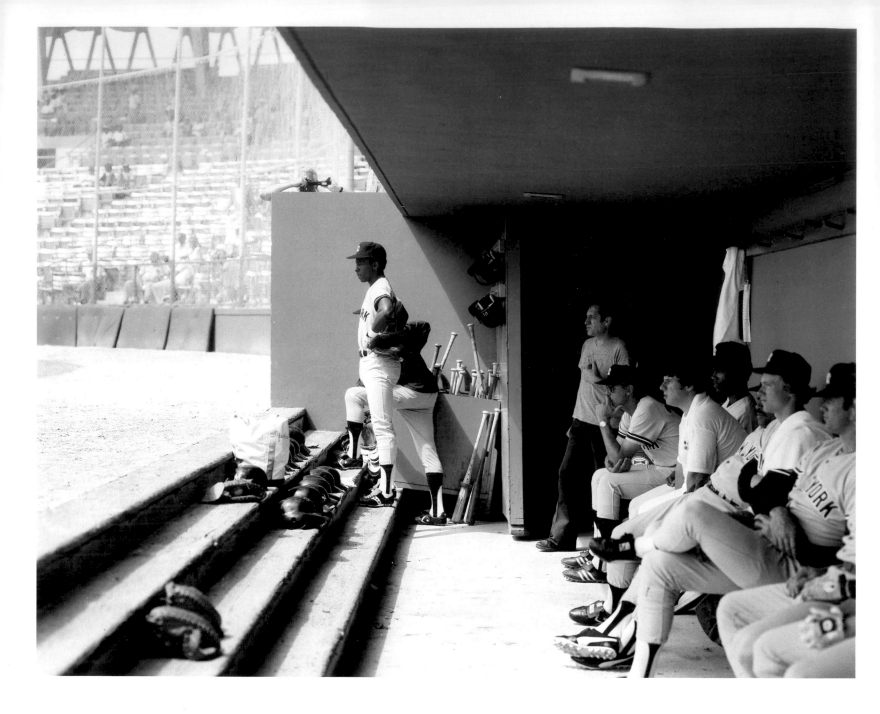

206 Stephen Shore *West Palm Beach Stadium, West Palm Beach, Florida, 1978*

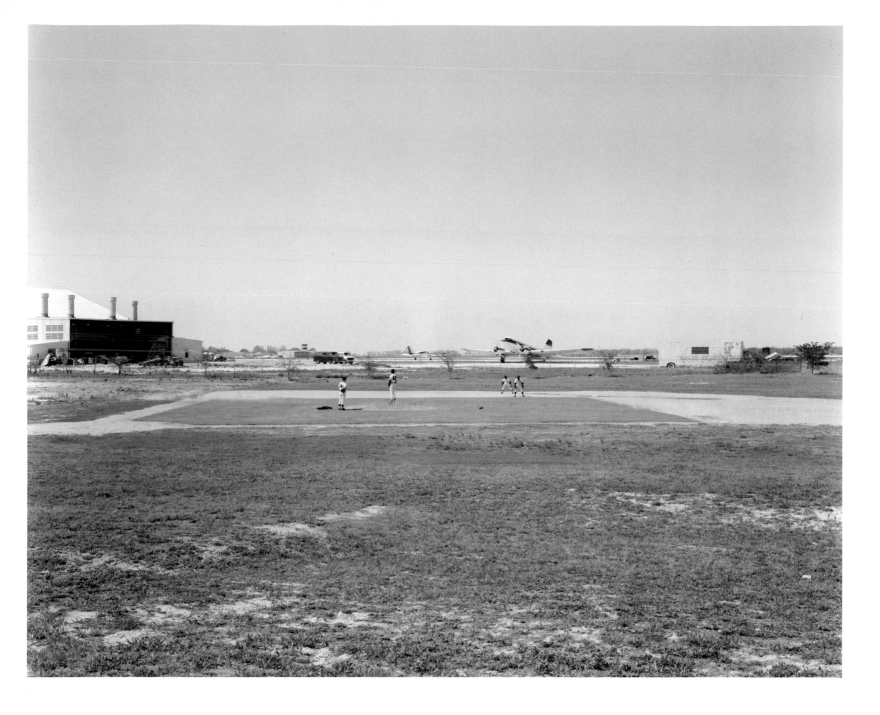

207 Stephen Shore *Ft. Lauderdale Yankee Stadium, Ft. Lauderdale, Florida, 1978*

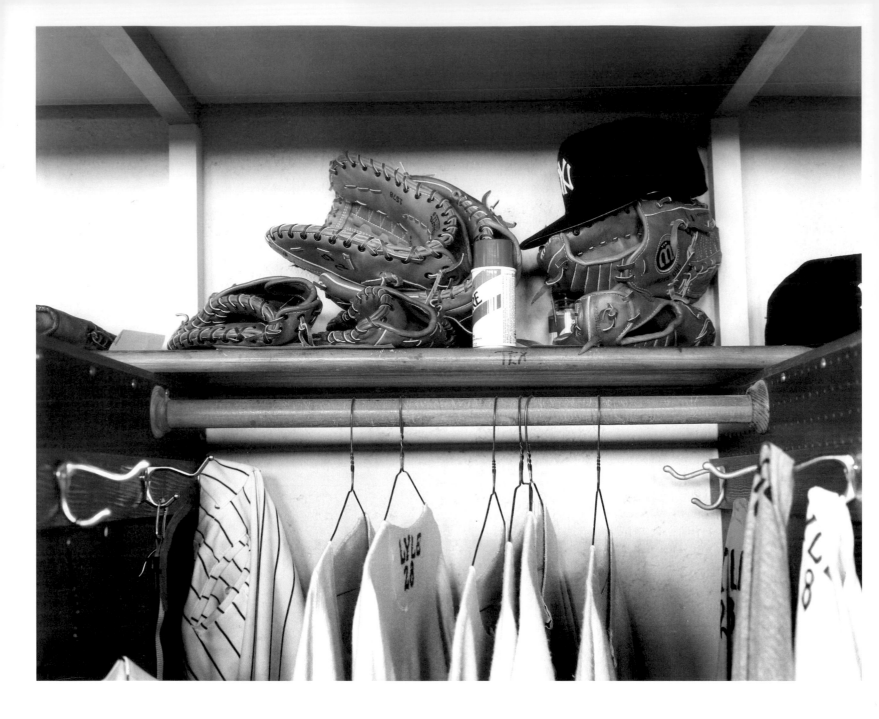

208 Stephen Shore *Sparky Lyle's Locker, Ft. Lauderdale Yankee Stadium, Ft. Lauderdale, Florida*

Born in 1947 in New York City; now living in Berkeley, California.

Background
National Endowment for the Arts Photographer's Fellowship, 1974
Guggenheim Fellowship, 1975

Selected Individual Exhibitions
1971 Metropolitan Museum of Art, New York
1972 Thomas Gibson Fine Arts, Ltd., London
 Light Gallery, New York
1973 Light Gallery, New York
1975 Light Gallery, New York
 Phoenix Gallery, San Francisco
 Galerie Lichttropfen, Aachen (Germany)
1976 Museum of Modern Art, New York
 Renwick Gallery, National Collection of Fine Arts, Washington, D.C.
1977 Light Gallery, New York
 Kunsthalle, Düsseldorf (Germany)
 Galerie Lichttropfen, Aachen (Germany)
 Delahunty Gallery, Dallas
1978 Light Gallery, New York
 Davis Art Gallery, University of Akron (Ohio)
 Galerie Gillespie – de Laage, Paris
 Photogalerie Lange – Irschl, Munich
 Robert Miller Gallery, New York
 Vision Gallery, Boston

Selected Group Exhibitions
1970 "Foto-Portret," Haags Gemeentemuseum, The Hague
1972 "Sequences," Photokina, Cologne

1973 "Landscape/Cityscape," Metropolitan Museum of Art, New York
 Pace Gallery, New York
1974 "New Images in Photography," Lowe Art Museum, University of Miami
1975 "New Topographics," George Eastman House, Rochester (traveling exhibition)
 "Color Photography: Inventors and Innovators, 1850 – 1975," Yale University Art Gallery, New Haven
1976 "100 Master Photographs," Museum of Modern Art (traveling exhibition)
 "Aspects of American Photography 1976," University of Missouri, St. Louis
 "American Photography: Past into Present," Seattle Art Museum
1977 "Court House," Museum of Modern Art, New York
 "Documenta," Kassel (Germany)
 "The Second Generation of Color Photography," Arles Festival (France)
 "Eye of the West," Hayden Gallery, MIT, Cambridge
1978 "Mirrors and Windows," Museum of Modern Art, New York
 "Photography Since 1955," Bologna Arts Fair (Italy)
 "American Landscape Photography," Neue Sammlung, Munich

Collections
Metropolitan Museum of Art, New York
Museum of Fine Arts, Houston
Museum of Modern Art, New York
Princeton University Art Museum
Joseph E. Seagram Collection, New York
Vassar College, Poughkeepsie, New York
Yale University Art Gallery, New Haven

Selected Publications and Articles

Robert Adams

Books

The New West: Landscapes along the Colorado Front Range, by Robert Adams (Introduction by John Szarkowski), Boulder: Colorado Associated University Press, 1974.

14 American Photographers, Renato Danese, ed., Baltimore: Baltimore Museum of Art, 1974.

Photography Year 1977, by Sean Callahan, New York: Time-Life Books, 1976.

Denver: A Photographic Survey of the Metropolitan Area, by Robert Adams, Boulder: Colorado Associated University Press, 1977.

American Landscape Photography, Munich: Neue Sammlung, 1978.

Prairie, Denver: Denver Art Museum, 1978

Mirrors and Windows, by John Szarkowski, New York: Museum of Modern Art, 1978

Articles

Review of *The New West,* by Lewis Baltz, *Art in America,* March–April 1975.

"Route 66 Revisited: The New Landscape Photography," by Carter Ratcliff, *Art in America,* January–February, 1976.

Book review: *Denver* and *The New West,* by Bill Jorden, *Photograph,* July 1977.

"Good News," [untitled], Carmel, Calif.: Friends of Photography, 1978.

"Inhabited Nature," *Aperture,* 1979.

Lewis Baltz

Books

14 American Photographers, Renato Danese, ed., Baltimore: Baltimore Museum of Art, 1974.

The New Industrial Parks Near Irvine, California, by Lewis Baltz, New York: Castelli Graphics Gallery, 1975.

The Photographs of Lewis Baltz 1967–1975, by Janet Kardon, Philadelphia: Philadelphia College of Art, 1975.

New Topographics, Rochester, N.Y.: George Eastman House, 1975.

Photographers' Choice, Kelly Wise, ed., Danbury, N.H.: Addison House, 1975.

Lewis Baltz: Maryland, Washington, D.C.: Corcoran Gallery, 1976.

Photography, John and Barbara Upton, eds., Boston: Little, Brown, 1976.

1977 Biennial Exhibition, New York: Whitney Museum, 1977.

Three Photographic Visions, Arnold Gassan, ed., Athens, Ohio: Ohio University, 1977.

Concerning Photography, Sue Davies, ed., London: Photographers' Gallery, 1977.

Contemporary American Photographic Works, Lewis Baltz, ed., Houston: Museum of Fine Arts, 1977.

Nevada, by Lewis Baltz, New York: Castelli Graphics Gallery, 1978.

23 Photographers—23 Directions, Liverpool (England): Walker Art Gallery, 1978.

Court House, Richard Pare, ed., New York: Horizon Press, 1978.

Mirrors and Windows, by John Szarkowski, New York: Museum of Modern Art, 1978.

Articles

"Los Angeles," by Peter Plagens, *Artforum,* October 1971.

"Notes on Recent Industrial Developments in Southern California," by Lewis Baltz and William Jenkins, *Image,* June 1974.

Review of "The New West," by Lewis Baltz, *Art in America,* March–April 1975.

"Art: What's in the Galleries," by Douglas Davis, *Newsweek,* December 8, 1975.

"Route 66 Revisited," by Carter Ratcliff, *Art in America,* January–February 1976.

"Sweeping up America," by Douglas Davis, *Newsweek,* July 12, 1976.

"The Anti-Photographers," by Nancy Foote, *Artforum,* September 1976.

"Lewis Baltz's Formalism," by Joan Murray, *Artweek,* August 27, 1977.

"The New American Photography," by Hilton Kramer, *New York Times Magazine,* June 23, 1978.

"Lewis Baltz's Nevada," by Mark Johnstone, *Artweek,* October 14, 1978.

"Photography Now," by Colin L. Westerbeck, Jr., *Artforum,* January 1979.

Harry Callahan

Books and Portfolios

Photographs: Harry Callahan (essay by Hugo Weber), Santa Barbara, Calif.: Van Riper and Thompson, 1964.

Harry Callahan (essay by Sherman Paul), New York: Museum of Modern Art, 1967.

Landscapes, 1941–1971 (portfolio of 10 original photographs in edition of 25), New York: Light Gallery, 1972.

Callahan, John Szarkowski, ed., Millerton, N.Y.: Aperture, 1976.

Articles

"In and Out of Focus," by Edward Steichen, *U.S. Camera 1949* (New York), 1948.

"Four Photographers," *U.S. Camera,* February 1949.

"The New Selective Lens," by Edward Steichen, *Art News,* September 1950.

"Harry Callahan: A Note," by Robert Creeley, *Black Mountain Review,* Autumn 1957.

"The Photographs of Harry Callahan," by Minor White, *Aperture,* 1958.

"Photographs: Harry Callahan," by Margery Mann, *Artforum,* September 1964.

"Double Exposure," by Margaret R. Weiss, *Saturday Review,* September 26, 1964.

"Harry Callahan," by Alan D. Coleman, *New York Times,* December 31, 1972.

"Harry Callahan Exhibition at Light Gallery," by Lizzie Borden, *Artforum,* February 1973.

"Harry Callahan Exhibition at Light Gallery, New York," by Sanford Schwartz, *Art International,* March 1975.

"Harry Callahan," *Special Report,* Tucson: Center for Creative Photography, University of Arizona, 1976.

"Harry Callahan," by Gene Thornton, *Art News,* November 1976.

"The Quiet Master of Light," by Douglas Davis, *Newsweek,* December 13, 1976.

"Harry Callahan, Shadow Stalker," by Shelley Rice, *Village Voice*, January 17, 1977.

"Harry Callahan," by R. Hellman and M. Hoshino, *Arts*, February 1977.

"Callahan," by David Herwaldt, *New Boston Review*, Spring 1977.

"Reconsideration," by Shelley Rice, *New Republic*, October 29, 1977.

"Harry Callahan's Detente with Experience," by Leo Rubinfien, *Village Voice*, April 10, 1978.

William Clift

Books and Portfolios

Old Boston City Hall, 108 original photographs in an edition of 12, published by the artist, 1971.

New Mexico, 8 original photographs in an edition of 100, published by the artist, 1975.

Beacon Hill: A Walking Tour (text by A. McVoy McIntyre), Boston: Little, Brown, 1975.

The Great West: Real/Ideal, Boulder: University of Colorado Department of Fine Arts, 1977.

Court House, Richard Pare, ed., New York: Horizon Press, 1978.

Mirrors and Windows, by John Szarkowski, New York: Museum of Modern Art, 1978.

A Court House Portfolio, 6 original photographs in an edition of 50, published by the artist, 1979.

Linda Connor

Books and Portfolios

Vision and Expression, Rochester, N.Y.: George Eastman House, 1969.

12 x 12, Providence: Rhode Island School of Design, 1970.

California Photographers, Davis, Calif.: University of California, 1970.

Be-ing without Clothes, Millerton, N.Y.: Aperture, 1970.

The Multiple Image, Cambridge: Massachusetts Institute of Technology, 1972.

Light and Lens, Dobbs Ferry, N.Y.: Morgan & Morgan, 1973.

Light and Substance, Albuquerque: University of New Mexico, 1974.

Private Realities, by Clifford S. Ackley, Boston: Museum of Fine Arts, 1974.

14 American Photographers, Renato Danese, ed., Baltimore: Baltimore Museum of Art, 1974.

Apeiron Portfolio No. 1, Millerton, N.Y., 1974.

Women See Women, New York: Thomas Y. Crowell, 1976.

Under Wear (portfolio), Chicago: Chicago Art Institute, 1976.

Photography Invitational, Louisville: J.B. Speed Art Museum, 1976.

8 x 10, Ten American Photographers, Dallas: Museum of Fine Arts, 1976.

The Less than Sharp Show, Howard Kaplan, ed., Chicago: Columbia College, 1977.

Darkroom, Eleanor Lewis, ed., Rochester: Lustrum Press, 1977.

The Great West, Hume, Manchester, Metz, eds., Boulder: University of Colorado, 1977.

40 American Photographers, Harvey Himmelfarb, ed., Sacramento, Calif.: Crocker Art Gallery, 1978.

Mirrors and Windows, by John Szarkowski, New York: Museum of Modern Art, 1978.

Bevan Davies

Books

Contemporary American Photographic Works, Lewis Baltz, ed., Houston: Museum of Fine Arts, 1977.

Articles

"Scenes," by Fred McDarragh, *Village Voice*, March 8, 1976.

"Two Photographic Visions," by Robert Woolard, *Artweek*, March 30, 1976.

"Reviews: New York," by Michael Sgan-Cohen, *Art in America*, November 1976.

Roy DeCarava

Books

Popular Photography Annual (New York), 1953.

U.S. Camera Annual (New York), 1953.

The Family of Man, New York: Simon & Schuster, 1955.

The Sweet Flypaper of Life, by Roy DeCarava and Langston Hughes (first published in 1955), New York: Hill & Wang, 1968.

The Movement, by Lorraine Hansberry, New York: Simon & Schuster, 1964.

The Photographer's Eye, New York: Museum of Modern Art, 1966.

The John Simon Guggenheim Memorial Fellows in Photography, Philadelphia: Philadelphia College of Art, 1966.

Photography in the Twentieth Century, New York: Horizon Press, 1967.

Roy DeCarava, Photographer, by Jim Alinder, Lincoln, Neb.: University of Nebraska Press, 1970.

Seventeen Black Artists, by Elton Fax, New York: Dodd, Mead, 1973.

Looking at Photographs, New York: Museum of Modern Art, 1973.

Black Photographers Annual, New York (3 volumes), 1973, 1974, and 1975.

Photography in America, by Robert Doty, New York: Random House, 1974.

Roy DeCarava: Photographs, by Alvia Wardlaw Short, Houston: Museum of Fine Arts, 1975.

Roy DeCarava, The Nation's Capital in Photographs, Washington, D.C.: Corcoran Gallery, 1976.

Articles

Review of "The Sweet Flypaper of Life," by Jacob Deschin, *New York Times*, March 21, 1955.

Review of "The Sweet Flypaper of Life," by Alan Lomax, *New York Herald Tribune*, November 11, 1955.

Review of "The Sweet Flypaper of Life," by Minor White, *Image*, December 1955.

"Pictures and Words," by Jacob Deschin, *New York Times*, December 15, 1955.

Review of "Through Black Eyes," by A.D. Coleman, *Village Voice*, October 2, 1969.

"Roy DeCarava: Through Black Eyes," by A.D. Coleman, *Popular Photography*, April 1970.

"Roy DeCarava," by Jim Alinder, *Creative Camera* (London), March 1972.

Review by A.D. Coleman, *New York Times*, July 2, 1972.

"Roy De Carava: Master Photographer," by Ray Gibson, *Black Creations* (New York University: Afro-American Institute), Fall 1972.

"Roy DeCarava/Port Washington Public Library," by David Shirey, *New York Times* (Long Island edition), March 5, 1978.

William Eggleston

Books and Portfolios

14 Pictures, Washington, D.C.: Graphics International, Ltd., 1974.

14 American Photographers, Renato Danese, ed., Baltimore: Baltimore Museum of Art, 1974.

William Eggleston's Guide (essay by John Szarkowski), New York: Museum of Modern Art, 1976.

Election Eve (100 type-c photographs), New York: Caldecot Chubb, 1977.

Mirrors and Windows, by John Szarkowski, New York: Museum of Modern Art, 1978.

American Landscape Photography, Munich: Neue Sammlung, 1978.

Articles

"Photography — A Different Kind of Art," by John Szarkowski, *New York Times Sunday Magazine*, April 13, 1975.

"New Frontiers in Color," by Douglas Davis, *Newsweek*, April 19, 1976.

"Art: Focus on Photo Shows," by Hilton Kramer, *New York Times*, May 28, 1976.

"Photographed Silence," by Malcolm Preston, *Newsday*, June 10, 1976.

"MOMA Lowers the Color Bar," by Sean Callahan, *New York*, June 28, 1976.

"Eggleston at MOMA," by Bill Jorden, *Photograph,* Summer 1976.
"Reviews: Color Me MOMA," by Dan Meinwald, *Afterimage,* September 1976.
"The Colors of William Eggleston," by Joan Murray, *Artweek,* September 18, 1976.
"MOMA Shows Her Colors," by Michael Edelson, *Camera,* October 1976.
"How to Mystify Color Photography," by Max Kozloff, *Artforum,* November 1976.
"The Second Generation of Color Photographers," by Allan Porter, *Camera,* July 1977.
"A Paradox in Color Photos," by Benjamin Forgey, *Washington Star,* September 21, 1977.
"Photography: Color," by Janet Malcolm, *New Yorker,* October 10, 1977.

Elliott Erwitt

Books

Photographs and Anti-Photographs, Greenwich, Conn.: New York Graphic Society, 1972
Observations on American Architecture, by Ivan Chermayeff, New York: Viking Press, 1972
Son of Bitch, New York: Grossman Publishers, 1974
Recent Developments, New York: Simon & Schuster, 1978

Larry Fink

Books

Un Printemps à New York, with Marc Albert Levin, Paris: Pauvert, 1969.
Tour de Force, with Marc Albert Levin, Paris: Pauvert, 1969.

Articles

Review by Carl Belz in *Boston Review of the Arts,* January 1973.
"Photography: United States," by Roberto Salbatini, *Progresso Fotografico* (Milan), 1977.
"Northampton Photographs," by Ricardo Viera, *Forms* (Lehigh University), 1978.

Frank Gohlke

Books

A Chronology of Photography, by Arnold Gassan, Athens, Ohio: Ohio University, 1972.
Photographers: Midwest Invitational, Minneapolis: Walker Art Center, 1973.
Light and Substance, Albuquerque: University of New Mexico, 1974.
New Topographics, Rochester, N.Y.: George Eastman House, 1975.
Photographs, by Ben Lifson, El Cajon, Calif.: Grossmont College, 1977.
Court House, Richard Pare, ed., New York: Horizon Press, 1978.
Mirrors and Windows, by John Szarkowski, New York: Museum of Modern Art, 1978.
American Landscape Photography, Munich: Neue Sammlung, 1978.

Articles

"Latent Image," by A.D. Coleman, *Village Voice,* October 28, 1971.
"Report from the Provinces," by Stephen West, *Village Voice,* February 10, 1975.
"Route 66 Revisited," by Carter Ratcliff, *Art in America,* January – February 1976.

John Gossage

Books and Portfolios

14 American Photographers, Renato Danese, ed., Baltimore: Baltimore Museum of Art, 1974
Better Neighborhoods of Greater Washington, by Jane Livingston, Washington, D.C.: Corcoran Gallery, 1976

Contemporary American Photographic Works, Lewis Baltz, ed., Houston: Museum of Fine Arts, 1977
23 Photographers – 23 Directions, Liverpool (England): Walker Art Gallery, 1978
Gardens (text by Walter Hopps), New York: Castelli Graphics, 1978

Articles

"Some People I Want to Remember," *Creative Camera,* February 1973.
"Four Photographs of John Gossage," *Georgia Review,* Durham, N.C.: Duke University Press, Winter 1975.
"On Exhibition: The Development of Photography in America," by Mark Power, *Washington Post,* February 8, 1975.
"14 American Photographers," *Afterimage,* March 1975.
"Review: New York," by Phil Patton, *Artforum,* April 1976
"Opposites Attract at an M Street Gallery," by Benjamin Forgey, *Washington Star,* April 25, 1976.
"Portraits Depict Paris of the 20s," by Alan Cohen, *Washington Star,* May 6, 1976.
"This Is Photography," *Christian Science Monitor,* January 3, 1977.
"Gardens Review," by Noel Frackman, *Arts,* May 1978.
"Art in Washington," *Art in America,* July – August 1978.

Jonathan Green

Books

Camera Work: A Critical Anthology, Jonathan Green, ed., Millerton, N.Y.: *Aperture,* 1973.
Celebrations, Minor White and Jonathan Green, eds., Millerton, N.Y.: *Aperture,* 1974.
The Snapshot, Jonathan Green, ed., Millerton, N.Y.: *Aperture,* 1974.

Articles

Review by Grace Mayer, *Afterimage,* March 1974.
Review by Hilton Kramer, *New York Times,* March 1, 1974.
Review by Hilton Kramer, *New York Times Book Review,* April 21, 1974.
Review by Douglas Davis, *Newsweek,* April 29, 1974.
Review by Sanford Schwartz, *New York Times Book Review,* December 1, 1974.
Review by Charles Desmarais, *Afterimage,* February 1975.
Review by Dru Shipman, *Exposure,* February 1975.
Review by Ian Jeffrey, *Photographic Journal of the Royal Photographic Society,* June 1975.
Review by Margaret Weiss, *Saturday Review,* April 5, 1975.

Jan Groover

Books

Photographers' Choice, Kelly Wise, ed., Danbury, N.H.: Addison House, 1975.
Mirrors and Windows, by John Szarkowski, New York: Museum of Modern Art, 1978.

Articles

"The Medium Is the Use," *Artforum,* November 1973.
"Not Good Ain't Necessarily Bad," by David Bourdon, *Village Voice,* December 8, 1975.
"(Drawing Now), One of the Modern's Best," by John Russell, *New York Times,* January 24, 1976.
"Photos within Photographs," by Max Kozloff, *Artforum,* February 1976.
"Entries," by Robert Pincus-Witten, *Arts,* March 1976.
"Jan Groover," by Phil Patton, *Artforum,* April 1976.
"Opposites Attract at an M Street Gallery," by Benjamin Forgey, *Washington Star,* April 25, 1976.
"Uses and Misuses of Sequential Images," by Robert Woolard, *Artweek,* May 22, 1976.

Mary Ellen Mark

Books

Vision and Expression, Nathan Lyons, ed., New York: Horizon Press, 1969.
The Photojournalist: Two Women Explore the Modern World and the Emotions of Individuals (with Anne Liebovitz), New York: Thomas Y. Crowell, 1974.
Passport, Rochester: Lustrum Press, 1974.
Ward 81 (with Karen Folger Jacobs), New York: Simon & Schuster, 1978.

Joel Meyerowitz

Books

Contemporary Photographers, Nathan Lyons, ed., New York: Horizon Press, 1967.
New American Photography, Nathan Lyons, ed., New York: Horizon Press, 1969.
Structures II, Philadelphia: University of Pennsylvania, 1970.
The City—American Experience, Peter Bunnell, ed., Oxford, University Press, 1971.
Looking at Photographs, by John Szarkowski, New York: Museum of Modern Art, 1973.
The Snapshot, Millerton, N.Y.: *Aperture*, 1974.
Calendar: *On Time*, New York: Museum of Modern Art, 1975.
Faces—A History of the Portrait, by Ben Maddow, Greenwich, Conn.: New York Graphic Society, 1977.
Mirrors and Windows, by John Szarkowski, New York: Museum of Modern Art, 1978.
Cape Light, Boston: New York Graphic Society, 1978.

Articles

Essay by Max Kozloff, *Artforum*, January 1975.
"New Frontiers in Color," by Douglas Davis, *Newsweek*, April 19, 1976.
"100 Years of Color," *Modern Photography*, December 1976.
"Chartreuse Light in a Phone Booth," by Pamela Allara, *Art News*, February 1979.

Richard Misrach

Books

Telegraph 3 A.M., Berkeley, Calif.: Cornucopia Press, 1974.
Young American Photographers, Kalamazoo: Kalamazoo Institute of Arts, 1975.
Popular Photography Annual, 1977.
Mirrors and Windows, by John Szarkowski, New York: Museum of Modern Art, 1978.
Photographic book on the desert [untitled], San Francisco: Grapestake Gallery, 1979.

Articles

"Contemporary American Photography," *Aura* (Andromeda Gallery, Buffalo, N.Y.), 1976.
"The Photographer and the Drawing," *Creative Camera*, August 1977.
"An Interview with Richard Misrach," by Sam Samore, *Bombay Duck*, 1978.
Review in *Outside* (a Rolling Stone publication), January 1978.
"Twenty Years of American Photography," *Horizon*, September 1978.
"Eyes of the West," *New West*, November 1978.
"Reflections on Mirrors and Windows," by Leo Rubinfien, *Art in America*, January 1979.

Nicholas Nixon

Books

New Topographics, Rochester, N.Y.: George Eastman House, 1975.
Photography Year: 1977, New York: Time-Life Books, 1977.
American Photographic Works, Lewis Baltz, ed., Houston: Museum of Fine Arts, 1977.

Court House, Richard Pare, ed., New York: Horizon Press, 1978.
Mirrors and Windows, by John Szarkowski, New York: Museum of Modern Art, 1978.

Tod Papageorge

Books

On Snapshots and Photography: The Snapshot, Millerton, N.Y.: *Aperture*, 1974.
14 American Photographers, Renato Danese, ed., Baltimore: Baltimore Museum of Art, 1974.
The Snapshot, Millerton, N.Y.: *Aperture*, 1975.
Public Relations, The Photographs of Garry Winogrand, Tod Papageorge, ed., New York: Museum of Modern Art, 1977.
Court House, Richard Pare, ed., New York: Horizon Press, 1978.
Mirrors and Windows, by John Szarkowski, New York: Museum of Modern Art, 1978.

Articles

"Winogrand's Theater of Quick Takes," *New York Times Sunday Magazine*, October 15, 1977.
"Photographic Tapestry," by David Elliott, *Chicago Daily News*, February 9, 1978.
"Love-Hate Relations," by Leo Rubinfien, *Artforum*, Summer 1978.

Stephen Shore

Books

Andy Warhol, Stockholm: Moderna Museet, 1968.
The City, Peter Bunnell, ed., New York: Oxford University Press, 1971.
New Topographics, Rochester, N.Y.: George Eastman House, 1975.
Aspects of American Photography 1976, St. Louis: University of Missouri, 1976.
Invitational Exhibition, Louisville, Ky.: J.B. Speed Art Museum, 1976.
Twelve Photographs, New York: Metropolitan Museum of Art, 1976.
Photography Year/1977, New York: Time-Life Books, 1977.
The Great West: Real/Ideal, Boulder: University of Colorado, 1977.
Court House, Richard Pare, ed., New York: Horizon Press, 1978.
23 Photographers—23 Directions, Liverpool (England): Walker Art Gallery, 1978.
American Landscape Photography 1860–1978, Munich: Neue Sammlung, 1978.
Mirrors and Windows, by John Szarkowski, New York: Museum of Modern Art, 1978.
Stephen Shore, Tokyo: *Camera Mainichi*, 1978.

Articles

"The Coming Age of Color Photography," by Max Kozloff, *Artforum*, January 1975.
"Route 66 Revisited," by Carter Ratcliff, *Art in America*, January–February 1976.
"The Ten Toughest Photographs of 1975," by Douglas Davis, *Esquire*, February 1976.
"New Frontiers in Color," by Douglas Davis and Mary Rourke, *Newsweek*, April 19, 1976.
"Signs of Life: Symbols in the American City," *Aperture* 77, 1976.
"The New Photography: Turning Traditional Standards Upside Down," by Gene Thornton, *Art News*, April 1978.
"Currents—American Photography Today," by Andy Grundberg and Julia Scully, *Modern Photography*, September 1978.
"Color Photography: The Walker Evans Legacy and the Commercial Tradition," by Carol Squiers, *Artforum*, November 1978.
"The Framing of Stephen Shore," by Tony Hiss, *American Photographer*, February 1979.

List of Titles

Robert Adams

1. *Green River, Wyoming, 1977*
2. *Fort Steele, Wyoming, 1977*
3. *Near Willard, Utah, 1978*
4. *Alkali Lake, Albany County, Wyoming, 1977*
5. *Below Mt. Garfield, Mesa County, Colorado, 1977*
6. *East of Eden, Colorado, 1977*
7. *Clear Creek Canyon, Jefferson County, Colorado, 1977*
8. *Near Lyons, Colorado, 1977*
9. *Arkansas River Canyon, Fremont County, Colorado, 1977*
10. *West of Canon City, Colorado, 1977*
11. *Mesa County, Colorado, 1977*
12. *Garden of the Gods, El Paso County, Colorado, 1977*
13. *Garfield County, Colorado, 1977*
14. *Grand Mesa and the edge of Grand Junction, Colorado, 1977*
15. *North Table Mountain, Jefferson County, Colorado, 1977*

Lewis Baltz

16. *Park Meadows, Subdivision #5, looking West, 1978*
17. *Lot #123, Prospector Park, Subdivision Phase 3, looking Northwest, 1978*
18. *Lot #105, Prospector Village, looking North, 1978*
19. *Lot #65, Park Meadows, Subdivision #2, looking East, 1978*
20. *Lot #81, Prospector Village, looking Southeast, 1978*
21. *Between Sidewinder Road and State Highway 248, looking North, 1978*
22. *Snowflower Condominiums during construction, looking West, 1978*
23. *Snowflower Condominiums during construction, looking East, 1978*
24. *Lot #7, Prospector Park, Subdivision Phase 1, looking Northwest, 1978*
25. *Lot #111, Prospector Village, looking Northwest toward Little Bessie Avenue, 1978*
26. *Between Sidewinder Road and State Highway 248, looking North, 1978*
27. *Parcel #102, Prospector Village, looking West, 1978*
28. *Tumbleweed and Greenhorn ski slopes, Parkwest, looking Southeast, 1978*
29. *Interstate 80, 1½ miles south of Junction with State Highway 224, looking North, 1978*
30. *State Highway 248, 1/10 mile east of Buffalo Bill Drive, looking North, 1978*

Harry Callahan

31. through 45. all *Untitled, 1978*

William Clift

46. *Rainbow, Waldo, New Mexico, 1978*
47. *View toward Cerro Seguro, 1978*
48. *La Mesita from Cerro Seguro, 1978*
49. *Ghost Ranch, 1978*
50. *End, Santa Fe River Gorge, 1978*
51. *From La Bajada Mesa toward the Ortiz Mountains, 1978*
52. *Santa Fe River Gorge from Cerro Seguro, 1978*
53. *Fence, Tetilla Peak, 1978*
54. *Santa Fe River Gorge and Tetilla Peak, 1978*
55. *Snow, Santa Fe River Gorge from Tetilla Peak, 1978*
56. *Santa Fe Canyon Wall from La Mesita, 1978*
57. *Sunlit Hills, La Cienega, 1978*
58. *Cerillos Hills, 1978*
59. *New Road to Cochiti, 1978*
60. *Snow, Santa Fe River Canyon from Cerro Seguro, 1978*

Linda Connor

61. *Petroglyphs, Hawaii, 1978*
62. *Pond, Connecticut, 1978*
63. *Volcano, Hawaii, 1978*
64. *Waterfall, Maui, Hawaii, 1978*
65. *Blue Ridge Mountains, 1978*
66. *Petroglyphs, Bishop, California, 1978*
67. *Petroglyphs, Bishop, California, 1978*
68. *Spiral Petroglyph, Canyon de Chelly, Arizona, 1978*
69. *Offering, Oahu, Hawaii, 1978*
70. *Canyon floor, Canyon de Chelly, Arizona, 1978*
71. *Rock formations, Utah, 1976*
72. *Trees, Connecticut, 1978*
73. *Seven Sacred Pools, Maui, Hawaii, 1978*
74. *Petroglyphs, Canyon de Chelly, Arizona, 1978*
75. *Woods, Belmont, Massachusetts, 1978*

Bevan Davies

76. *Washington, D.C., 1978*
77. *Washington, D.C., 1978*
78. *Washington, D.C., 1978*
79. *Washington, D.C., 1978*
80. *Washington, D.C., 1978*
81. *Baltimore, Maryland, 1978*
82. *Baltimore, Maryland, 1978*
83. *Baltimore, Maryland, 1978*
84. *Baltimore, Maryland, 1978*
85. *Baltimore, Maryland, 1978*
86. *Baltimore, Maryland, 1978*
87. *Washington, D.C., 1978*
88. *Washington, D.C., 1978*
89. *Washington, D.C., 1978*
90. *Washington, D.C., 1978*

Roy DeCarava

91. *Brevoort Place, 1978*
92. *Halsey Street, morning, 1978*
93. *Apartment for Rent, 1978*
94. *Windows over a garden, 1978*
95. *Mother and child on stoop, 1978*
96. *Boy in print shirt, 1978*
97. *Public school entrance, 1978*
98. *Man in a window, 1978*
99. *Man smoking cigar on ashcan, 1978*
100. *Man walking a black dog, 1978*
101. *Sunday morning, Fulton Street, 1978*
102. *Subway station, 2 men, bars, 1978*
103. *Graffiti, 1978*
104. *Coney Island boardwalk, man, 1978*
105. *Man and girl at crossing, 1978*

William Eggleston

106. through 120. all *Untitled, 1978*

Elliott Erwitt

121. through 135. all *Untitled, 1978*

Larry Fink

136. through 150. all *Untitled, 1978*

Frank Gohlke

151. *House — Waxahachie, Texas, 1978*
152. *House — Galveston, Texas, 1978*
153. *Marsh fire, Bolivar Peninsula, Texas, 1978*
154. *Grove of trees near Ft. Worth, Texas, 1978*

Tod Papageorge

271. *Hermosa Beach #7, 1978*
272. *Malibu Beach #5, 1978*
273. *Hermosa Beach, 1978*
274. *Hermosa Beach #6, 1978*
275. *Manhattan Beach, 1978*
276. *Ocean Front Walk, Venice, 1978*
277. *Ocean Front Walk, Venice #4, 1978*
278. *Downtown Pasadena, 1978*
279. *Sunset Blvd., Hollywood, 1978*
280. *Above Laguna Beach, 1978*
281. *Cat and Surfer, Laguna Beach, 1978*
282. *Laguna Beach, 1978*
283. *Hermosa Beach, 1978*
284. *Hollywood Blvd., Hollywood, 1978*
285. *Public Demonstration, "Legalize Nude Beaches," Zuma Beach, 1978*

Stephen Shore

286. *Graig Nettles, Ft. Lauderdale Yankee Stadium, Ft. Lauderdale, Florida, 1978*
287. *West Palm Beach Stadium, West Palm Beach, Florida, 1978*
288. *Ron Guidry, Ft. Lauderdale Yankee Stadium, Ft. Lauderdale, Florida, 1978*
289. *Ft. Lauderdale Yankee Stadium, Ft. Lauderdale, Florida, 1978*
290. *Catfish Hunter, Ft. Lauderdale Yankee Stadium, Ft. Lauderdale, Florida, 1978*
291. *West Palm Beach Stadium, West Palm Beach, Florida, 1978*
292. *Ft. Lauderdale Yankee Stadium, Ft. Lauderdale, Florida, 1978*
293. *Sparky Lyle's locker, Ft. Lauderdale Yankee Stadium, Ft. Lauderdale, Florida, 1978*
294. *Ft. Lauderdale Yankee Stadium, Ft. Lauderdale, Florida, 1978*
295. *Clubhouse, Ft. Lauderdale Yankee Stadium, Ft. Lauderdale, Florida, 1978*
296. *Graig Nettles, Ft. Lauderdale Yankee Stadium, Ft. Lauderdale, Florida, 1978*
297. *West Palm Beach Stadium, West Palm Beach, Florida, 1978*
298. *Ft. Lauderdale Yankee Stadium, Ft. Lauderdale, Florida, 1978*
299. *Graig Nettles, Ft. Lauderdale Yankee Stadium, Ft. Lauderdale, Florida, 1978*
300. *Billy Martin, West Palm Beach Stadium, West Palm Beach, Florida, 1978*